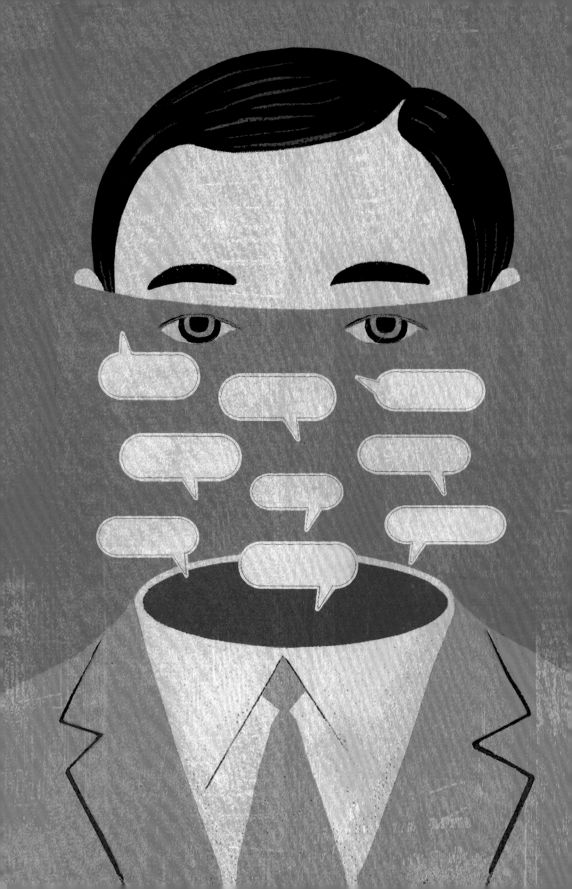

3x3Annual14

THREE BY THREE INTERNATIONAL ILLUSTRATION ANNUAL
SPONSORED BY 3X3 THE MAGAZINE OF CONTEMPORARY ILLUSTRATION

Gary Aagaard
UNITED STATES

Yael Albert
ISRAEL

Sonia Alins
SPAIN

Ofra Amit
ISRAEL

Laura Anastasio
GERMANY

Scott Anderson
UNITED STATES

Scott Bakal
UNITED STATES

Anna and Elena Balbusso
ITALY

Allison Bamcat
UNITED STATES

Melinda Beck
UNITED STATES

Becky M
SWITZERLAND

Mary Jane Begin
UNITED STATES

Dan Bejar
UNITED STATES

Roberta Berezoschi
ROMANIA

Orit Bergman
ISRAEL

Katarzyna Bogdańska
POLAND

Skye Bolluyt
UNITED STATES

Davide Bonazzi
ITALY

Jens Bonnke
GERMANY

Richard Borge
UNITED STATES

Joana Rosa Bragança
PORTUGAL

Dieter Braun
GERMANY

Nigel Buchanan
NEW ZEALAND

Jill Calder
UNITED KINGDOM

Nan Cao
CHINA

Siyu Cao
CHINA

Maria Carluccio
UNITED STATES

André Carrilho
PORTUGAL

Alberto Castillo
UNITED STATES

Angel Chang
UNITED STATES

Janice Chang
UNITED STATES

Pei-Yu Chang
GERMANY

Eszter Chen
TAIWAN

Lidan Chen
UNITED STATES

Joro Chen
TAIWAN

Ying-Hsiu Chen
TAIWAN

Marianne Chevalier
CANADA

Kun-Sen Chiang
TAIWAN

Pei-Hsin Cho
TAIWAN

Ryan Cho
UNITED STATES

Yu-Ching Chuang
UNITED KINGDOM

Jenna Nahyun Chung
UNITED STATES

Julien Chung
CANADA

Livia Cives
ITALY

Jim Cohen
UNITED STATES

Allison Cole
UNITED STATES

João Concha
PORTUGAL

Sandra Conejeros Fuentes
CHILE

Rodrigo Cordeiro
UNITED STATES

Inês Costa
GERMANY

Cameron Cottrill
UNITED STATES

Mirko Cresta
SWITZERLAND

Hannah Cunningham
UNITED STATES

Paolo d'Altan
ITALY

Giovanni Da Re
ITALY

Owen Davey
UNITED KINGDOM

Alessandra De Cristofaro
ITALY

Adam de Souza
CANADA

Mai Ly Degnan
UNITED STATES

Alice Yu Deng
CHINA

Sandra Dionisi
CANADA

Sean Dockery
UNITED STATES

Patrick Doyon
CANADA

Yukai Du
UNITED KINGDOM

John S. Dykes
UNITED STATES

Leon Edler
UNITED KINGDOM

Mina Elise
UNITED STATES

Ellakookoo
GERMANY

Pete Ellis
UNITED KINGDOM

Nick A. Erickson
UNITED STATES

Fabulo
ITALY

Maia Faddoul
CANADA

Logan Faerber
UNITED STATES

Aaron Fernandez
UNITED STATES

Chris Ferrantello
UNITED STATES

Tom Froese
CANADA

Norbert Fuckerer
GERMANY

Ryan Garcia
CANADA

Aliya Ghare
CANADA

Beppe Giacobbe
ITALY

James Gilleard
UNITED KINGDOM

Igor Gnedo
UNITED STATES

Abigail Goh
UNITED STATES

Esther Goh
SINGAPORE

Aad Goudappel
THE NETHERLANDS

Christian Gralingen
GERMANY

Tyler Gross
UNITED STATES

Morgan Gruer
UNITED STATES

Joey Guidone
ITALY

Yiran Guo
UNITED STATES

Shreya Gupta
UNITED STATES

Elizabeth Haidle
UNITED STATES

Olaf Hajek
GERMANY

Sally Soweol Han
AUSTRALIA

Eron Hare
UNITED STATES

Christopher Harper
UNITED KINGDOM

Takahisa Hashimoto
JAPAN

Kellen Hatanaka
CANADA

Chi He
UNITED KINGDOM

Heather Heckel
UNITED STATES

Caleb Heisey
UNITED STATES

Lars Henkel
GERMANY

Jef Hinchee
UNITED STATES

Mark Hoffmann
UNITED STATES

Frank Hoppmann
GERMANY

Øivind Hovland
UNITED KINGDOM

Chenfu Hsing
JAPAN

David Huang
UNITED STATES

Mago Huang
UNITED STATES

Kuri Huang
UNITED STATES

Rod Hunt
UNITED KINGDOM

Philip Huntington
UNITED KINGDOM

Enrique Ibanez
UNITED KINGDOM

IC4Design
JAPAN

Sergio Ingravalle (Maivisto)
GERMANY

Maya Ish-Shalom
UNITED STATES

Celia Jacobs
UNITED STATES

Phillip Janta
GERMANY

Hyun Jung Ji
UNITED STATES

Rina Jost
SWITZERLAND

Gayle Kabaker
UNITED STATES

John Kachik
UNITED STATES

Aya Kakeda
UNITED STATES

Simone Karl
GERMANY

Angela Keoghan
NEW ZEALAND

Johan Keslassy
FRANCE

Manuel Kilger
GERMANY

Grace Heejung Kim
UNITED STATES

Hokyoung Kim
UNITED STATES

Soomyeong Kim
SOUTH KOREA

Richard Klippfeld
AUSTRIA

Bartosz Kosowski
POLAND

Menelaos Kouroudis
GREECE

Olivier Kugler
UNITED KINGDOM

Anna Kwan
CANADA

Ahra Kwon
SOUTH KOREA

Katherine Lam
UNITED STATES

Till Lauer
SWITZERLAND

Cindy Lee
CANADA

Eunjoo Lee
UNITED KINGDOM

Kaliz Lee
HONG KONG

Vic Lee
UNITED KINGDOM

José María Lema de Pablo
SPAIN

Wei-Ming Leong
UNITED STATES

Ricky Leung
CANADA

Nick Levesque
UNITED STATES

Jennifer Lewis
UNITED KINGDOM

Jon Lezinsky
UNITED STATES

Hanrou Li
UNITED STATES

Helen Li
UNITED STATES

Jing Li
UNITED STATES

Nancy Liang
AUSTRALIA

Vanya Liang
UNITED STATES

Ahn Na Lim
CANADA

Donghyun Lim
SOUTH KOREA

Jia Dong Lin
TAIWAN

Jianrong Lin
UNITED STATES

Nick Little
UNITED STATES

Enzo Lo Re
ITALY

Max Loeffler
GERMANY

Miren Asiain Lora
ITALY

Chris Lyons
UNITED STATES

Amber Ma
UNITED STATES

Pauliina Mäkelä
FINLAND

Diego Mallo
SPAIN

Wenkai Mao
UNITED STATES

Tanya Marriott
NEW ZEALAND

Bistra Masseva
UNITED KINGDOM

Caitlin Mavilia
UNITED STATES

John Mavroudis
UNITED STATES

Bill Mayer
UNITED STATES

Stuart McReath
UNITED KINGDOM

Xiao Mei
UNITED STATES

Eugenia Mello
UNITED STATES

Cameron Miller
CANADA

Fausto Montanari
ITALY

Miguel Montaner
SPAIN

Joseph Murphy
UNITED KINGDOM

Manica K. Musil
SLOVENIA

Varvara Nedilska
CANADA

Tram Nguyen
UNITED STATES

Ricardo Nunez Suarez
UNITED STATES

Mayumi Oono
JAPAN

Yi Pan
UNITED STATES

Enzo Pérès-Labourdette
THE NETHERLANDS

Helena Perez Garcia
UNITED KINGDOM

Daria Petrilli
ITALY

Valeria Petrone
ITALY

Zara Picken
UNITED KINGDOM

Asia Pietrzyk
SWEDEN

Anna Pini
ITALY

Luis Pinto
GUATEMALA

Robert Pizzo
UNITED STATES

Emiliano Ponzi
ITALY

Spooky Pooka
UNITED KINGDOM

Andy Potts
UNITED KINGDOM

Natalie Pudalov
ISRAEL

Yuwei Qiu
UNITED STATES

Kiké Quintero
UNITED STATES

Fatinha Ramos
BELGIUM

Xin Ren
UNITED KINGDOM

Nicole Rifkin
UNITED STATES

Pablo J Rivera
UNITED STATES

Bene Rohlmann
GERMANY

Emilio Rolandi
SPAIN

Manuel Romero
SPAIN

Giulia Rossi
ITALY

Feifei Ruan
UNITED STATES

Merav Salomon
ISRAEL

Amy Schimler-Safford
UNITED STATES

Stephan Schmitz
SWITZERLAND

Schorsch Feierfeil
AUSTRIA

Thom Sevalrud
CANADA

Ann Sheng
CANADA

Qiaoyi Shi
UNITED STATES

Jhao-Yu Shih
TAIWAN

Catalina Silva Guzmán
CHILE

Steve Simpson
IRELAND

Jasjyot Singh Hans
UNITED STATES

Lasse Skarbövik
SWEDEN

Mark Smith
UNITED KINGDOM

Lily Snowden-Fine
CANADA

Deena So Oteh
UNITED STATES

Ileana Soon
UNITED STATES

Carlo Stanga
GERMANY

Studio-Takeuma
JAPAN

Kati Szilagyi
GERMANY

May Ta
UNITED STATES

Elisa Talentino
ITALY

Binny Talib
AUSTRALIA

Jacqueline Tam
UNITED STATES

Shaun Tan
AUSTRALIA

Wenjia Tang
UNITED STATES

Sébastien Thibault
CANADA

Marc Torices
SPAIN

Callum Trowbridge
UNITED KINGDOM

Rita Tu
UNITED STATES

Gerry Turley
UNITED KINGDOM

Andrea Ucini
DENMARK

João Vaz de Carvalho
PORTUGAL

Mario Wagner
UNITED STATES

Manuja Waldia
UNITED STATES

Dora Wang
UNITED STATES

Lin Wang
UNITED STATES

Luyi Wang
UNITED STATES

Mark Wang
UNITED STATES

Shu-Man Wang
TAIWAN

Michael Waraksa
UNITED STATES

Andrew Watch
CANADA

Neil Webb
UNITED KINGDOM

Katja Weikenmeier
GERMANY

Taylor Wessling
UNITED STATES

Joe Whang
UNITED STATES

Carl Wiens
CANADA

Natalia Wilkoszewska
UNITED KINGDOM

Ilene Winn-Lederer
UNITED STATES

Chen Winner
ISRAEL

Sara Wong
UNITED STATES

Chen Wu
TAIWAN

Taili Wu
UNITED STATES

Stephanie Wunderlich
GERMANY

Keiko Nabila Yamazaki
UNITED STATES

James Yang
UNITED STATES

Sunny B. Yazdani
UNITED STATES

Ji Hyun Yu
GERMANY

Natalia Zaratiegui
SPAIN

Alice Zeng
CANADA

Congrong Zhou
UNITED STATES

Francesco Zorzi
ITALY

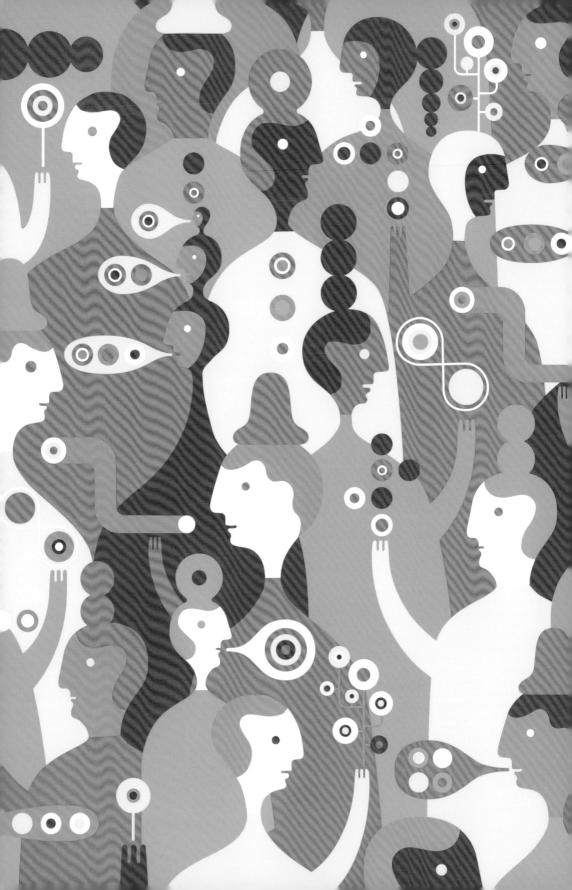

CONTENTS

8 JUDGES

10 INTRODUCTION

11 ILLUSTRATOR : EDUCATOR
OF THE YEAR

15 BEST OF SHOWS : GOLD MEDALISTS

21 PROFESSIONAL SHOW

257 PICTURE BOOK SHOW

305 STUDENT SHOW

387 INDEX

396 HONORABLE MENTIONS

Sam Arthur
PROFESSIONAL SHOW
Sam is a founding partner and CEO of Nobrow. Sam attended Central Saint Martins and went on to direct commercials, music videos and short films before setting up Nobrow in 2008 as a narrative and graphic art publishing platform. Sam created the children's book imprint Flying Eye Books, with two offices, in London and New York. They currently publish around 35 new titles per year. Sam is also co-founder of the East London Comics & Arts Festival (ELCAF) now in its 6th year.

Orit Bergman
PICTURE BOOK SHOW
Orit is a writer and an illustrator of children books. She studied at the Bezalel Academy of Arts and Design, where she currently teaches illustration and design. She has written nine books, two of which she adapted for stage, and has illustrated a number of books for various authors. Her books have been published in Israel, France, China and the United States. She has won numerous awards, among them a silver medal from the Society of Illustrators, prizes from the Israel Museum, Bologna Book Fair and the Israel Ministry of Culture.

Louise Bolongaro
PICTURE BOOK SHOW
Louise has more than fifteen years experience in children's publishing. She cut her teeth on novelty books but has focused on picture books, her one true love, for the last 12 years. She started out at Macmillan Children's Books, before becoming editorial director at Puffin, Penguin and joined Nosy Crow in late 2012. Now a proud member of the Crow's Nest, she is very excited to develop its wonderful list even further.

Dieter Braun
PROFESSIONAL SHOW
Dieter is an award-winning illustrator and children's book author based in Hamburg. His editorial clients include *Time Magazine*, the *New York Times, Wall Street Journal*, World Wildlife Fund and many more. Dieter gets his inspiration from nature and traveling. He is a passioned collector of illustrated books and toys from all over the world. Recently, he fulfilled his dream job creating two illustrated wildlife encyclopedias: *Wild Animals of the North* and *Wild Animals of the South*.

Michael Byers
STUDENT SHOW
Michael uses his optimistic and whimsical attitude to create fun, dynamic and emotionally driven illustrations. His line work is deliberate and full of energy achieving an instant organic feel to his images. His work has appeared in publications including the *New York Times, Wall Street Journal, Men's Health, Family Circle, Plansponsor, Sports Illustrated, Variety* and *Entertainment Weekly* to name a few. He has received recognition from *American Illustration, Communication Arts* and the Society of Illustrators.

Andrea D'Aquino
PICTURE BOOK SHOW
Andrea has illustrated two books, a modern take on the classic *Alice's Adventures in Wonderland* as well as *Once Upon a Piece of Paper*, which she also authored. Her illustrations have appeared internationally in magazines, newspapers and book jackets. Andrea's work has been recognized by *American Illustration*, Society of Illustrators, *Communication Arts*, the Type Director's Club, the Art Director's Club and others. Clients include *Uppercase* magazine, Anthropologie, Amnesty International and One Kings Lane.

Geneviève Gauckler
STUDENT SHOW
Genevieve is a French artist, illustrator and art director who is best known for her ever-evolving procession of lovable characters and technicolour digital mashes. Some clients include: Renault, Bourjois, Coca-Cola, Skype, PlayStation, Le Buisson, Medicom Toys and Adobe. Three books have been published about her work, in Japan by Gas Book and in France by Pyramyd. Her favorite places are Japan and India but she also loves spending time in the French countryside accompanied by her faithful dog, Kawa and of course her laptop.

Johan Holm
STUDENT SHOW
Founder of the publishing company Me and My Magazines, Johan has worked for the biggest magazine publishing houses in Sweden. Nowadays he puts most of his time into his craft beer and food magazine c/o HOPS.

Jonathan Kenyon
PROFESSIONAL SHOW
As co-founder and executive creative director of Vault49, Jonathan guides the agency's strategic and creative direction. With creative origins as an internationally recognized street artist, Jonathan has built on this unique background with 15 years of experience in branding, illustration and communications, primarily derived from building Vault49 from the brainchild of two ambitious artists into the internationally recognized and commercially successful agency it is today.

André da Loba
STUDENT SHOW
Born in Portugal, André is a published and exhibited artist whose work has received international acclaim from the Society of Illustrators, *Communication Arts, 3x3, Luerzer's Magazine, Creative Quarterly* and the Bologna Children's Book Fair. As an illustrator, animator, graphic designer, sculptor and educator, Andre's combination of curiosity, experience, knowledge and unknowing serves as the constant medium with which he creates and inspires. Some of his clients include the *New York Times, Washington Post, Boston Globe*, NPR and Bloomberg.

Orlie Kraus
PROFESSIONAL SHOW
Orlie is art director of the *Wall Street Journal Reports*. Creating striking and intelligent visuals that engage readers is a critical part of her work. Collaborating with talented artists, often giving them room to experiment in new directions, allows for great work to happen. She also leads a small group of graphic designers who create dynamic infographics for both the print and digital editions. Orlie has been recognized by the Society of Publication Design, Society of News Design, Society of Illustrators, *American Illustration* and *3x3*.

Melissa Manlove
PICTURE BOOK SHOW
Melissa is a senior editor at Chronicle Books in San Francisco. She has been with Chronicle for 12 years. Her acquisitions tend to be all ages in nonfiction; ages 0–8 for fiction. When acquiring, she looks for fresh takes on familiar topics as well as the new and unusual. An effective approach and strong, graceful writing are important to her. She has 17 years of children's bookselling experience.

Julia Rothman
PROFESSIONAL SHOW
Julia is an illustrator, pattern designer and author. In addition to working for such clients as the *New York Times*, Target and Ann Taylor, she has her own lines of wallpaper, stationery, fabric and dishware. You'll find her designs on products for Urban Outfitters, Hello!Lucky and Hygge & West. She has authored and illustrated nine books. Her homage to her hometown, *Hello NY: An Illustrated Love Letter to the Five Boroughs*, was praised by the *New York Times*, *New York Daily News* and on WNYC's *The Brian Lehrer Show*. She lives and works from her studio in Brooklyn, New York.

Daniela Silva
PROFESSIONAL SHOW
Daniela is the designer at Granta Publications. She joined Granta in 2011 after finishing her master's degree in editorial design at Central Saint Martins. She is the art director for *Granta* magazine, where she commissions illustrations and photography. She also designs book covers for Granta and Portobello Books. Daniela is a co-founder of *Fotoautomat*, an international photography magazine dedicated to the work of emerging photographers.

Ivylise Simones
PROFESSIONAL SHOW
Ivylise is the creative director of *Mother Jones*. Before joining *Mother Jones*, she oversaw a redesign as the design director of the *New York Observer*, and she served as the art director of the *Village Voice* and the associate art director of the *Miami New Times*. She also applied her design and photography finesse at Showtime, *Popular Science* and *American Photo*, and in 2010 she helped launch *People* magazine's iPad app. She has a cat named Inspector Picklejuice.

Sophie Stericker
PICTURE BOOK SHOW
Having graduated from Camberwell School of Art with a degree in graphic design, Sophie has spent most of her career in children's publishing. She has freelanced for many publishers including HarperCollins Children's Books, Egmont and Orchard Books. Sophie is currently creative director at Hachette Children's Group. Over the years she's commissioned more than a thousand artists and photographers and never ceases to be amazed by the quality and skill of the universe of talented image-makers.

Gina Triplett
STUDENT SHOW
Gina is an illustrator living in Philadelphia. She has worked with editorial clients that have included the *New York Times* and *Rolling Stone*. She's illustrated books for Random House and Penguin, worked on advertising posters for Apple, gift cards for Target, a signature shoe for Converse and a visual identity for Whole Foods Market. When not working on projects she enjoys spending time exploring the city with her two kids, sitting at cafés, playing with her dog and collaborating on paintings with her husband, Matt Curtius, working under the name Gina and Matt.

Rod Hunt
SHOW CHAIR
Rod is an award-winning London-based Illustrator who has built a reputation for retro-tinged illustrations and detailed, character-filled landscapes. With UK and international clients, he's illustrated everything from book covers to advertising campaigns, theme park maps, iPhone apps and large-scale installation. Rod also illustrated the bestselling *Where's Stig?* books for the BBC's hit TV show *Top Gear*; the books have sold in excess of 600,000 copies to date. Rod has served on the boards of ICON9 and was chairman of the Association of Illustrators. Rod regularly lectures on the business of illustration.

WE ARE ONCE AGAIN PLEASED TO PRESENT OUTSTANDING EXAMPLES OF ILLUSTRATION FROM ACROSS THE GLOBE. EACH YEAR WE REACH OUT TO ILLUSTRATORS IN ALL FIELDS, IN ALL COUNTRIES. THIS YEAR, WE RECEIVED MORE THAN 4,700 ENTRIES FROM FIFTY-SIX COUNTRIES. OUR TWO BEST OF SHOW WINNERS ARE FROM JAPAN—ONE STUDENT, ONE PROFESSIONAL. OUR MEDALISTS REPRESENT FOURTEEN COUNTRIES, MERIT WINNERS ARE FROM THIRTY-TWO COUNTRIES AND HONORABLE MENTIONS FROM TWENTY-TWO. TEN OUT OF TWELVE OF OUR GOLD MEDALISTS WERE FROM OUTSIDE THE UNITED STATES. SEEING THESE RESULTS WE CAN TRUTHFULLY SAY OURS IS INDEED AN INTERNATIONAL SHOW. THIS YEAR WE RECEIVED A GROWING NUMBER OF ENTRIES FROM CHINA, RUSSIA AND IRAN; ILLUSTRATION KNOWS NO BORDERS. POLITICS AREN'T AT PLAY HERE. ENTRANTS ARE NEITHER IDENTIFIED BY NAME NOR COUNTRY, OUR JUDGES MERELY SELECT WINNERS BASED ON THE QUALITY OF THE WORK. AND WITHOUT INTERNATIONAL BIAS. JUDGES WERE EVENLY SPLIT BETWEEN THE UNITED STATES AND THE REST OF THE WORLD. WE TRUST YOU'LL ENJOY PURUSING THE WORK IN THE PAGES THAT FOLLOW AS MUCH AS WE ENJOYED PREPARING THIS ANNUAL. NOW LET US WELCOME YOU TO THE WORLD OF CONTEMPORARY ILLUSTRATION 2017. *Enjoy!*

—THE PUBLISHER

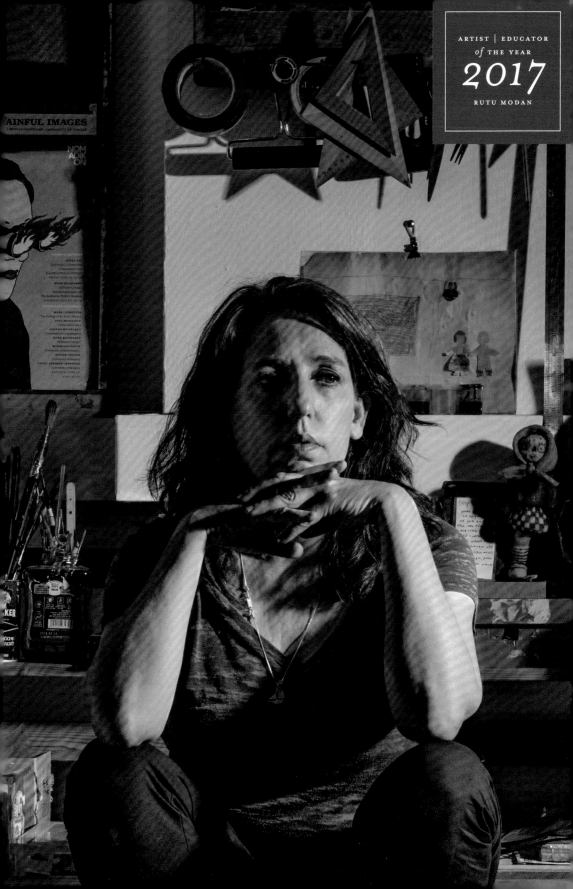

RUTU MODAN is a comics wunderkind. As one of the few established comics artists in Israel, she is also one of the few established female comics artists in the world. A graduate of the first comics course in Israel she moves between comics, editorial illustration and children's books. She also co-founded an alternative comics collective, co-edited Mad magazine and had her first book become a best seller. Graphic novels followed as well as international acclaim. Her other joy? Each week she drives three-hours to teach at her alma mater. Her advice to students: Open yourself to influences, but not to imitate. Or do what's comfortable. Or what people like. Because you won't succeed. Recognized in her home country as a national treasure we are delighted to name Rutu Modan our 3x3 Illustrator/Educator of the Year, 2017.

I was one of the six students who chose his class. On the first day he brought in his wonderful comics collection, piled the books on the tables, and said: "Just read." It was the first time I saw *Watchmen*, Edward Gorey, Robert Crumb and Aline Kominksy-Crumb, *Raw* magazine and many others. It was culture shock; I was falling in love. By the end of the class, I had decided to become a comics artist. Three months later I already had a strip in a local newspaper and I've never stopped making comics since.

Q Tell us a bit about your background, were you always interested in illustration?
A You might say it started in kindergarten when I was four or five years old. I would often dictate the text to my teacher for my drawings. Drawing for me means, even at that early age, to tell a story. I loved picture books so much that in junior high school I secretly signed up my little sister to the kids' public library so I could continue to look at picture books.

On the other hand, I didn't think of illustration as my future profession. Back then I had planned to be an Arctic explorer.
Q What prompted you to become a comics artist?
A Comics weren't popular in Israel when I was young. I think Israel is the only country in the world where Tintin, Superman and Asterix were commercial failures. There was a comic strip in a children's magazine from time to time, one Tintin book published by a brave publisher, there were a few Tex comics I'd find in my dentist's reception room and one political comic artist in the newspaper my dad read—that was about it. But I loved comics whenever, where-ever I saw them.

In my third year at the art academy, my illustration teacher, Michel Kishka, one of Israel's few comics artists, initiated the first comics course;

Q Which comes first, the text or the images?
A The text, always. I write everything down first. The next stage is making a rough but complete storyboard. Then I take photographs for reference and only then do I decide on the style. The next step is to start making sketches for the characters and only then start drawing. I'm quite rigid about this process.
Q How hard was it for you to enter the field?
A Actually, I was lucky. The 90s were a good time to start an illustration career in Israel. A new generation of young, enthusiastic editors changed what

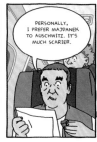

was an extremely conservative approach—both in style and content. There were suddenly a lot of new magazines, supplements, local editions, etc. Illustrations, which had been rarely used before in newspapers, were considered hip and innovative. And with so many new supplements, there were spaces to fill. It literally seemed like all I had to do to get a comics strip was to suggest one, so I did.
Q What artists influenced you?
A Oh, there are so many. Tomi Ungerer, Art Spiegelman, Daniel Clowes, Saul Steinberg, Hergé, Tove Jansson, Anke Fuechtenberger to

name a few. But it's not necessarily the style or the technique that influences me. It can be the storytelling or the approach to composition. For instance Art Spiegelman's influence was mostly the myriad possibilities he showed to use the medium to tell any type of story.

Q Tell us about your *Mad* magazine experience.

A An Israeli publisher, who happened to be my uncle, liked comics and so he bought the Hebrew rights in the early 90s. My good friend, the comics artist Yirmi Pinkus, and I were the co-editors. We

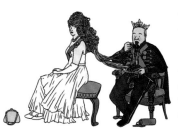

did everything from choosing the *Mad* material, translating, printing, and the best part, commissioning work from all our friends.

It was a great fun but an absolute commercial disaster.

The Israeli work we commissioned were alternative comics. *Mad*'s fans hated the local work, alternative comics' fans hated the *Mad* part. Nobody bought it. After ten issues the project was canceled.

Q Why did you feel the need to initiate the publishing collective, Actus Tragicus?

A After we failed with *Mad*, Yirmi and I decided that if creating comics meant losing money, we better lose it doing exactly what we wanted to do.

There were three artists in the collective beside Yirmi and me: Batia Kolton, Itzik Rennert and Mira Friedmann. Between 1996–2008 we published a comics project almost every year. At that time there were no comics shops in the country (now there are two). So to sell our comics we invited other types of artists and created events in bars or public spaces that drew large crowds. This became "the way" to sell our comics and art.

To reach a wider audience, we started publishing our books in English and distributed them abroad through comics festivals in Europe and the US.

Actus was to become an independent comics

publishing house, but it eventually became like a support group. We admired each other work enough to criticize and to help one another grow. Even though it never became huge, commercially speaking, I consider Actus my most important and influential project.

Q Where do your story ideas come from?

A The news, documentaries, family stories, gossip, eavesdropping at queues. The next good idea can be anywhere, so it's important to always be on the watch to catch it.

Most ideas pop up when I'm half a sleep. If it wakes me up and I cannot go back to sleep, there's a real good chance it's exciting enough to keep me interested long enough for the days, weeks, months, years it will take me to complete the comics.

Q There's quite a bit of dark humor in your work, why is that a central theme in your projects?

A It's well known that humor can be a great tool for coping with terrible things and black humor for coping with the tragic. Luckily, there's never a shortage of either.

The roots could come from the fact that I grew up around a hospital inside a neighborhood where all the doctors and nurses lived. Our parents worked long hours and we were left alone from a very young age. It seems the grown-ups never thought there were things you should hide from kids. During the 1973 war, helicopters brought wounded soldiers from the front landing on the field where we were playing ball. As kids we didn't consider it frightening or extreme, it was just everyday reality. Looking back, it might have had some influence on my work, after all there's always a dead person in the story.

In my stories, I try to show my point-of-view which is that nothing is ever crystal clear, nothing is simple and that it's often impossible to decide what is good and what is bad.

Q How has illustration and comics changed in Israel since you were in school?

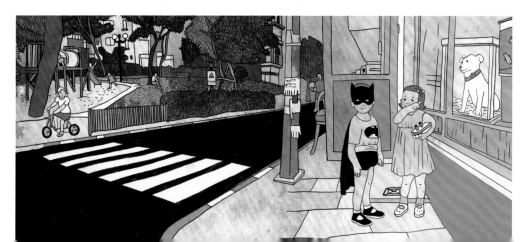

A There's been a huge change but there's still a lot to be done. There are many wonderful comics artists, unfortunately most are self-published. What has changed a lot is the attitude towards comics. Today if you say you're a comics artist, the reaction is usually "cool" rather than "what does that mean?"

In the children's books market, publishers are more daring than they used to be. It's also easier for a young artist to be hired to illustrate a book. It took me seven years after art school before a publisher gave me that chance. As for the current editorial illustration market, unfortunately like in the rest of the world, it's shrinking.

Having said that I do believe the illustration scene in Israel is one of the best in the world, if not financially, at least in the quantity of illustrators and in the quality of their work.

Q Let's talk about another love of yours, how long have you been teaching?

A It's been twenty-three years now. I started teaching an editorial illustration course in a private design school in Tel Aviv. But since 1999 I've taught comics, children's books illustration and foundation classes at the Bezalel Academy in Jerusalem. I used to teach editorial illustration at Bezalel as well, but that's not a separate course anymore.

Q What do you feel the role of an instructor is?

A The main thing is that I try to make students love illustration and comics as much as I do. In the past I thought that my goal was to teach my students how to draw: composition, coloring, styling and so on. I'm still doing that of course but my ambition is to help them discover how and what they want to draw and say.

That's even more complicated and even frightening because I have to trust the student and doubt myself more, and be able to fail and watch the student fail. It's less instructing and more like handing the tools to a workman while he's doing his thing.

Q How are you able to juggle teaching and your work projects?

A Easy answer, sleeping six hours a night instead of eight adds one more working day to the week. More seriously, sometimes the juggling is difficult but it's like having both a career and a family, to give one of them up is unthinkable.

Most of the time I don't separate teaching and work. They support and enrich each other. And honestly, it's nice to have a break from the studio, to

go out and deal with my students' artistic problems rather than dealing with my own. Other people's problems are always much simpler to solve.

Q What is your advice to graduates entering the field today?

A Always have a personal project besides commissioned work. Commercial illustration can be a lot of fun, you are like an image-detective trying to solve problems. But at the same time you are being told what to do and that can be frustrating. So if you have your own personal project, no matter if it will be published or not, you're like a king doing exactly what you want. These project are the ones that usually take you to your next level, which impacts your paid work as well. Even if it doesn't at least you're having fun. Fun is very important.

And calm your parents down. Everything will be fine, you will not starve to death. Tell them I said so.

Q Final words to teachers?

A Remind the students from time to time that they love to draw—sometimes they are so stressed out they forget that.

And share with them all your difficulties and failures so they'll know learning doesn't end when they get their degree. A student once said to me: "Something is wrong. I'm in my fourth year and it's still so difficult!" I told him that as long as you want to become better, creating will always be difficult. It's easy only if you continue doing what you've already done, but then it's also boring. If you suffer, that means you're on the right track.

Q And finally, what's in your future, personally and professionally?

A At the moment I'm working on a new graphic novel and afterwards there's a children's book; I already have the text ready.

As for teaching, the Bezalel Academy just opened a visual communication graduate program, the first program of its kind in Israel, and I'm going to teach there. The program will be emphasizing the multidisciplinary aspect of visual communication. I'll be teaching how to apply the principals of illustration and storytelling not only to illustrators, but also designers from other disciplines. At the same time, I'm sure to encounter new ways of thinking that will affect illustrators in the program and their projects. Anyway, it's a new challenge and I'm already looking forward to it.

Read Rutu Modan's complete interview at 3x3mag.com/annual14/rutu

3X3 SHOW NO.14

16 BEST OF SHOW

19 GOLD MEDALISTS

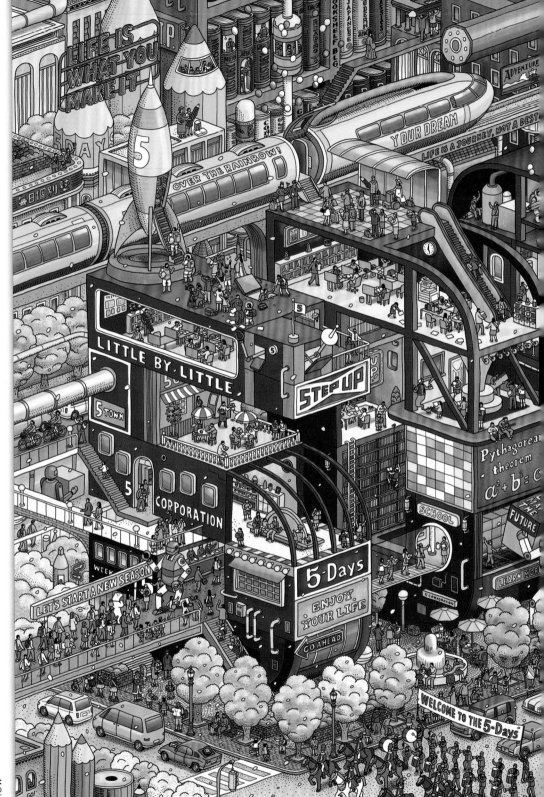

IC4Design

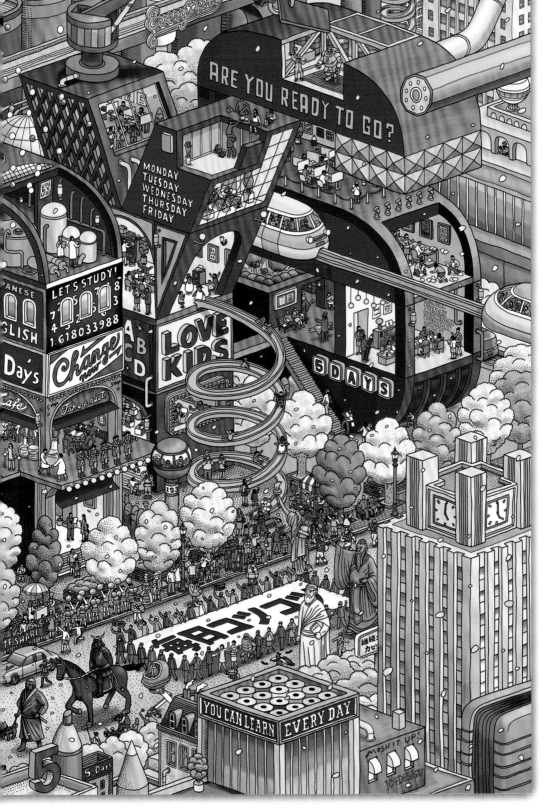

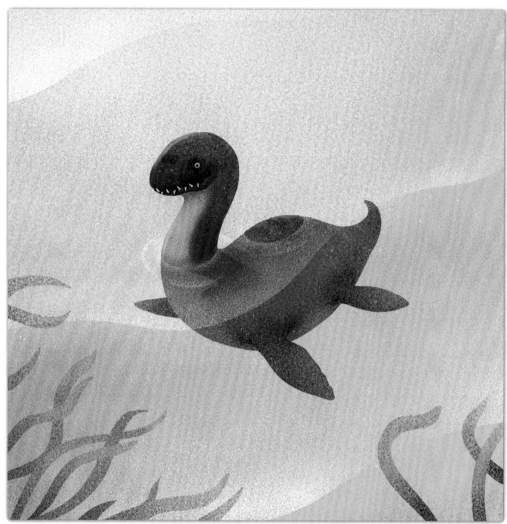

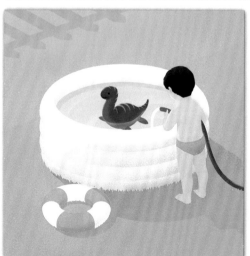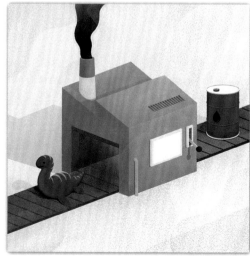

Chenfu Hsing

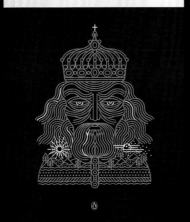

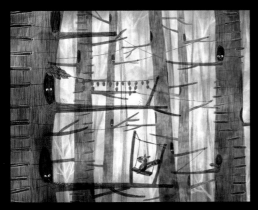
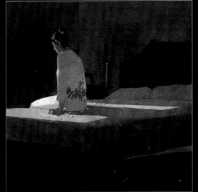
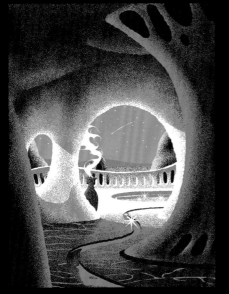
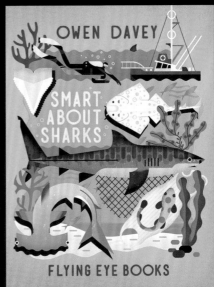

Manuja Waldia *Katarzyna Bogdańska* *Sally Soweol Han* *Katherine Lam* *Max Loeffler* *Owen Davey*

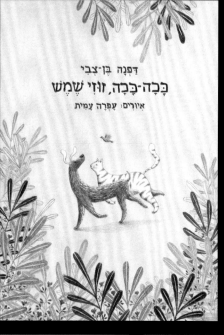

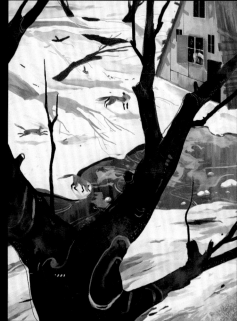

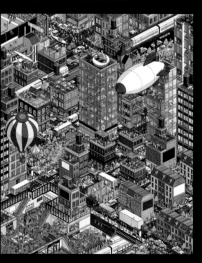

(TL) *Ofra Amit* (TR) *Xin Ren* (ML) *Elisa Talentino* (MR) *Enzo Lo Re* (BL) *Rod Hunt* (BR) *João Concha*

22 ADVERTISING

40 ANIMATION

45 BOOKS

57 CALENDARS

59 CORPORATE
 COMMUNICATIONS

64 COVERS

79 EDITORIAL

153 FASHION

154 GALLERY

164 GRAPHIC NOVELS

168 GREETING CARDS

169 PACKAGING

176 POSTERS

188 SCI-FI

190 SELF-PROMOTION

217 SEQUENTIAL

218 TEXTILES + PATTERNS

224 THREE-DIMENSIONAL

227 UNPUBLISHED

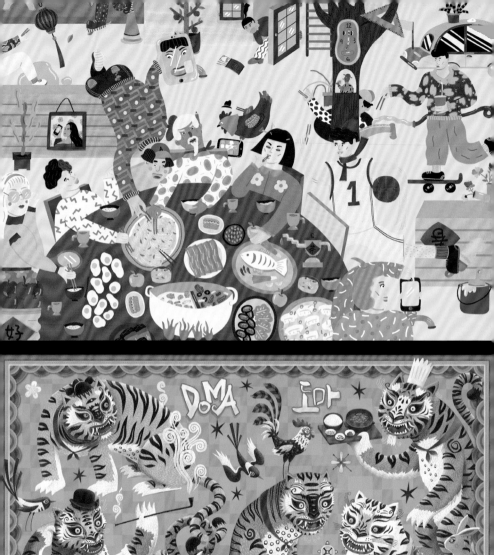
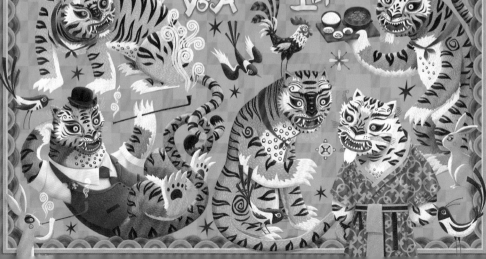

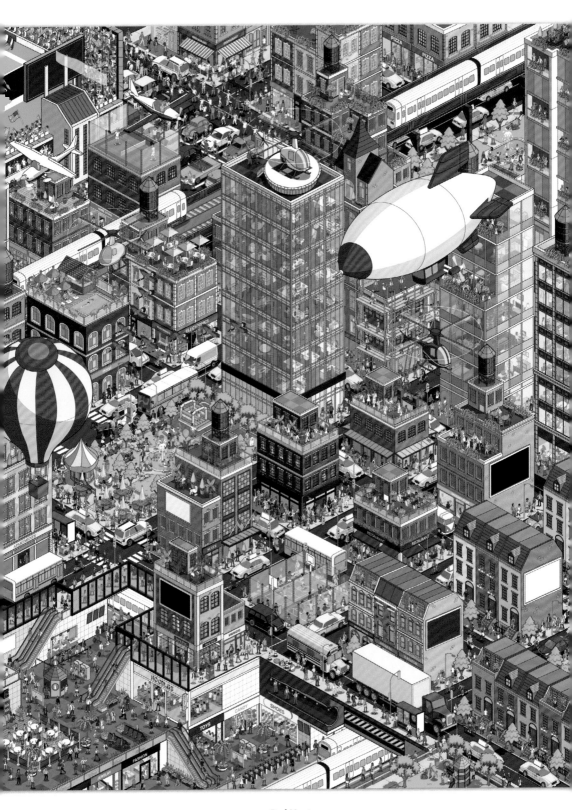

GOLD *Rod Hunt*

MERIT *Pete Ellis*

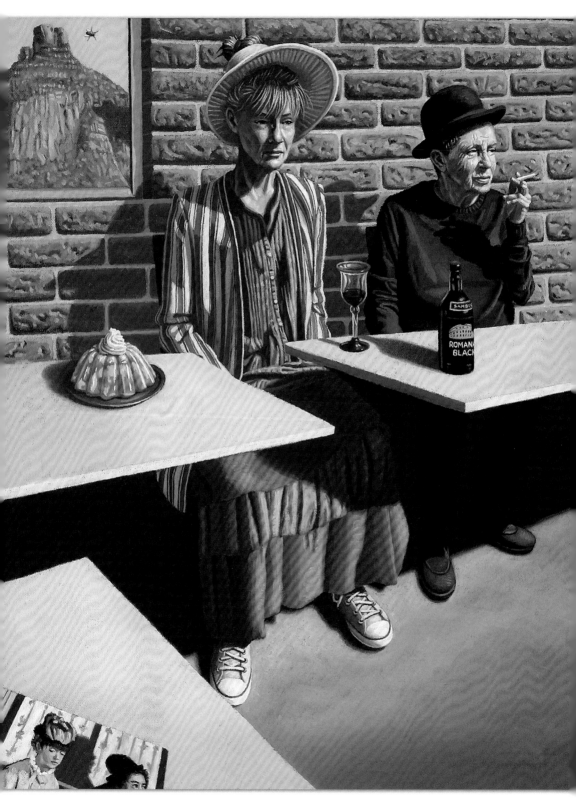

MERIT *Gary Aagaard*

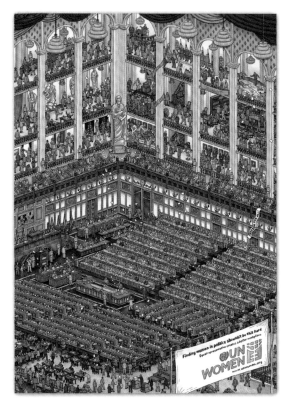

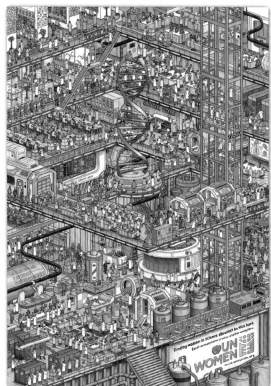

MERIT *IC4Design*

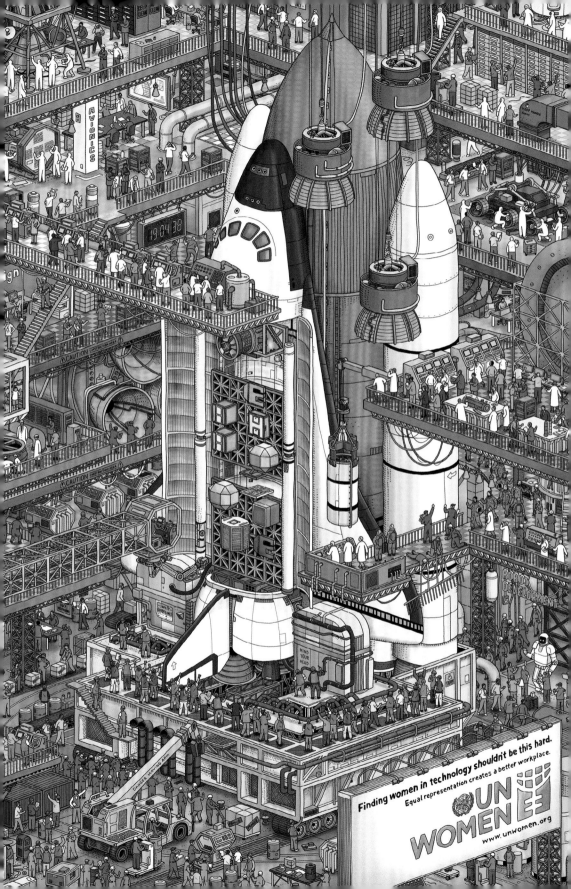

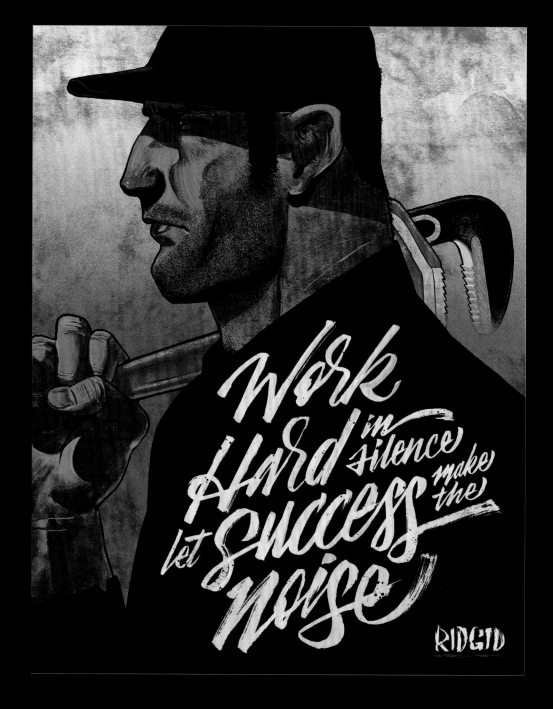

MERIT *Sean Dockery*

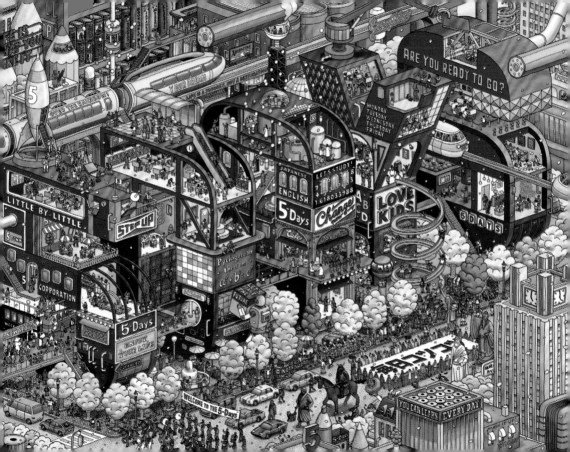

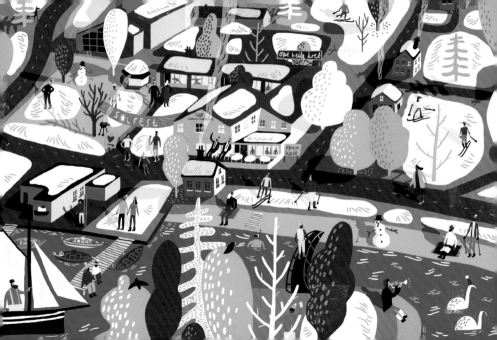

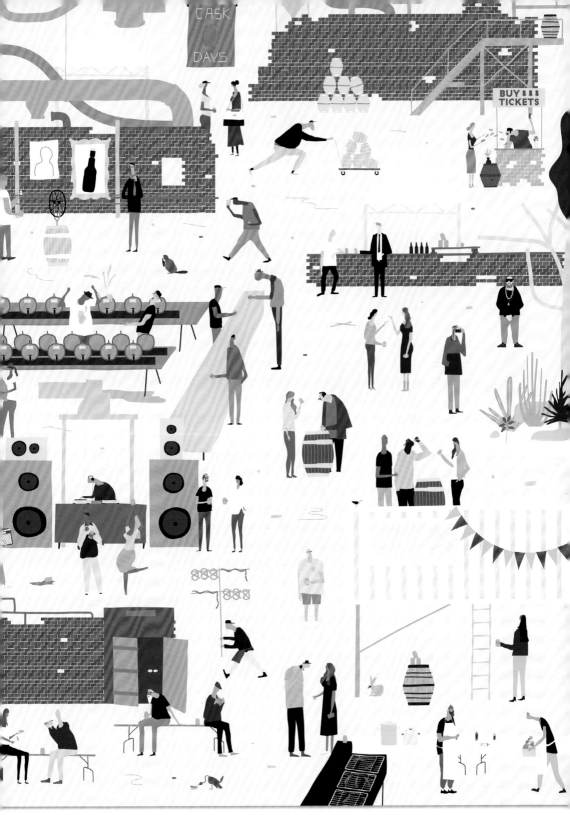

MERIT *Kellen Hatanaka*

DISTINGUISHED MERIT *Esther Goh*

Range

Land

Sea

MERIT *Bill Mayer*

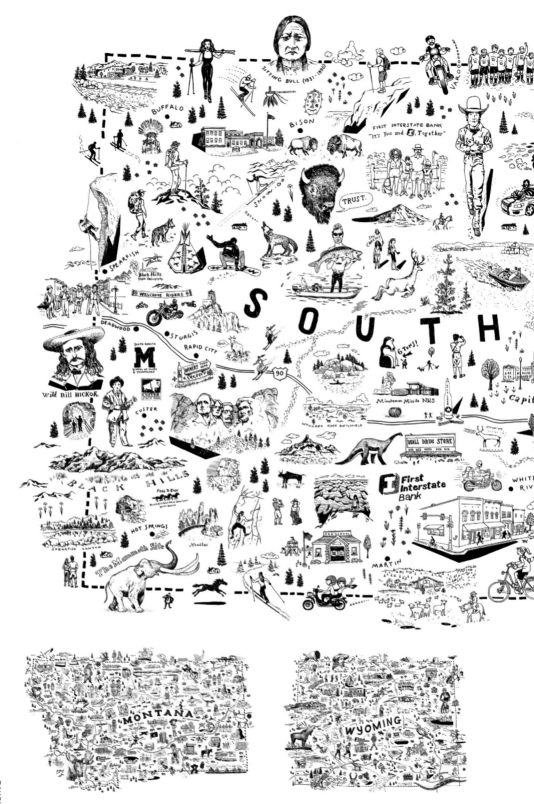

MERIT *John S. Dykes*

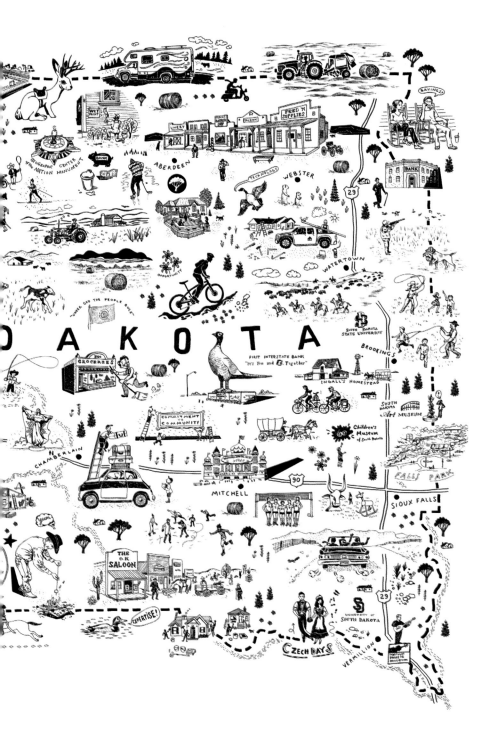

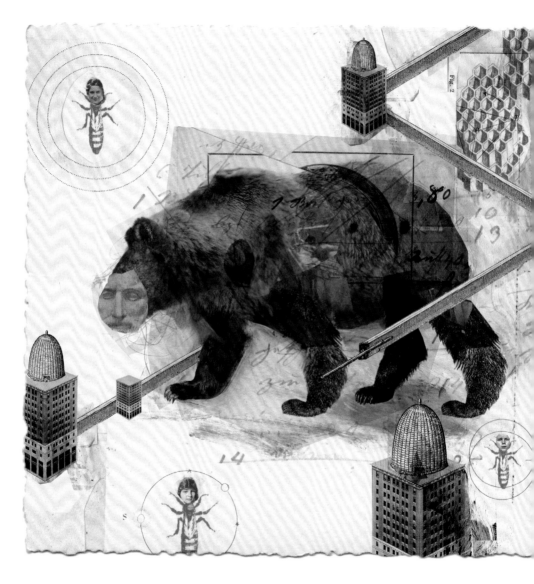

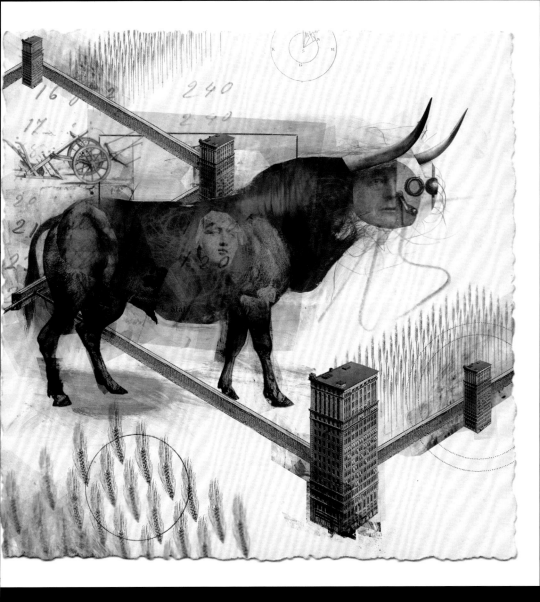

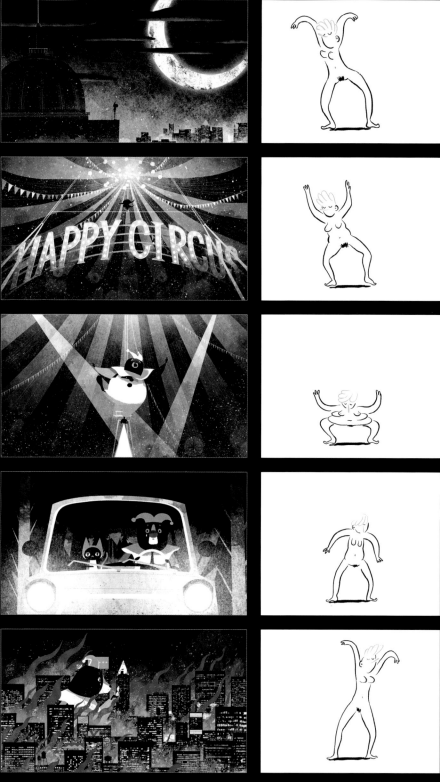

(L) MERIT *Nick Little* (R) MERIT *Fausto Montanari*

41

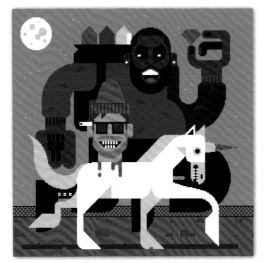

(L) MERIT *Nick Little* (R) MERIT *Taili Wu*

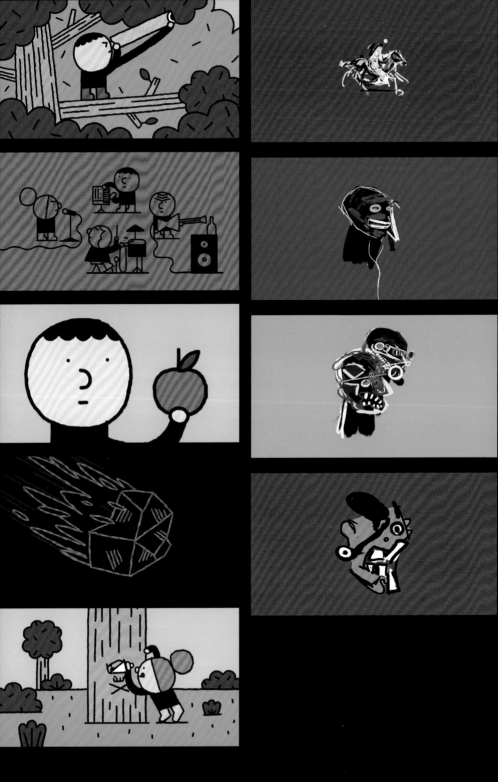

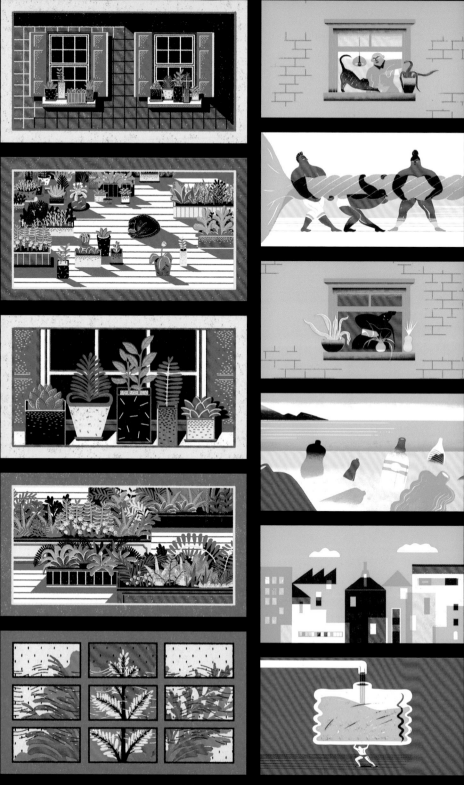

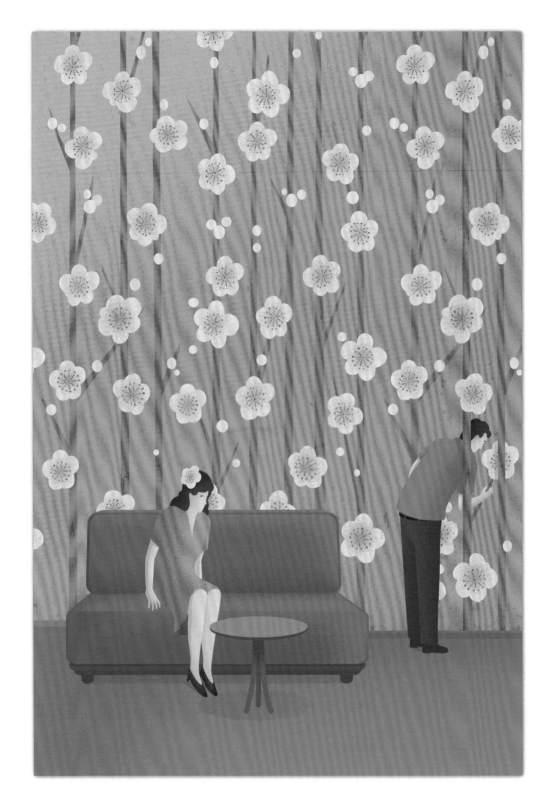

MERIT *Stephan Schmitz*

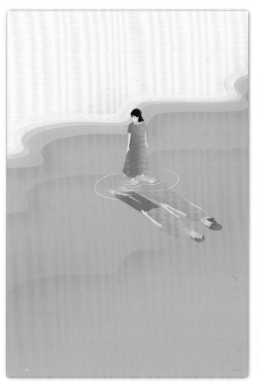
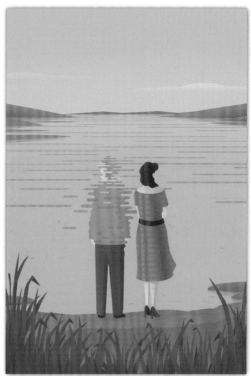

47

GOLD *Elisa Talentino*

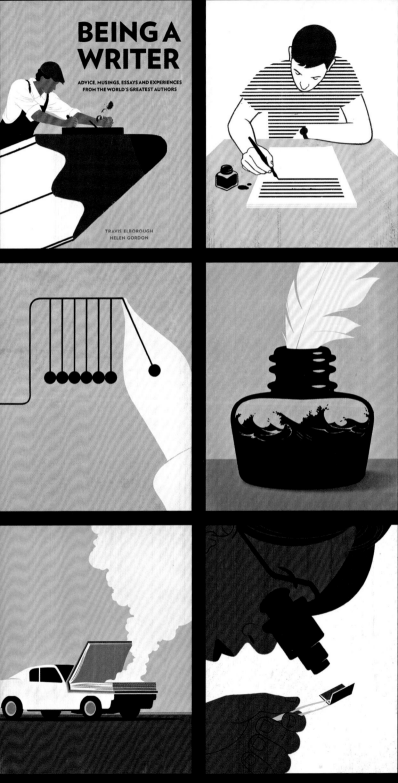

BEING A WRITER

ADVICE, MUSINGS, ESSAYS AND EXPERIENCES
FROM THE WORLD'S GREATEST AUTHORS

TRAVIS ELBOROUGH
HELEN GORDON

MERIT *Joey Guidone*

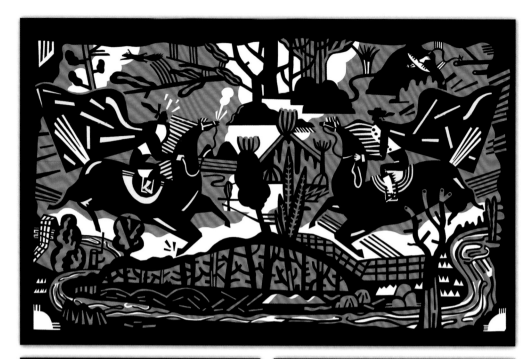

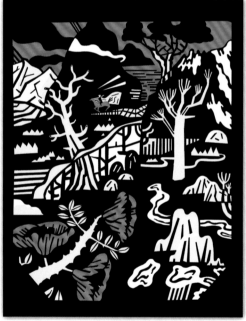

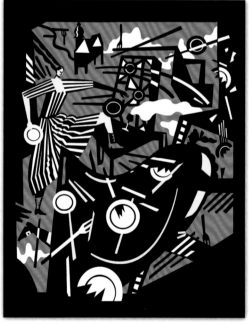

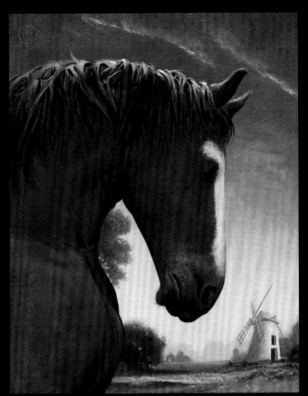

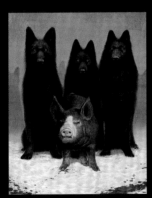

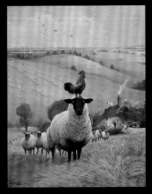

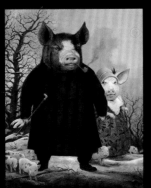

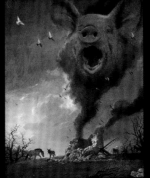

MERIT *Bill Mayer*

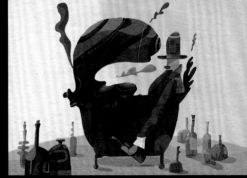

MERIT *Mark Smith*

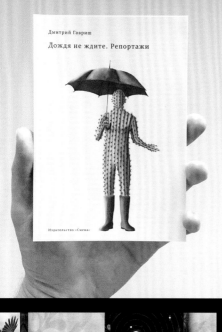

Дмитрий Гавриш

Дождя не ждите. Репортажи

Издательство «Снежа»

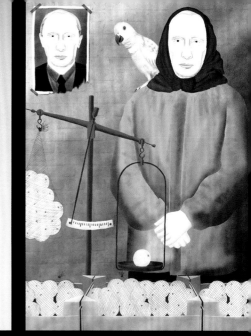

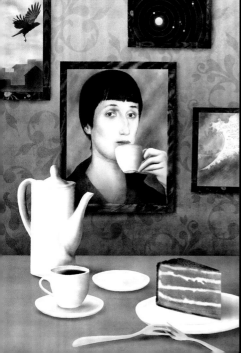

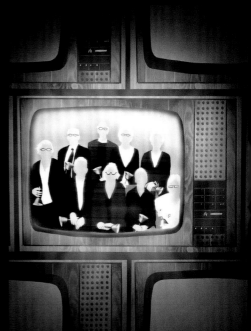

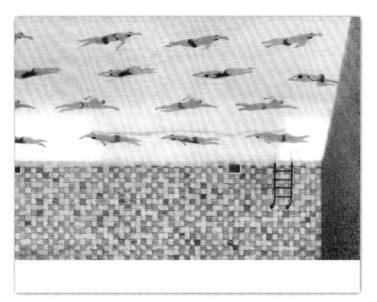

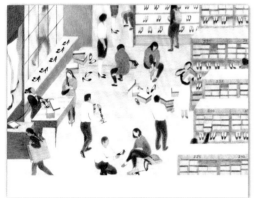

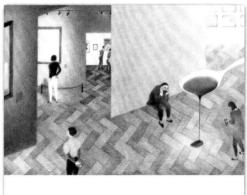

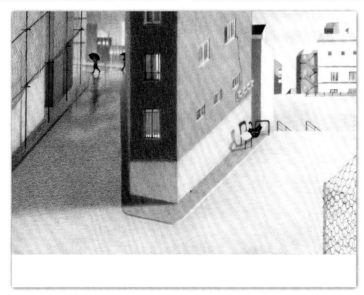

MERIT *Soomyeong Kim*

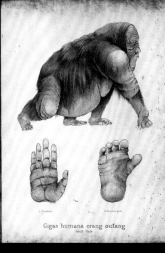

Gigas humana orang outang
Adult Male

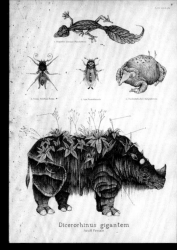

Dicerorhinus gigantem
Adult Female

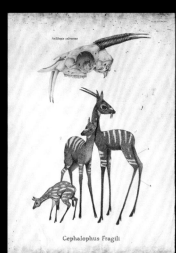

Cephalophus Fragili

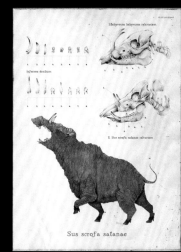

Sus scrofa satanae

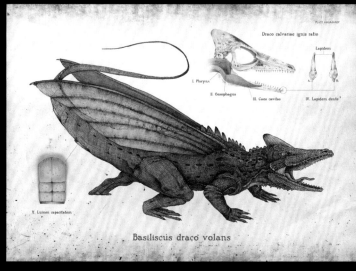

Draco calvariae ignis ratio

Basiliscus draco volans

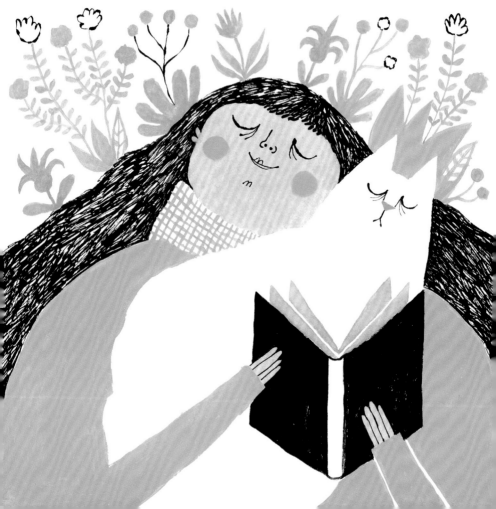

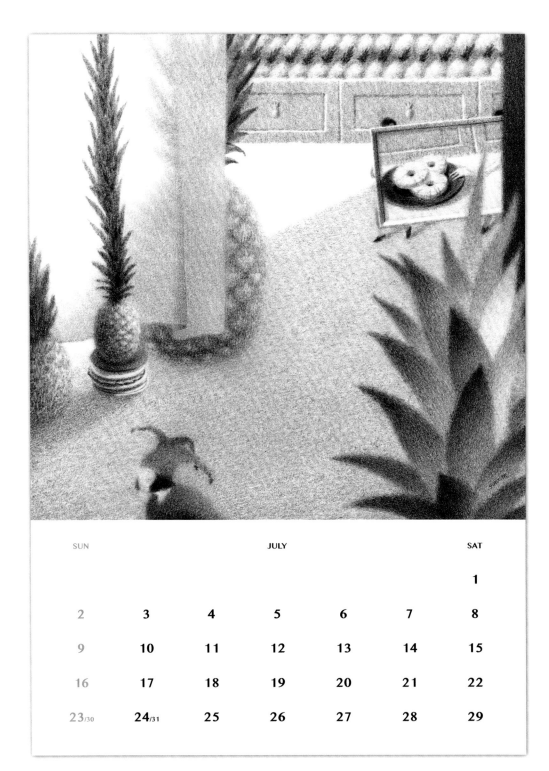

SUN			JULY			SAT
						1
2	**3**	**4**	**5**	**6**	**7**	**8**
9	**10**	**11**	**12**	**13**	**14**	**15**
16	**17**	**18**	**19**	**20**	**21**	**22**
23/30	**24**/31	**25**	**26**	**27**	**28**	**29**

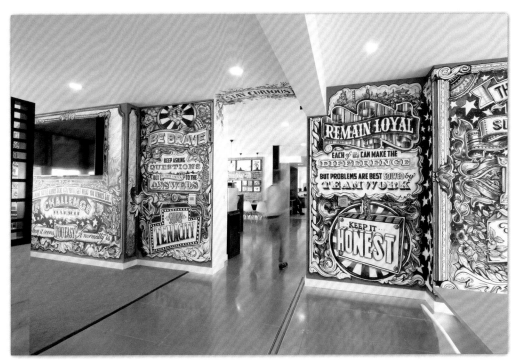

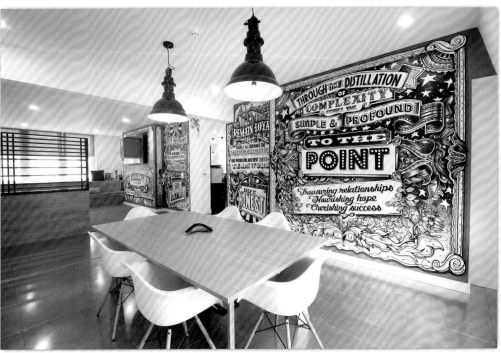

(T) MERIT *Eugenia Mello* (B) MERIT *Neil Webb & Studio Sutherland*

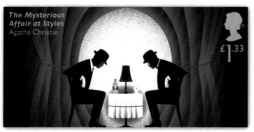

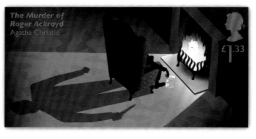

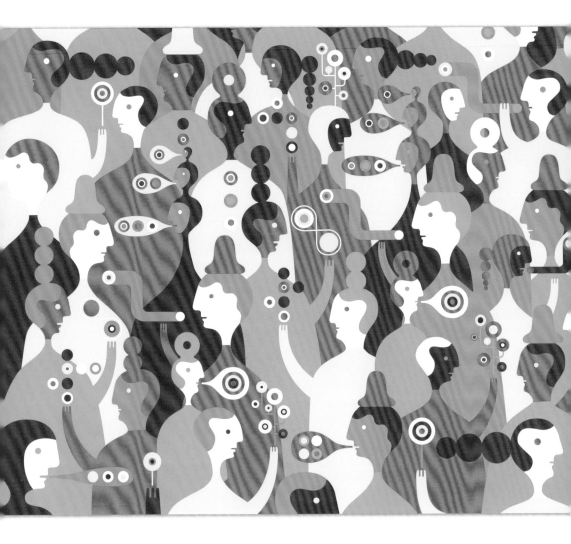

MERIT *Melinda Beck*

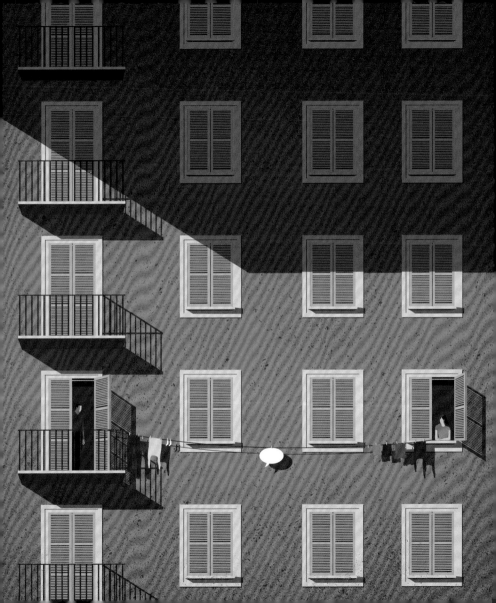

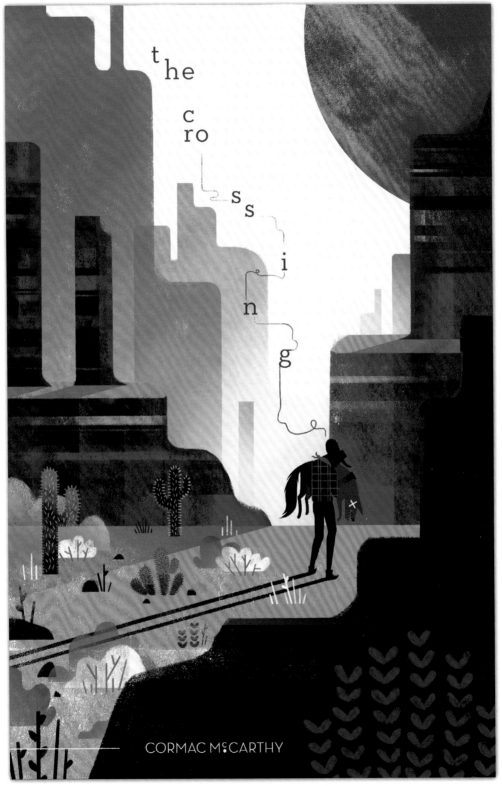

the crossing

CORMAC McCARTHY

(L) MERIT *Sara Wong* (R) MERIT *Jim Cohen*

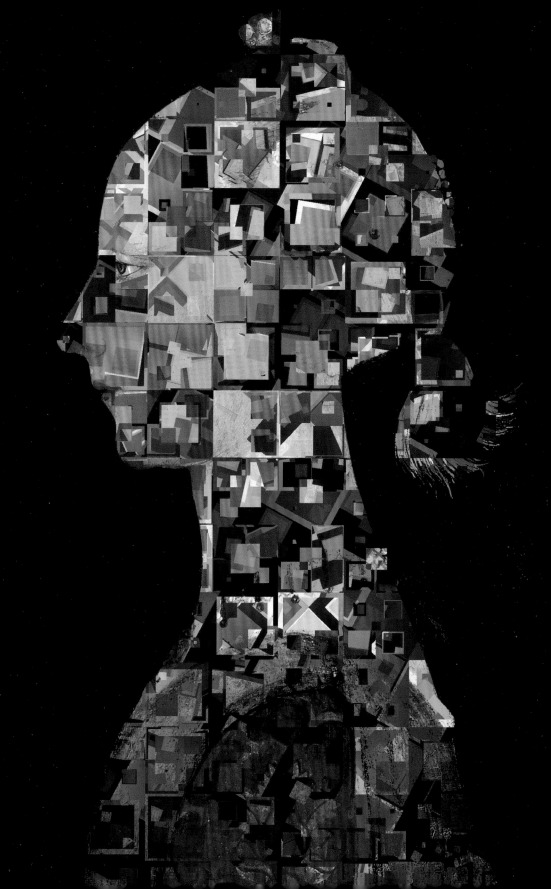

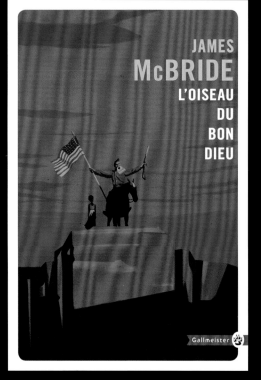

JAMES
McBRIDE
L'OISEAU
DU
BON
DIEU

Gallmeister

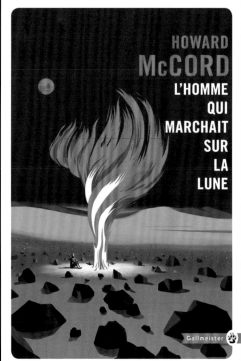

HOWARD
McCORD
L'HOMME
QUI
MARCHAIT
SUR
LA
LUNE

Gallmeister

DAVID
VANN
DÉSOLATIONS

Gallmeister

TREVANIAN
THE
MAIN

Gallmeister

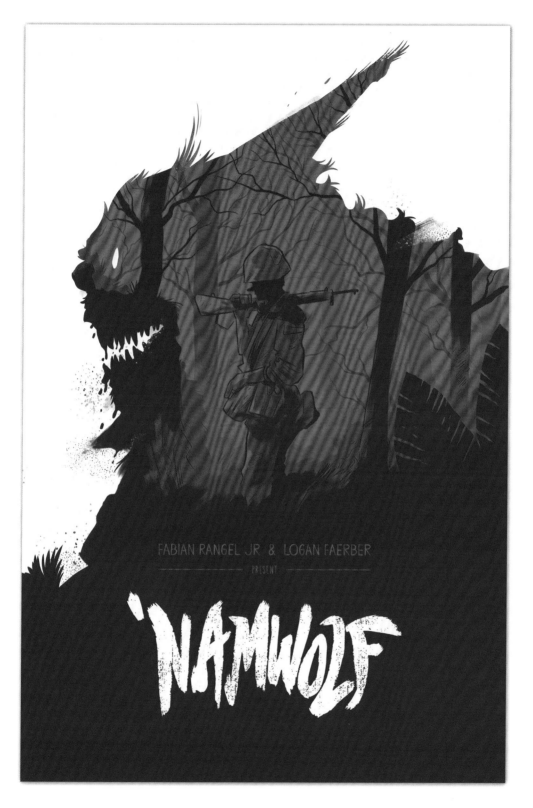

DISTINGUISHED MERIT *Logan Faerber*

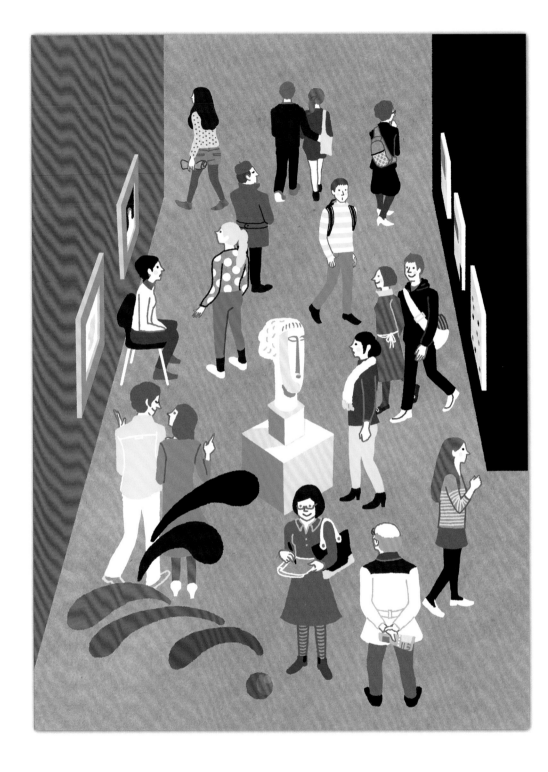

MERIT *Mayumi Oono*

Max Bill
Jan Tschichold
Paul Renner

DISPUTE

MERIT *Yi Pan*

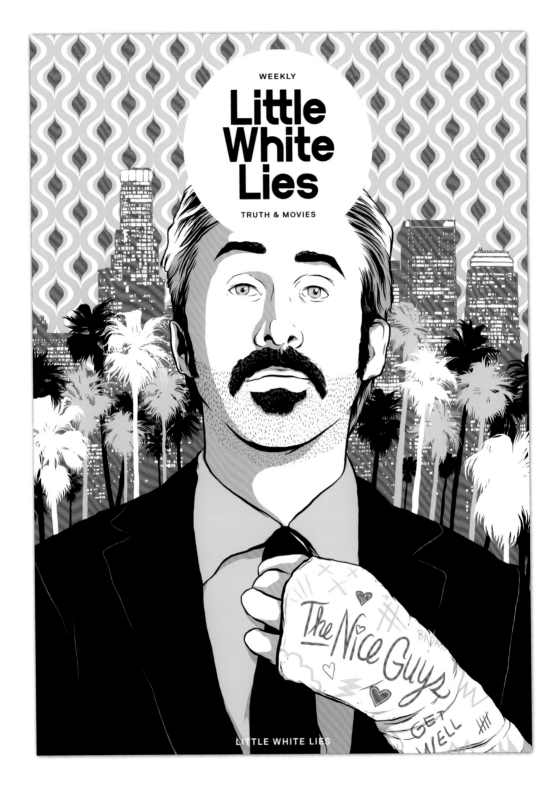

MERIT *Luis Pinto*

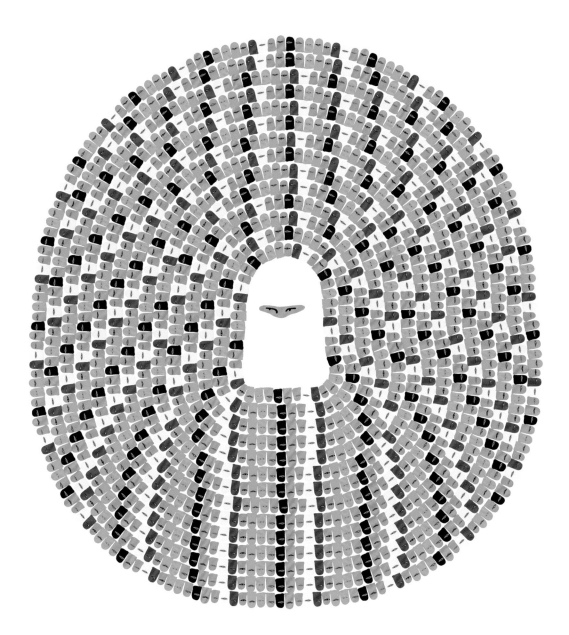

BRONZE *Menelaos Kouroudis*

This blessed plot, this earth,
this realm, this England

The Pelican
SHAKESPEARE

RICHARD II

Edited By
FRANCES E DOLAN

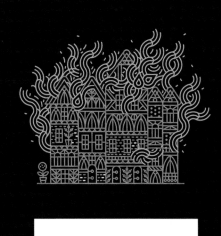

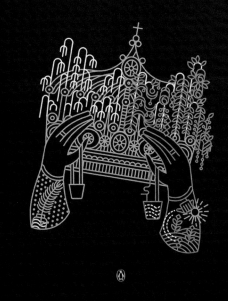

This blessed plot, this earth,
this realm, this England

The Pelican
SHAKESPEARE

HENRY IV

Edited By
STEPHEN ORGEL

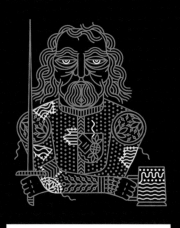

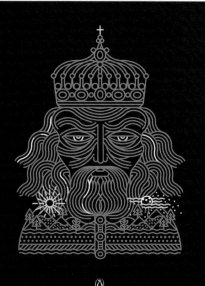

Pardon, master;
I will be correspondent to command
And do my spiriting gently.

The Pelican THE TEMPEST *Edited By*
SHAKESPEARE **PETER HOLLAND**

The Pelican THE MERCHANT OF *Edited By*
SHAKESPEARE VENICE **CLAIRE McEACHERN**

The Pelican HENRY IV *Edited By*
SHAKESPEARE PART II **CLAIRE McEACHERN**

The Pelican THE SONNETS *Edited By*
SHAKESPEARE **CLAIRE McEACHERN**

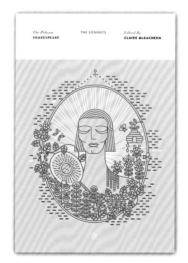

The Pelican TROILUS AND *Edited By*
SHAKESPEARE CRESSIDA **CLAIRE McEACHERN**

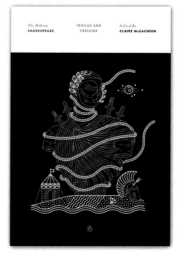

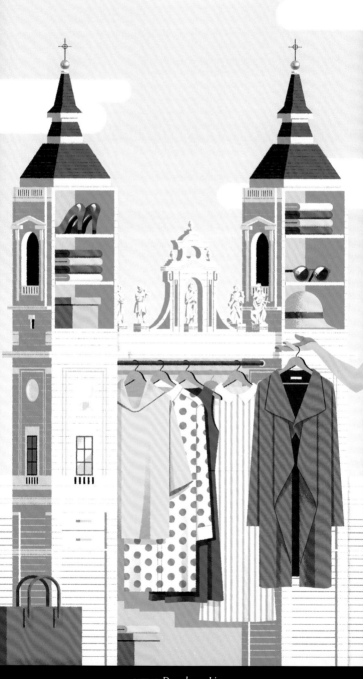

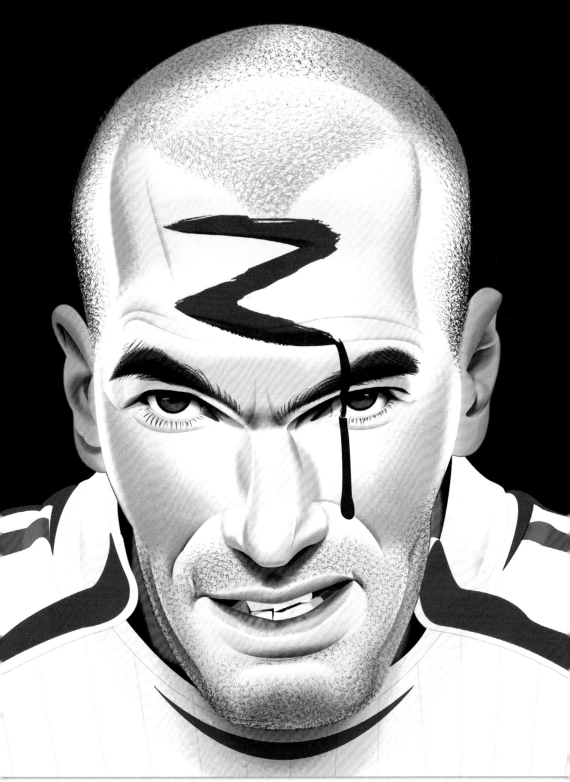

MERIT *Nigel Buchanan*

MERIT *Diego Mallo*

Jens Peter Jacobsen
MOGENS

ardicia

MERIT *Thom Sevalrud*

MERIT *Melinda Beck*

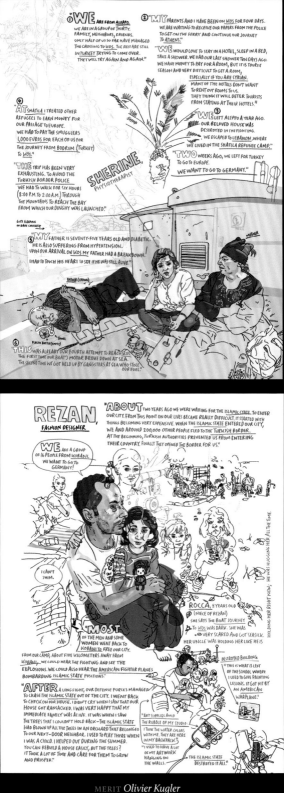

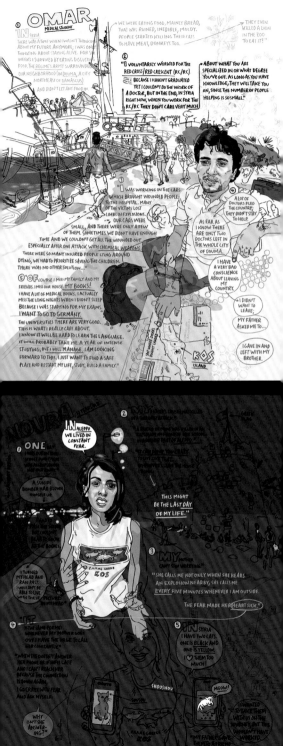

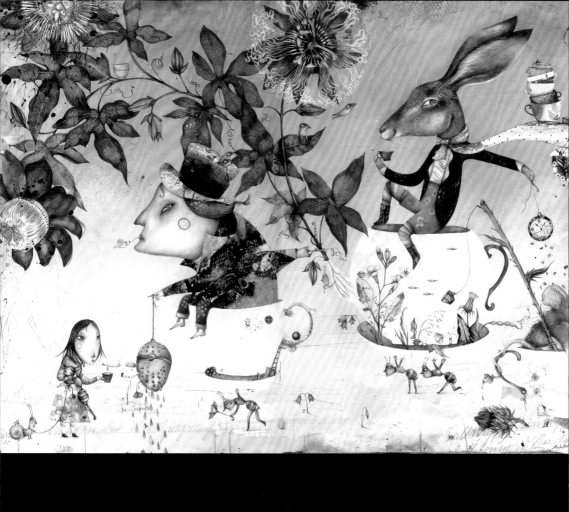

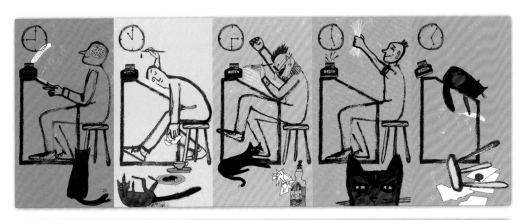

(T) MERIT *Jill Calder* (B) MERIT *Beppe Giacobbe*

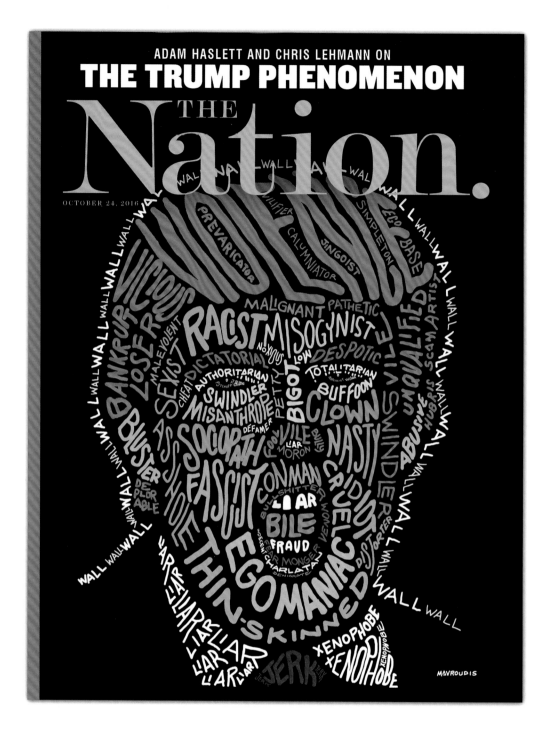

MERIT *John Mavroudis*

MERIT *Jon Lezinsky*

MERIT *Michael Waraksa*

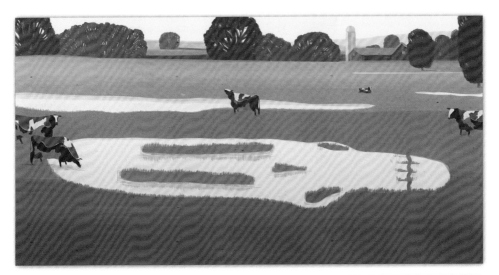

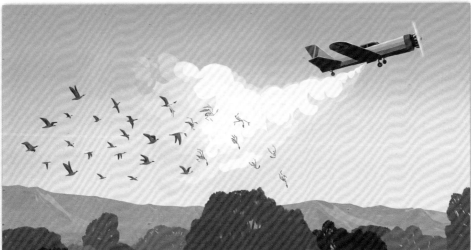

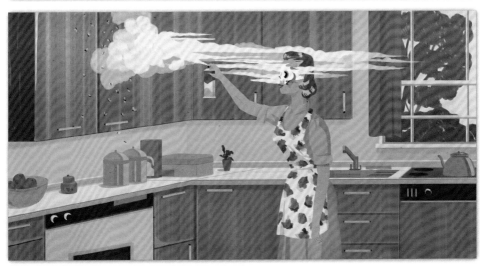

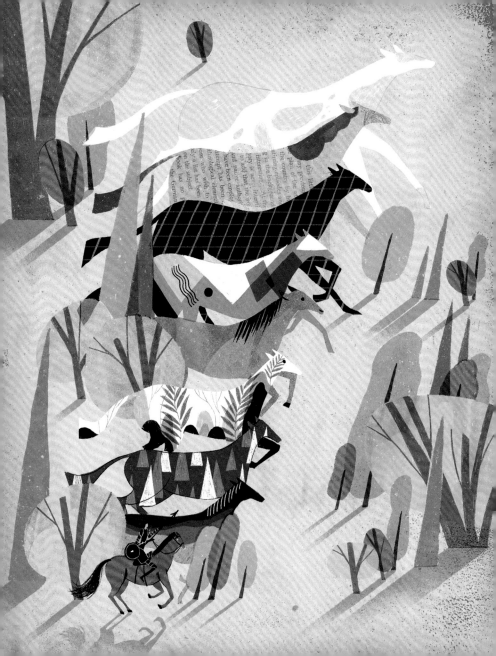

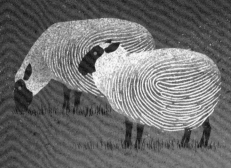
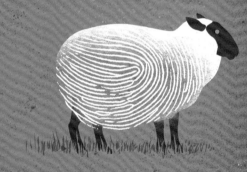

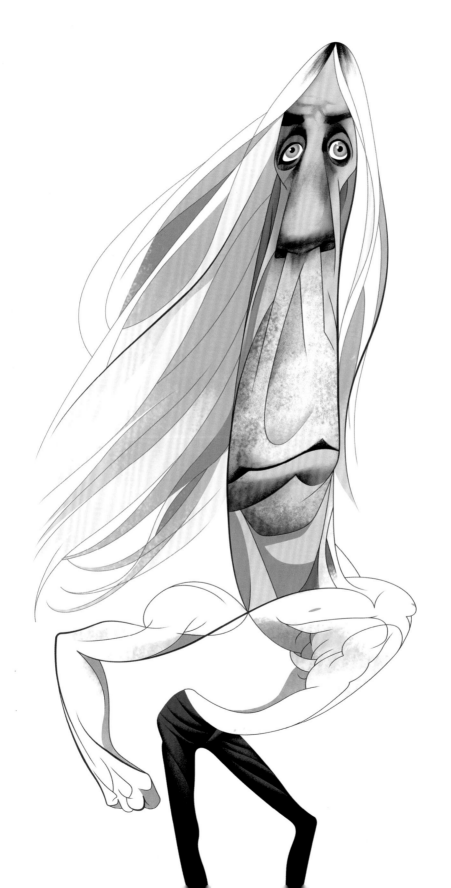

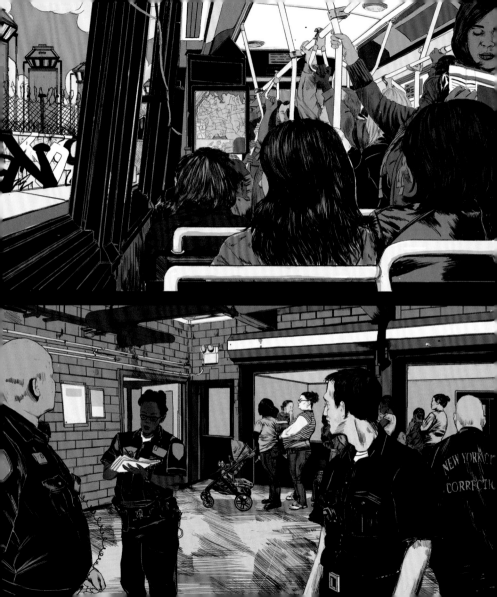

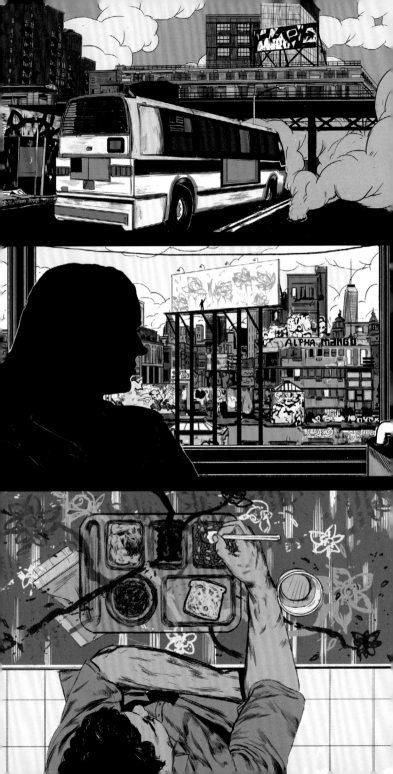

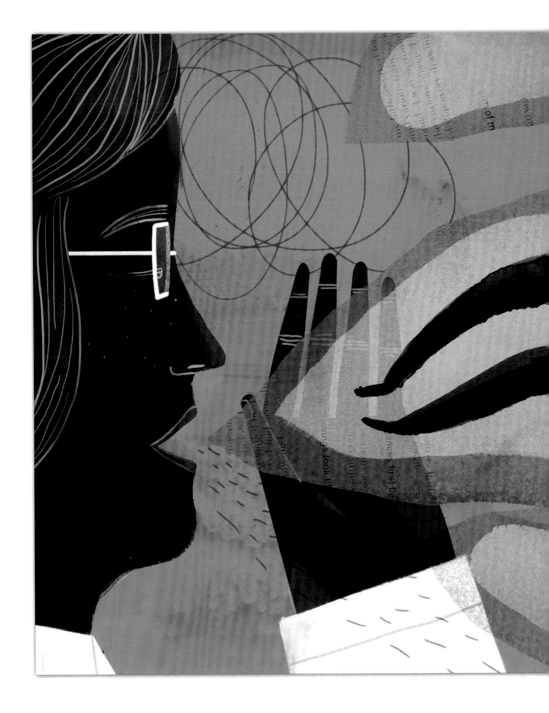

MERIT *Richard Klippfeld*

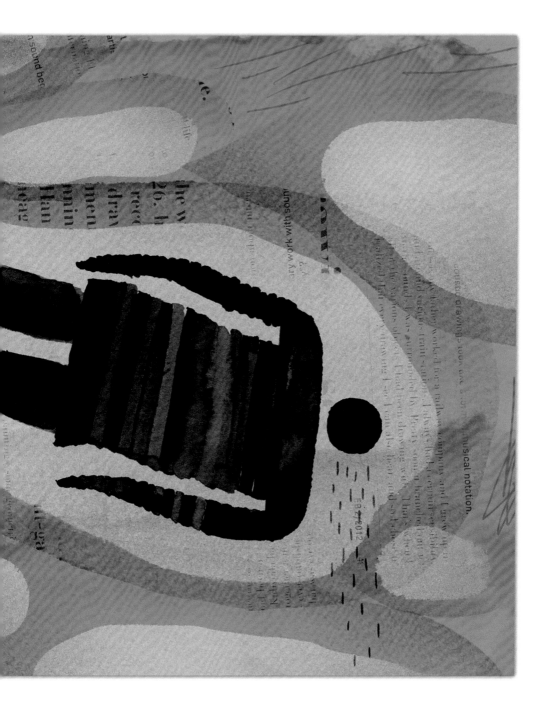

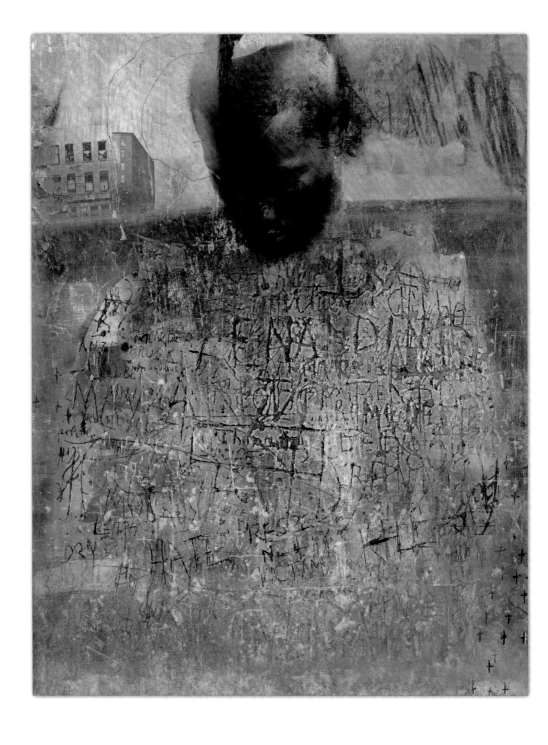

MERIT *Jon Lezinsky*

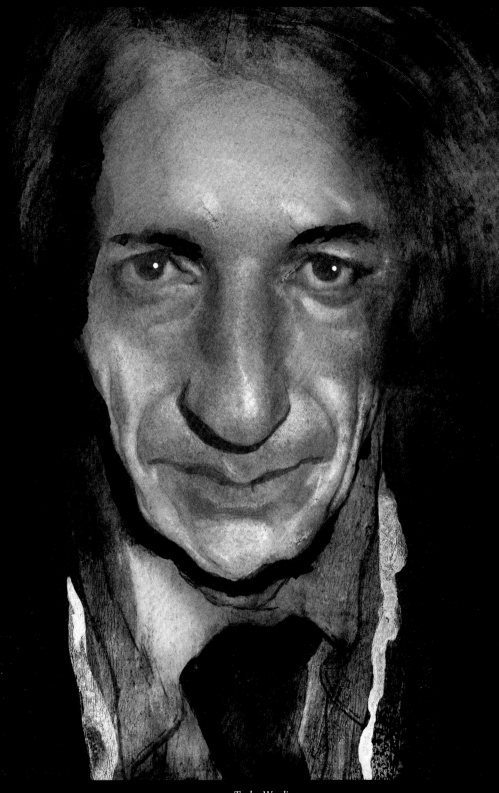

MERIT *Taylor Wessling*

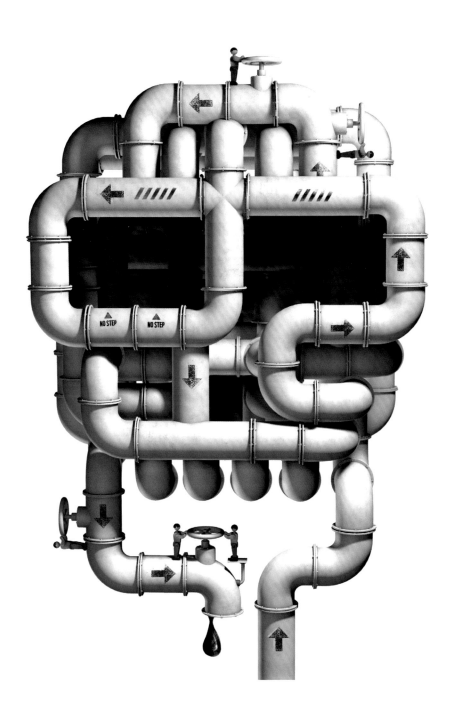

MERIT *Richard Borge*

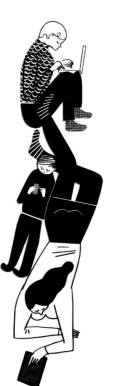

EDITORIAL

ISSN 2095-5731

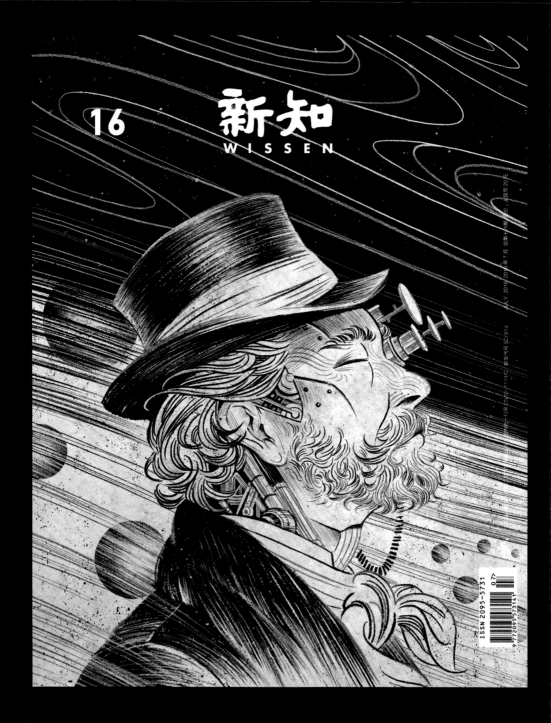

DISTINGUISHED MERIT *Feifei Ruan*

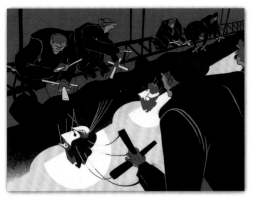
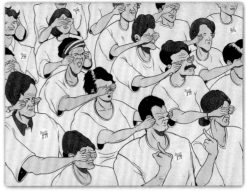

BRONZE *Ryan Garcia*

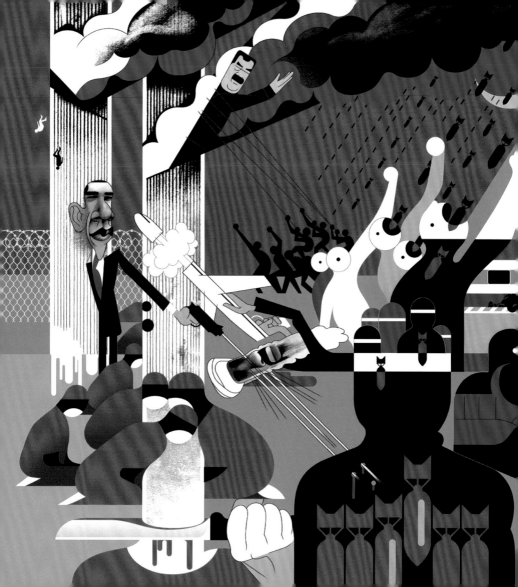

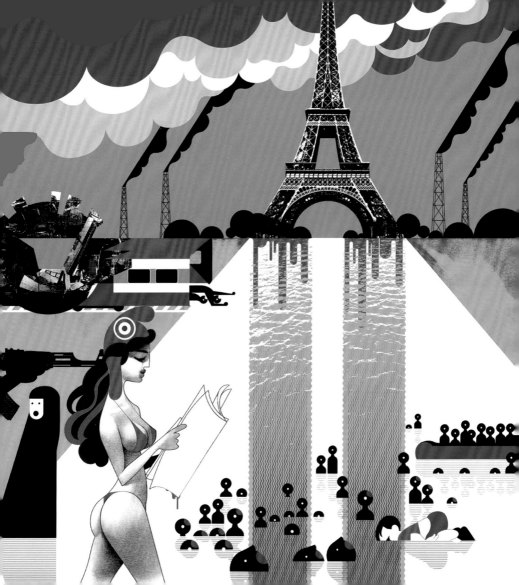

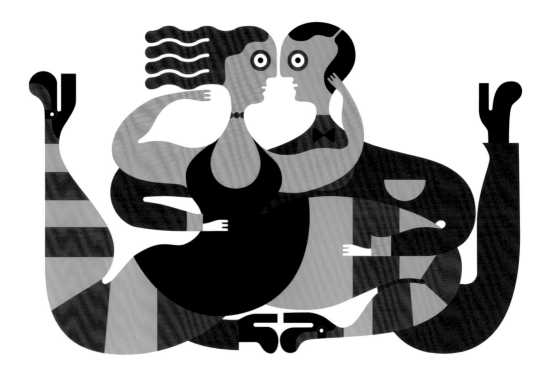

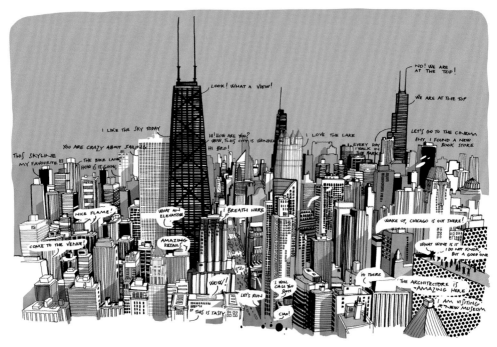

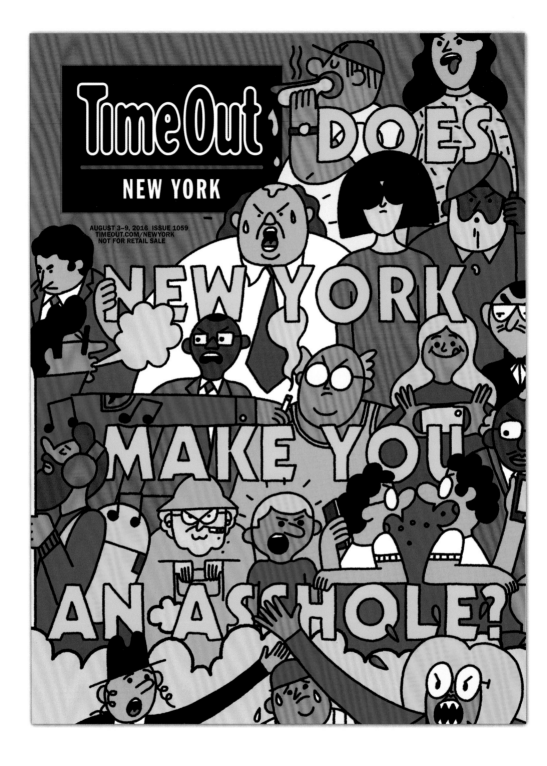

DISTINGUISHED MERIT *Leon Edler*

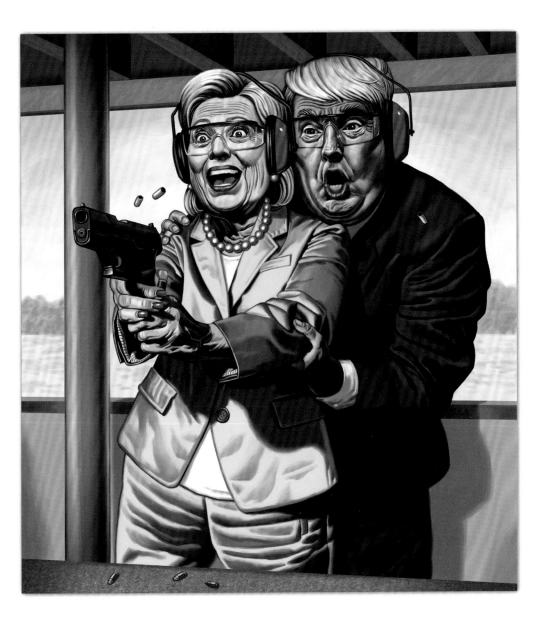

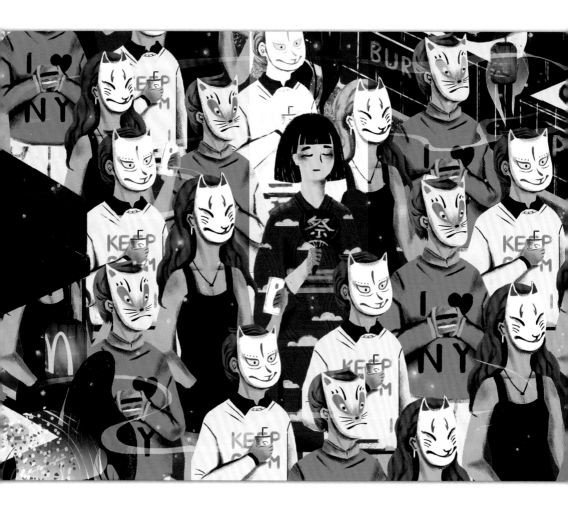

MERIT *Yuwei Qiu*

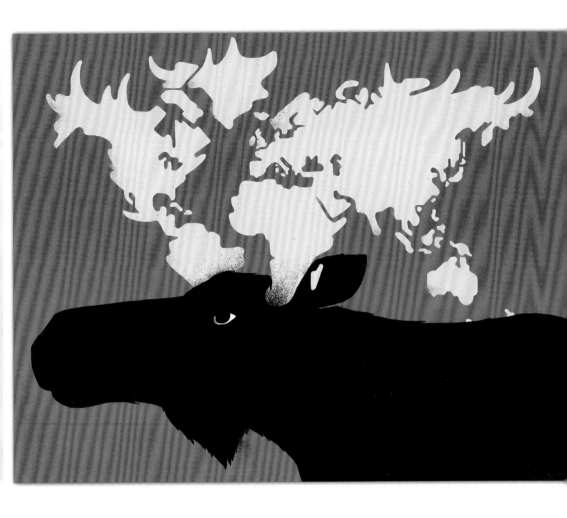

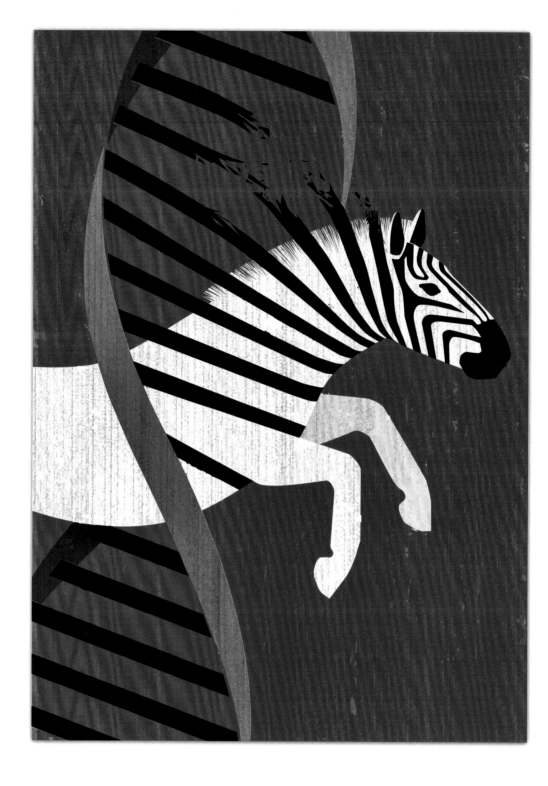

MERIT *Joey Guidone*

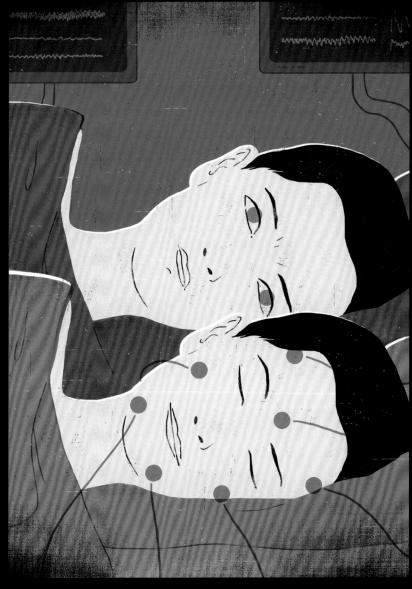

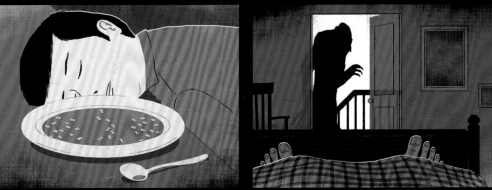

MERIT *Jens Bonnke*

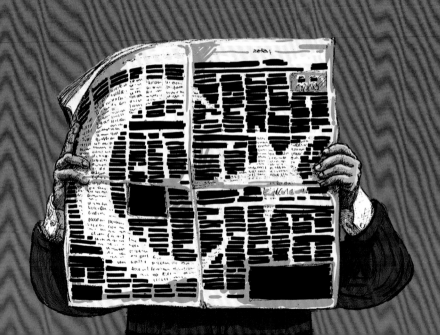

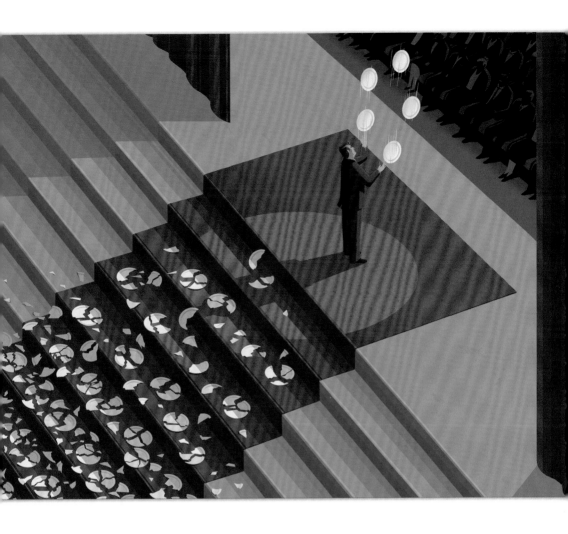

(L) MERIT *Sébastien Thibault* (R) MERIT *Øivind Hovland*

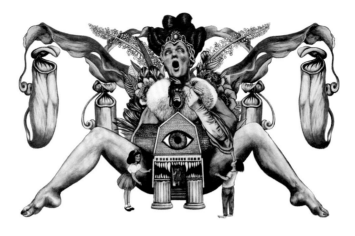

MERIT *Pauliina Mäkelä*

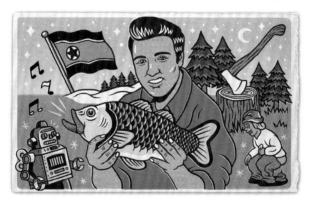

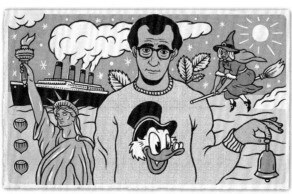

MERIT *Bene Rohlmann*

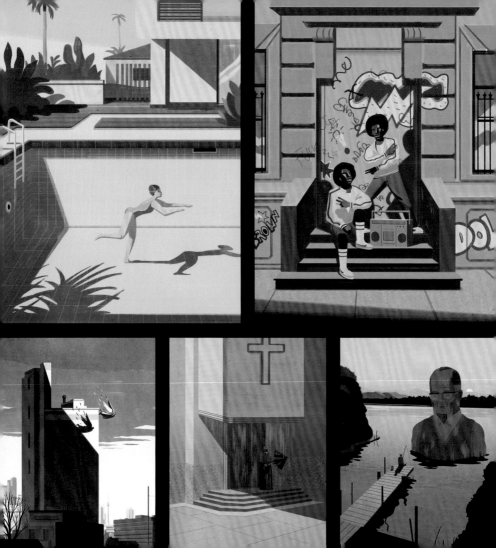

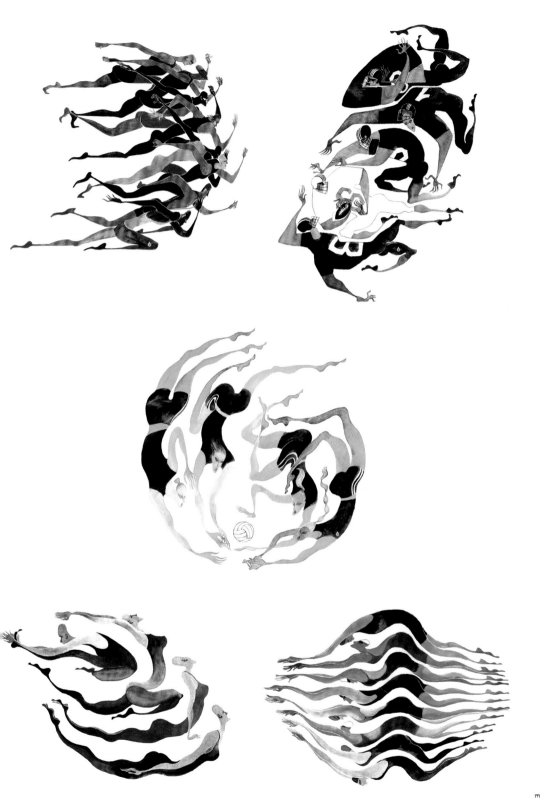

SILVER *Jianrong Lin*

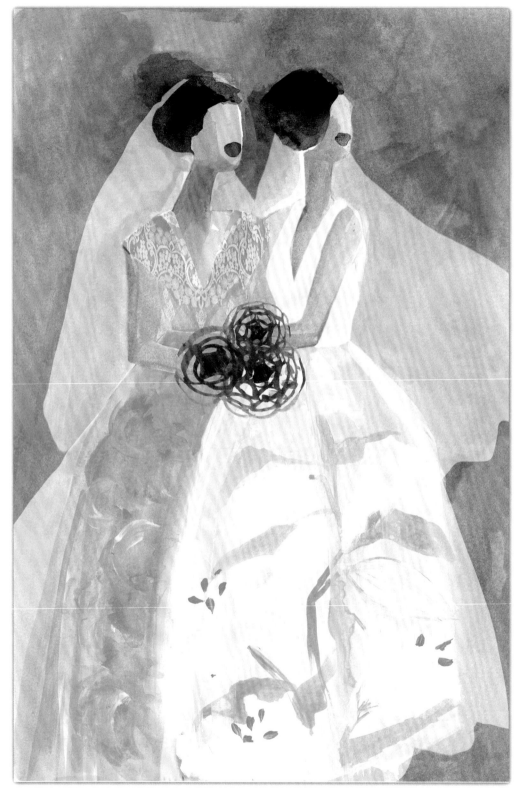

MERIT *Gayle Kabaker*

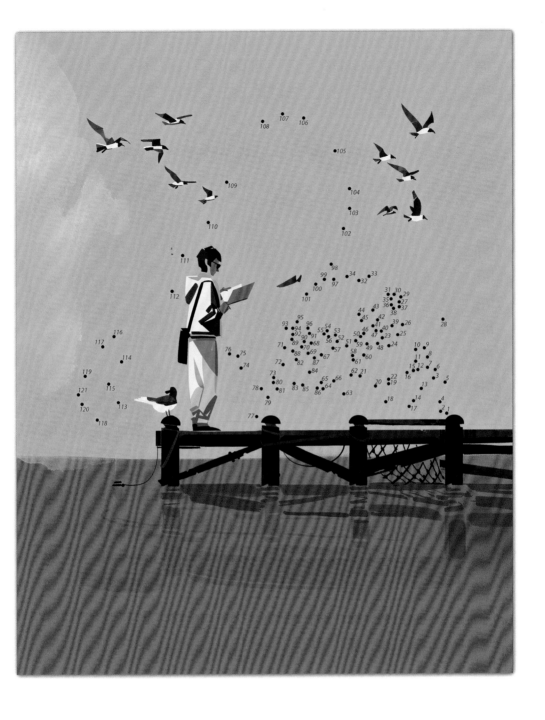

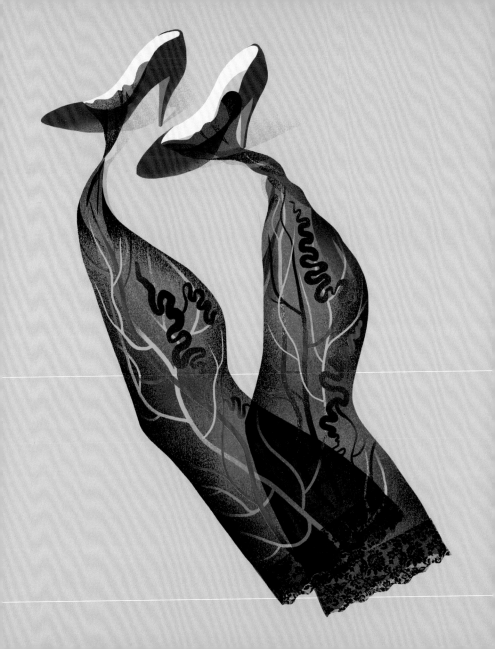

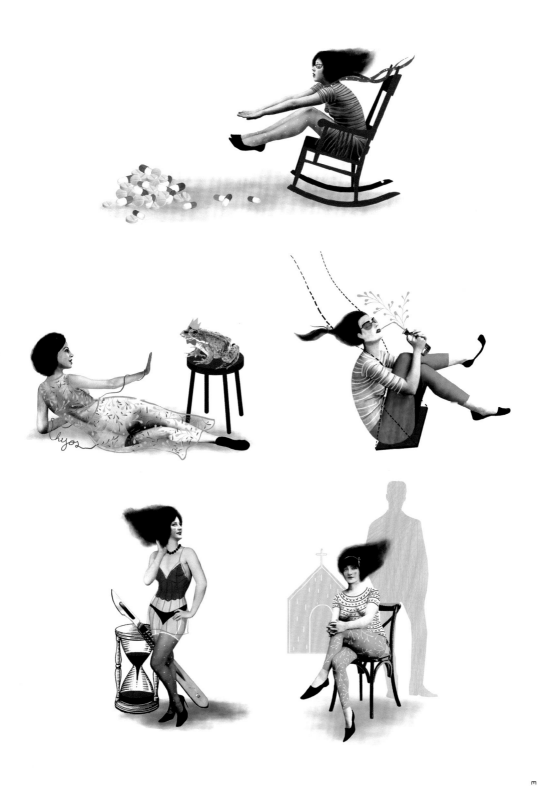

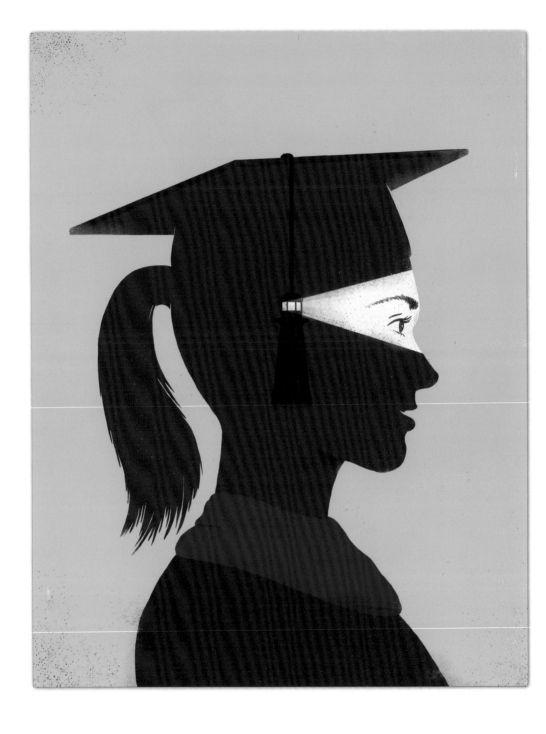

MERIT *Sébastien Thibault*

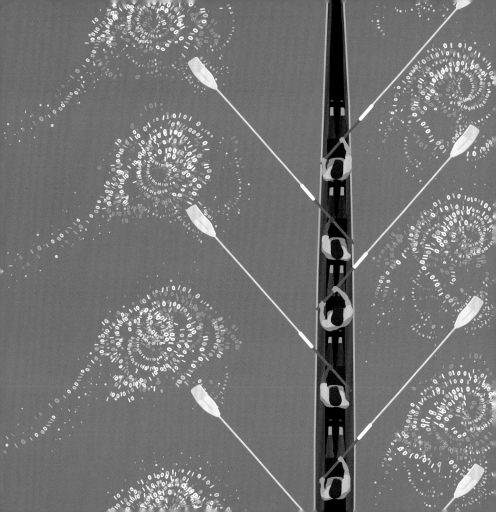

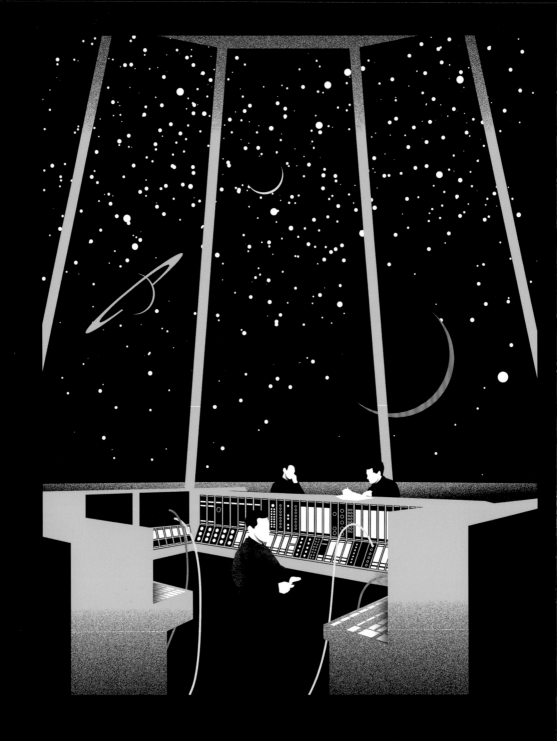

MERIT *Mario Wagner*

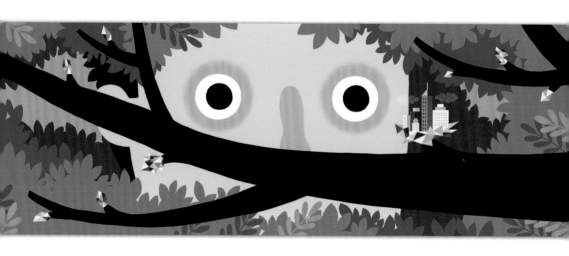

MERIT *Beppe Giacobbe*

MERIT *Øivind Hovland*

MERIT *Nigel Buchanan*

137

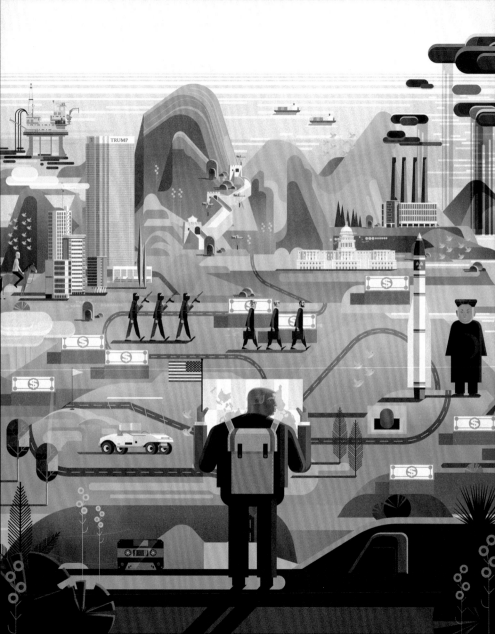

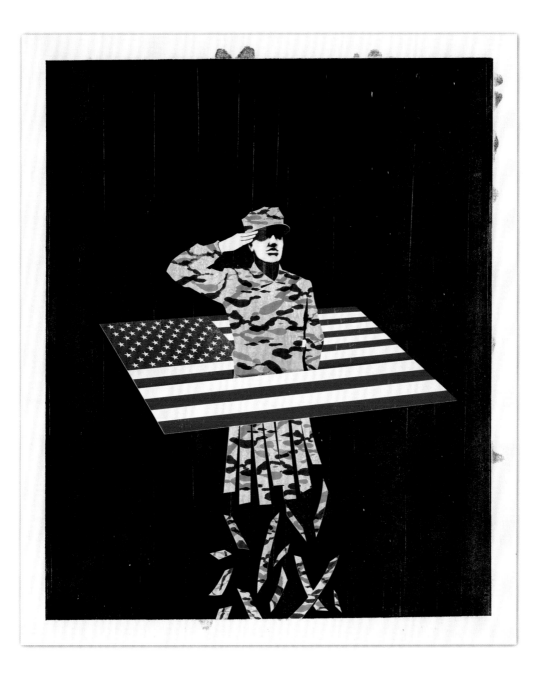

MERIT *Dan Bejar*

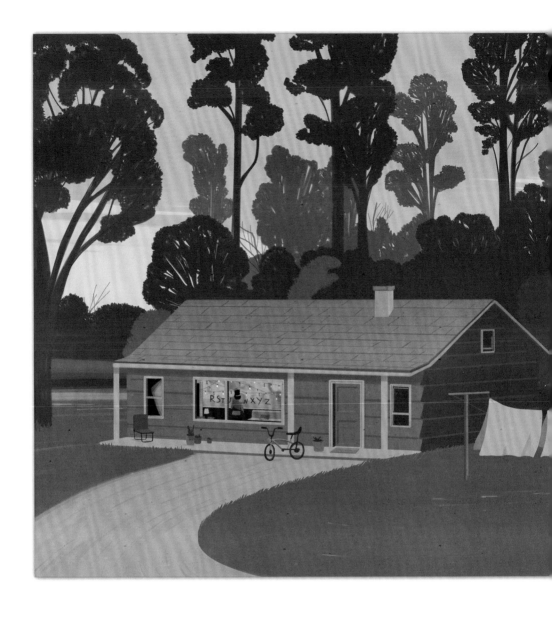

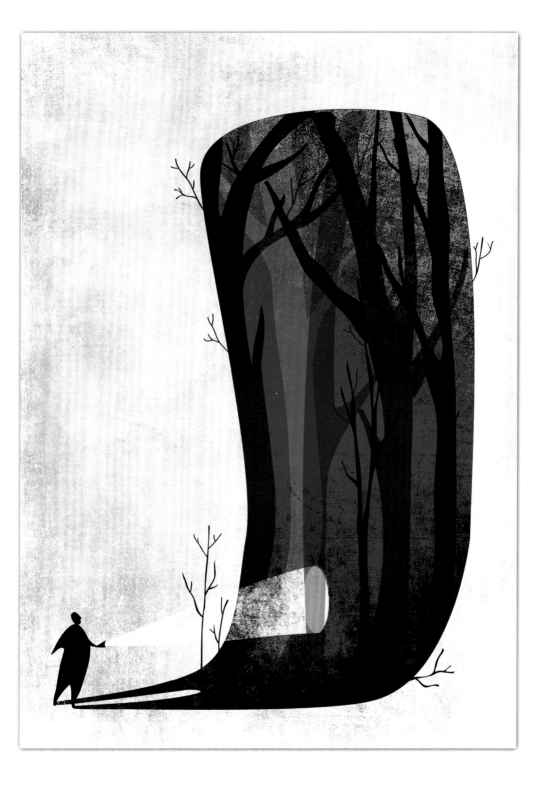

MERIT *Chris Ferrantello*

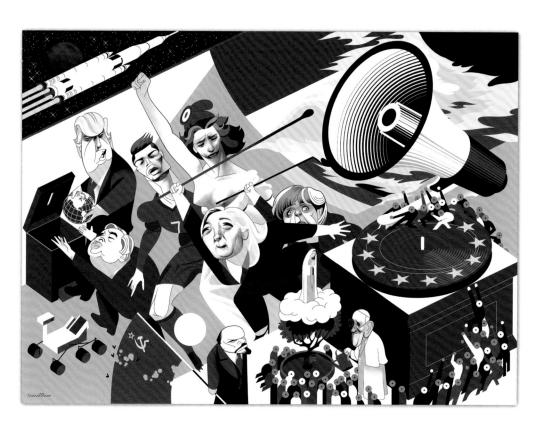

MERIT *André Carrilho*

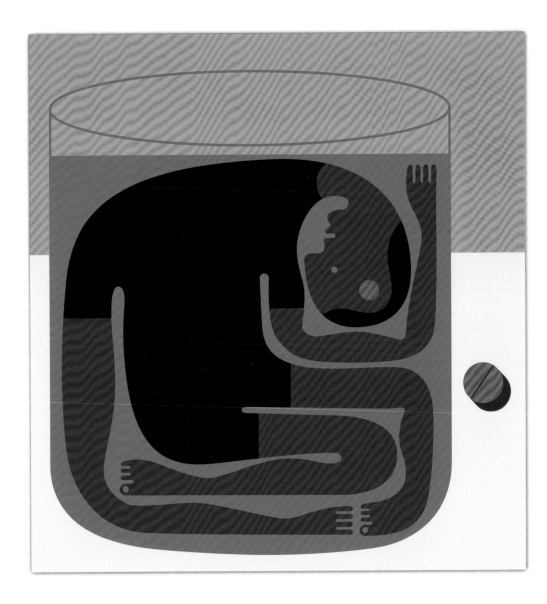

MERIT *Melinda Beck*

MERIT *Giovanni Da Re*

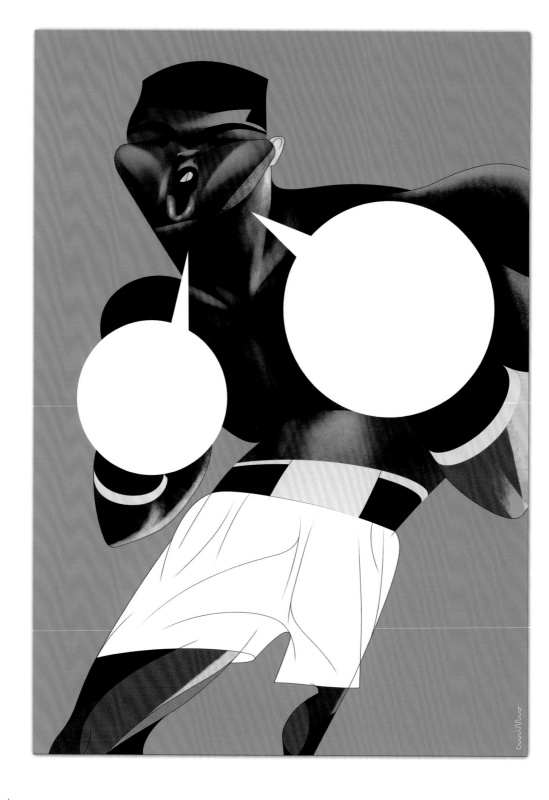

MERIT *André Carrilho*

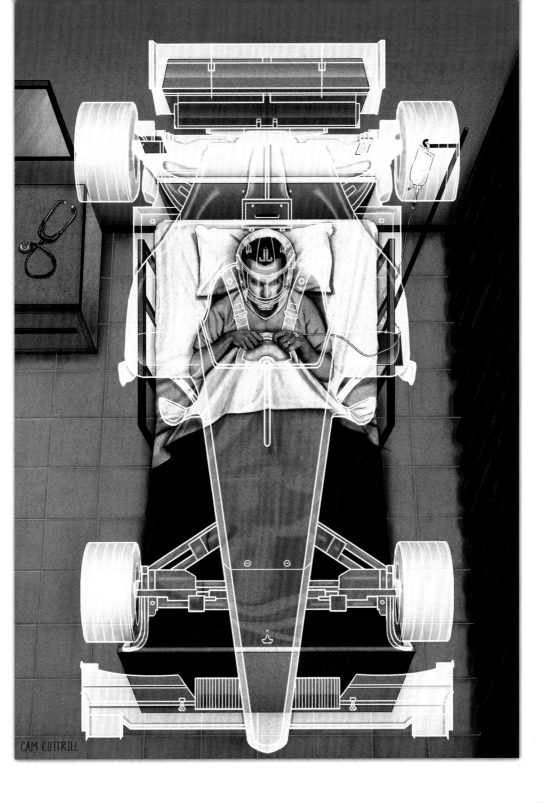

MERIT *Cameron Cottrill*

149

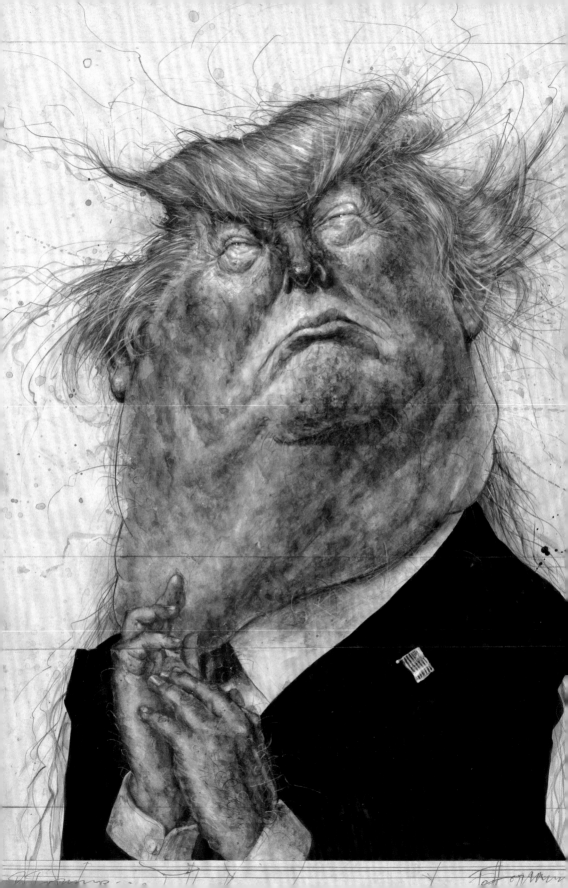

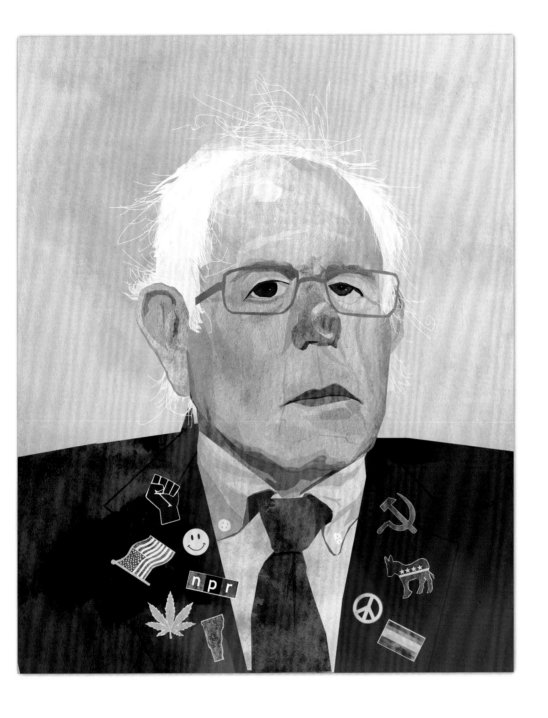

(L) MERIT *Frank Hoppmann* MERIT *Tram Nguyen*

MERIT *Aad Goudappel*

MERIT *Jianrong Lin*

155

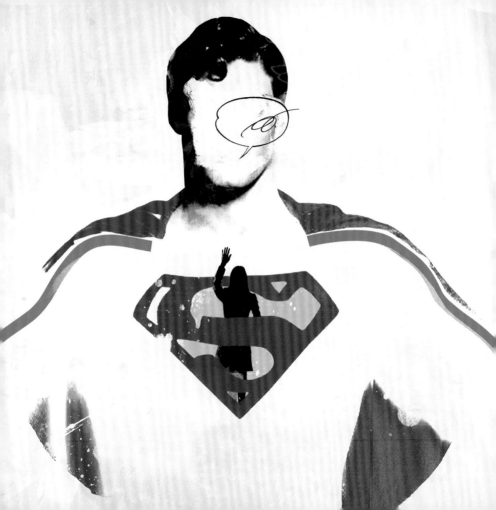

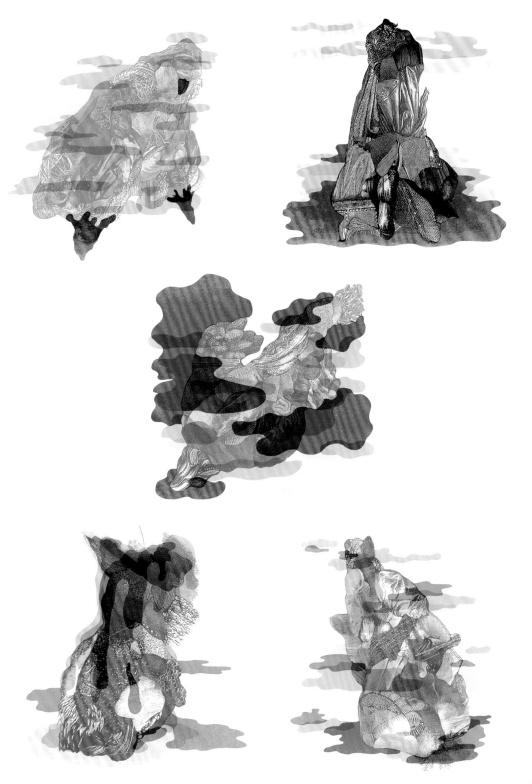

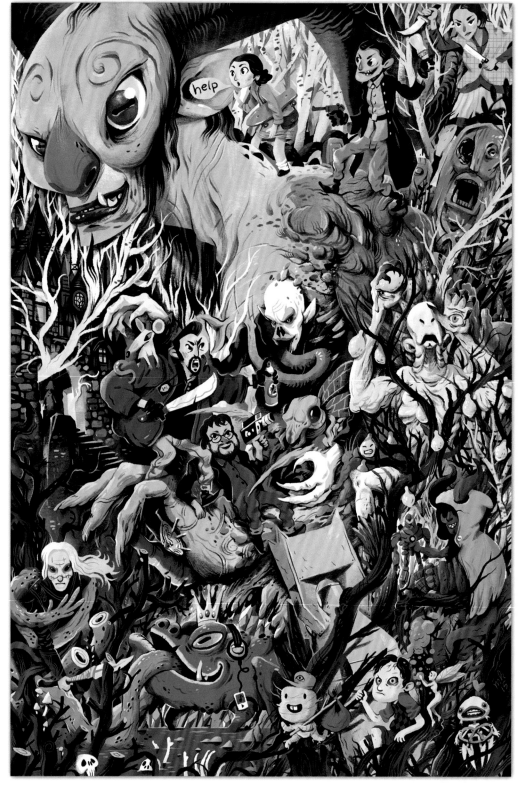

MERIT *Manuel Kilger*

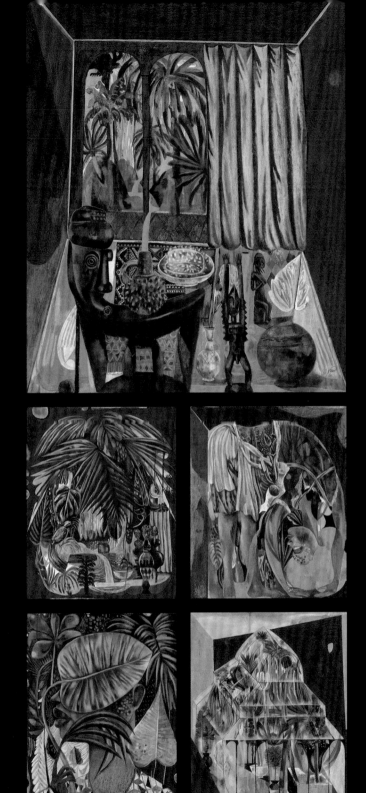

MERIT *Olaf Hajek*

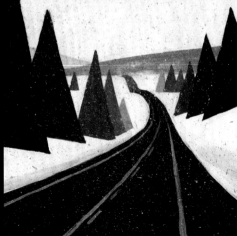

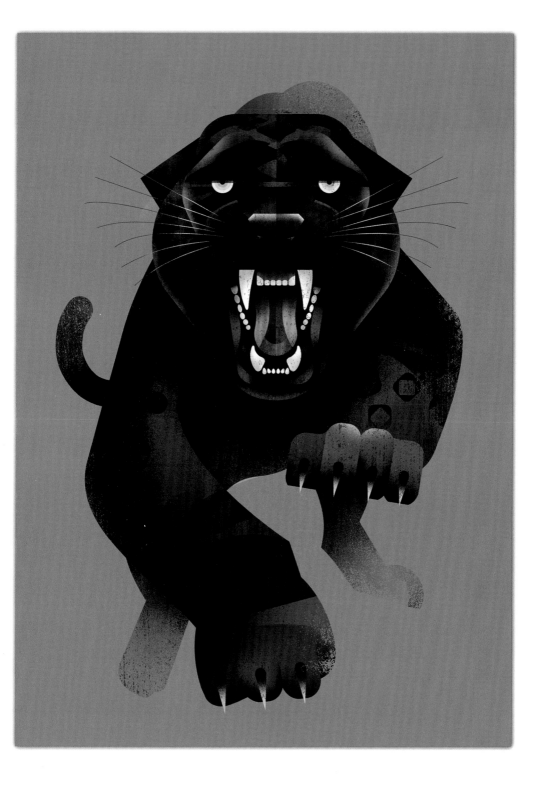

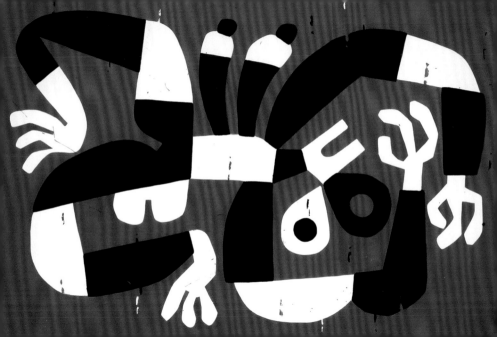

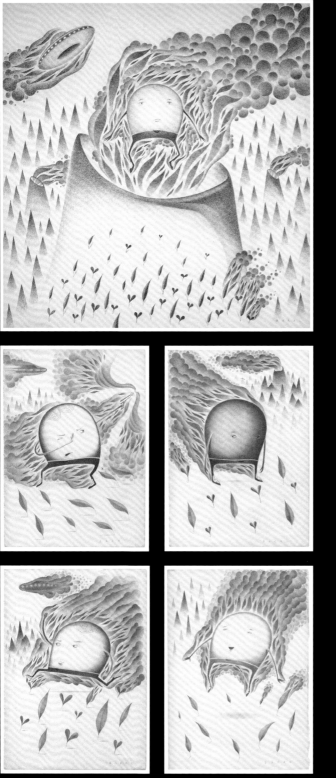

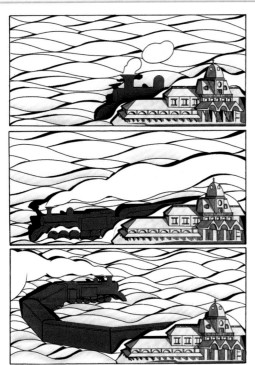

ASÍ, LA PRIMERA QUINCENA DE MAYO DE 1937, EN PLENO OTOÑO AUSTRAL, LLEGÓ A BOLÍVAR, EN EL CENTRO NORTE DE LA PROVINCIA DE BUENOS AIRES.

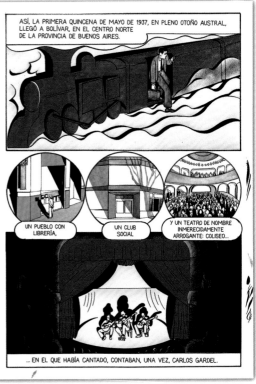

UN PUEBLO CON LIBRERÍA,

UN CLUB SOCIAL

Y UN TEATRO DE NOMBRE INMERECIDAMENTE ARROGANTE: COLISEO...

... EN EL QUE HABÍA CANTADO, CONTABAN, UNA VEZ, CARLOS GARDEL.

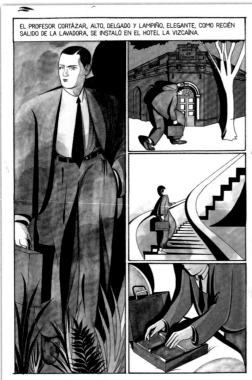

EL PROFESOR CORTÁZAR, ALTO, DELGADO Y LAMPIÑO, ELEGANTE, COMO RECIÉN SALIDO DE LA LAVADORA, SE INSTALÓ EN EL HOTEL LA VIZCAÍNA.

AL DÍA SIGUIENTE EN LA SALA DE PROFESORES SE ANOTARON LOS NOMBRES DE LAS ASIGNATURAS.

Y LOS PAPELITOS SE INTRODUJERON EN EL SOMBRERO DEL PROFESOR DE MATEMÁTICAS.

Y DE ESE MODO, POR SORTEO...

... CORTÁZAR SE CONVIRTIÓ EN PROFESOR DE GEOGRAFÍA, UNA ASIGNATURA QUE DETESTABA.

MERIT *Marc Torices*

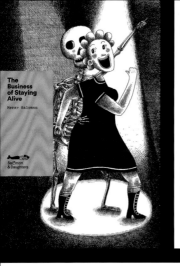

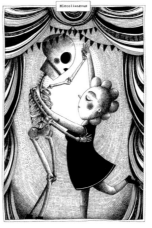

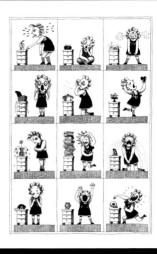

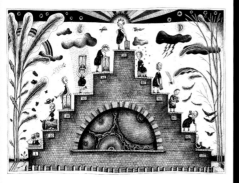

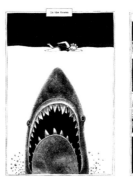

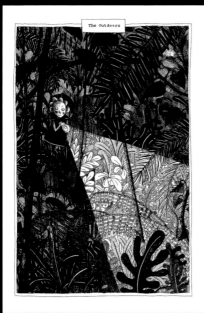

MERIT *Merav Salomon*

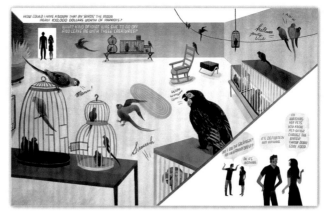

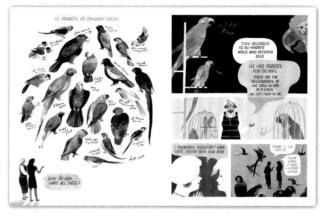

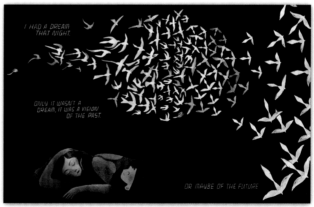

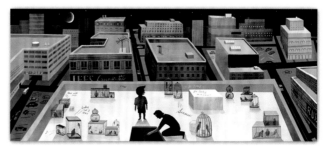

MERIT *Elizabeth Haidle*

167

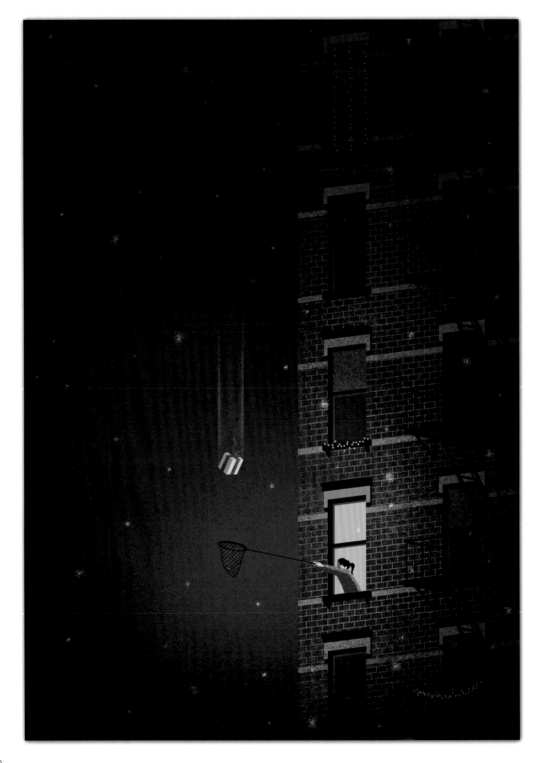

MERIT *Davide Bonazzi*

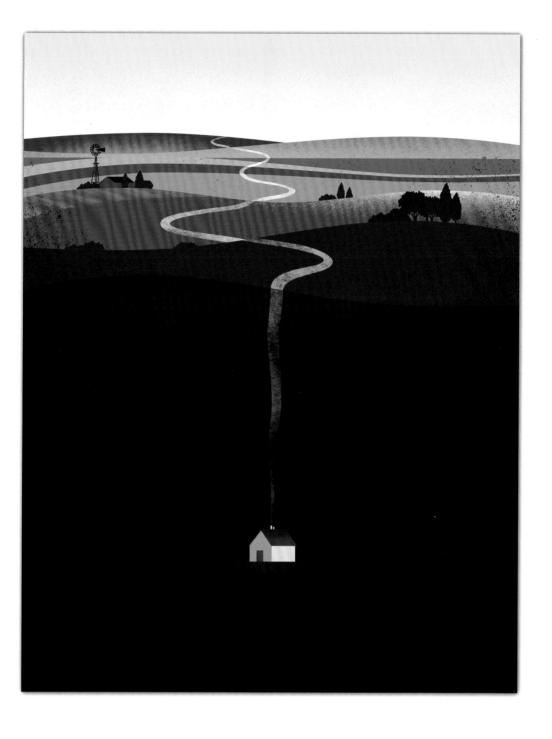

MERIT *Menelaos Kouroudis*

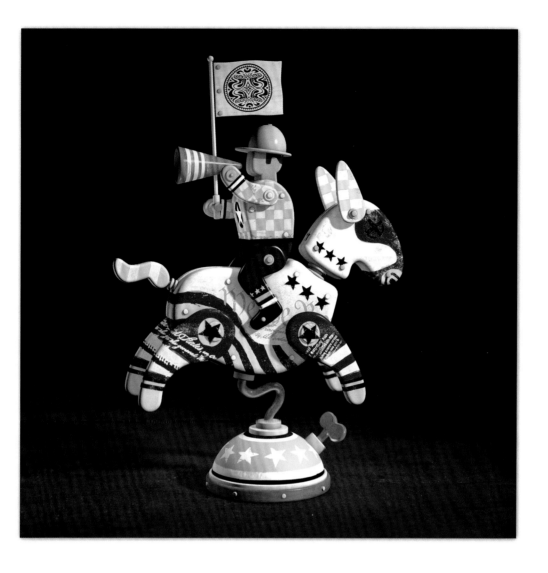

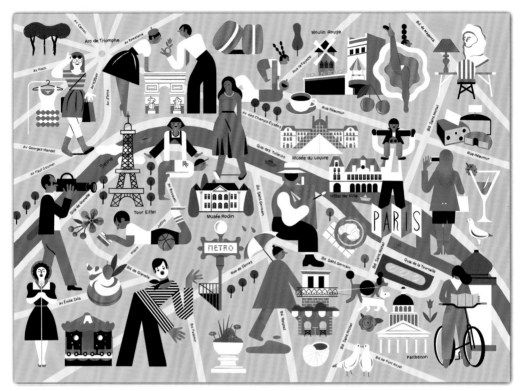

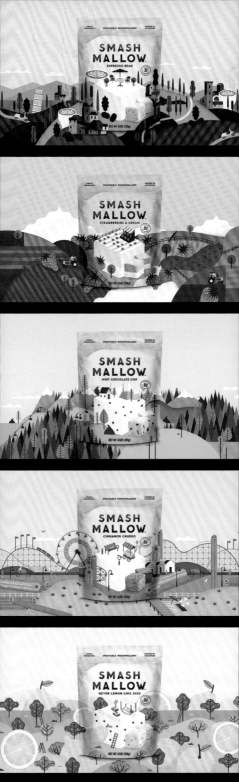

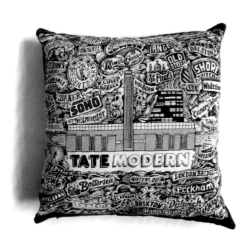

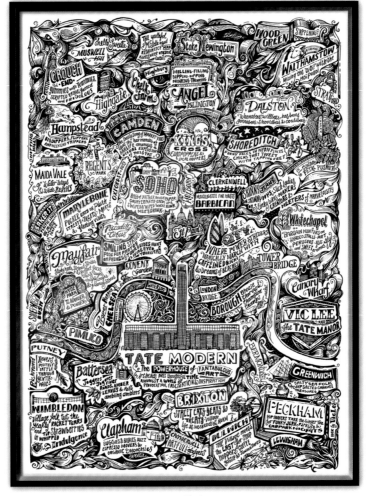

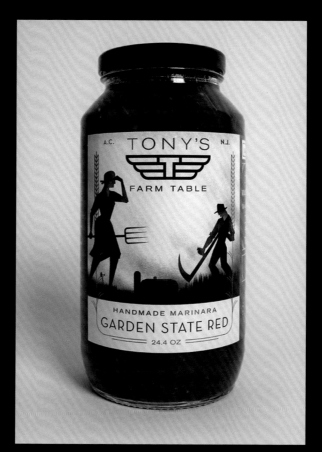

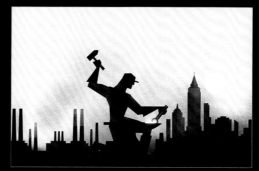

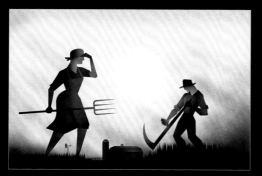

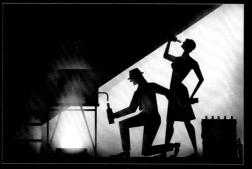

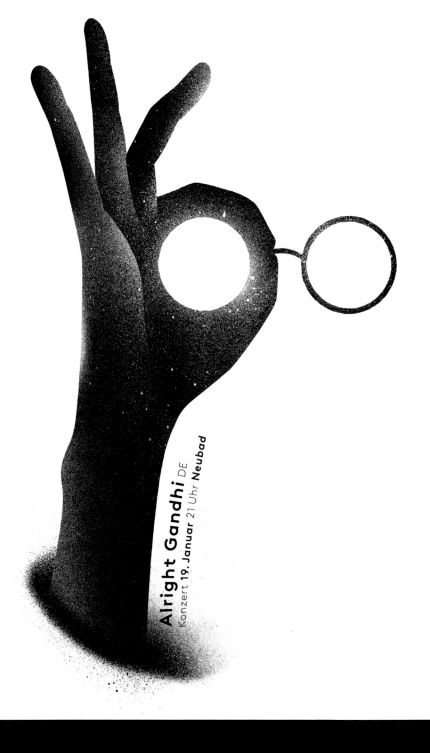

Alright Gandhi DE
Konzert 19. Januar 21 Uhr **Neubad**

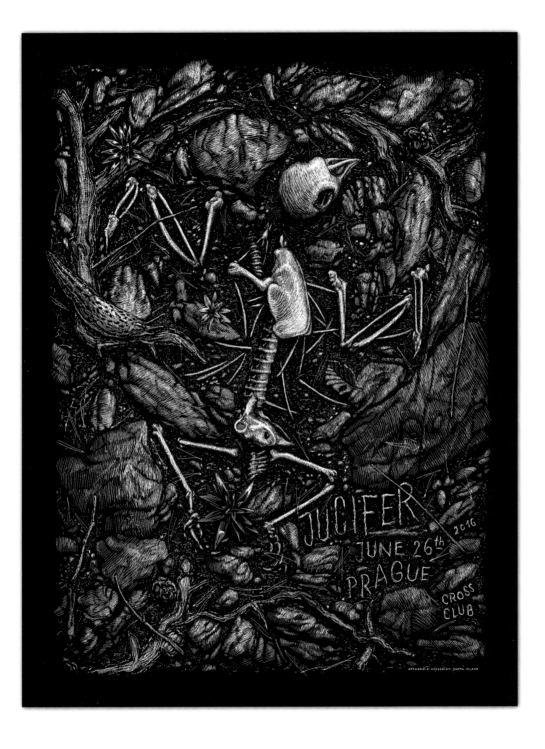

FESTIVAL DEL CINEMA DOCUMENTARIO

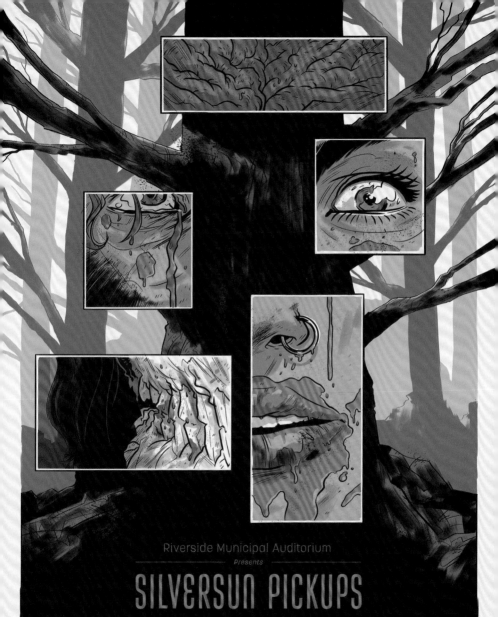

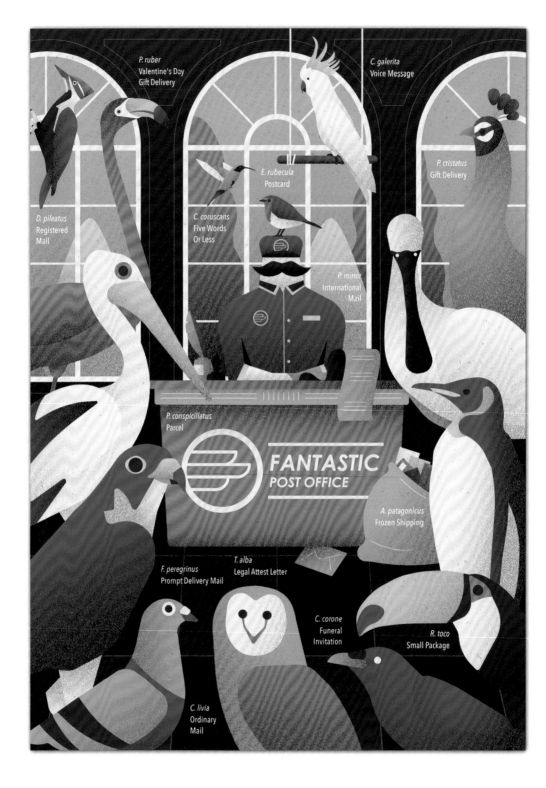

MERIT *Ying-Hsiu Chen*

MERIT *Fabulo*

MERIT *James Yang*

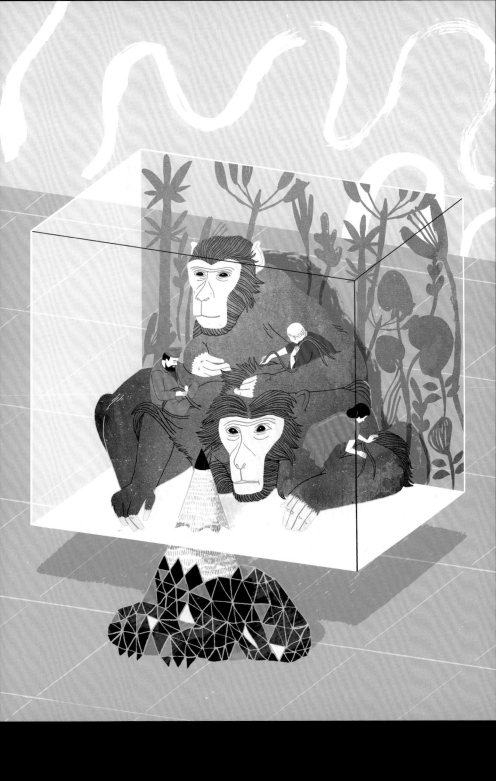

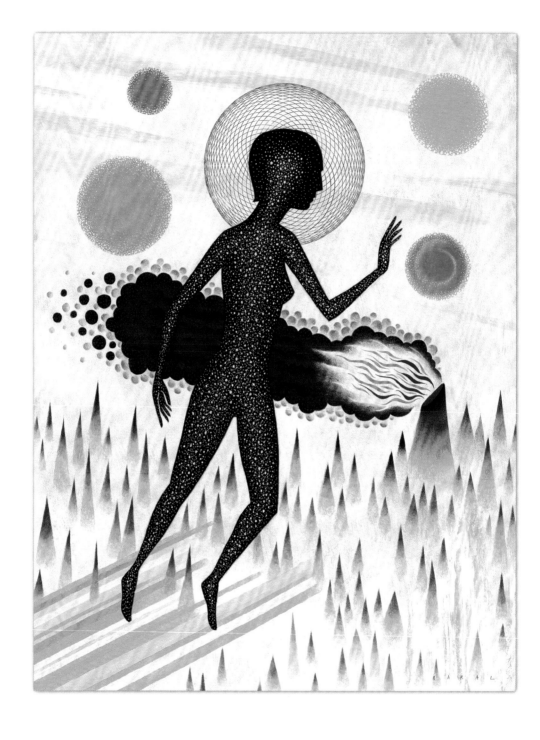

MERIT *Scott Bakal*

186

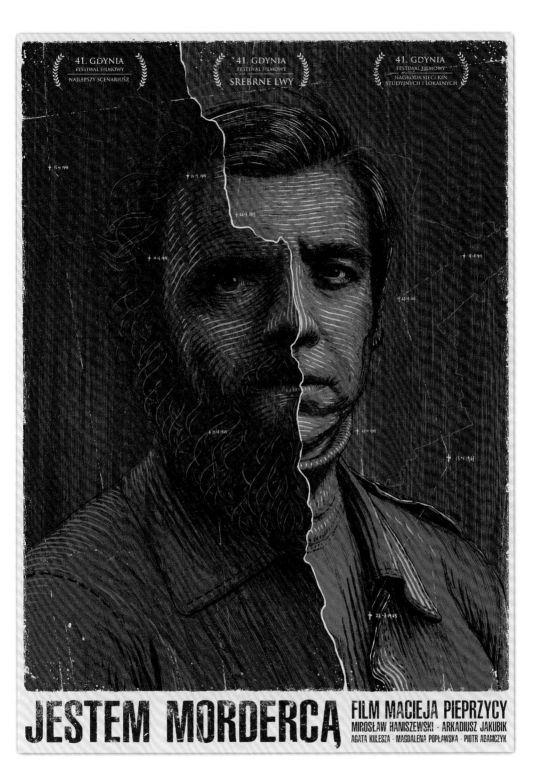

JESTEM MORDERCĄ

FILM MACIEJA PIEPRZYCY
MIROSŁAW HANISZEWSKI · ARKADIUSZ JAKUBIK
AGATA KULESZA · MAGDALENA POPŁAWSKA · PIOTR ADAMCZYK

MERIT *Bartosz Kosowski*

187

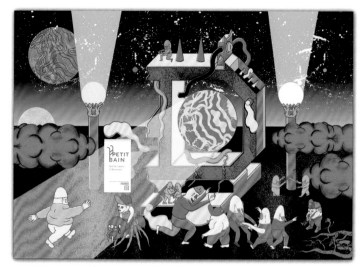

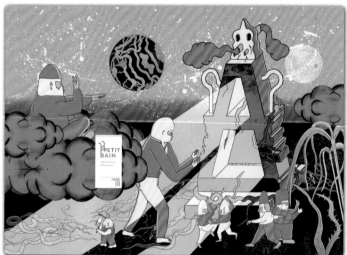

MERIT *Philip Huntington*

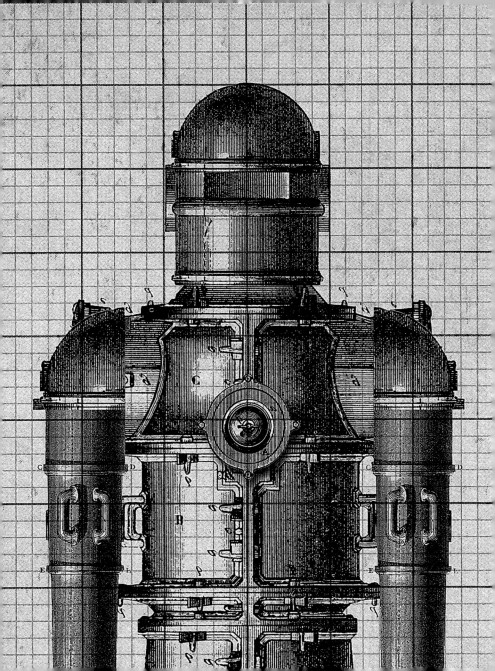

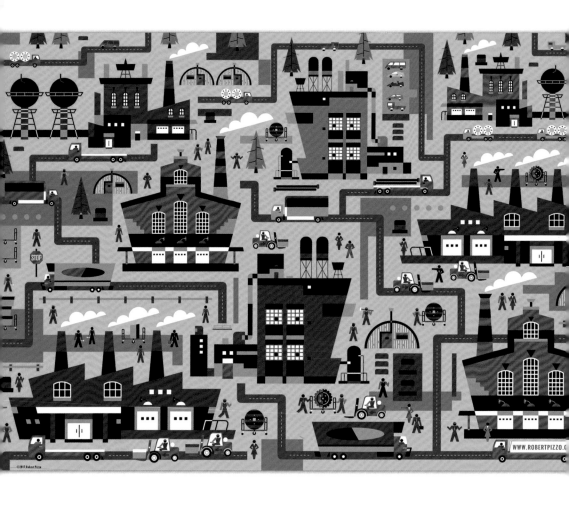

MERIT *Robert Pizzo*

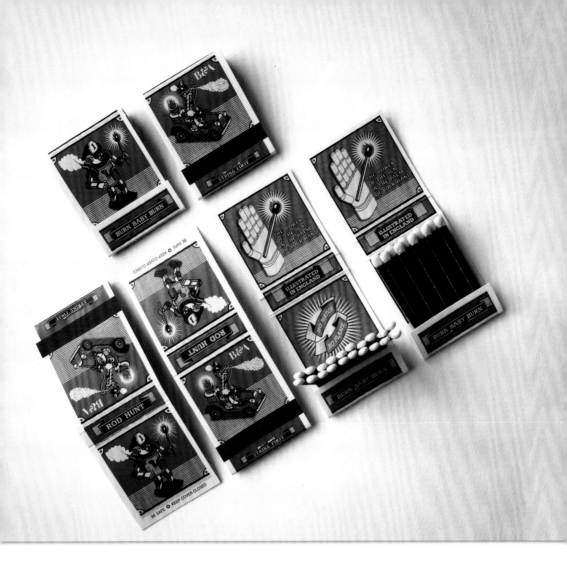

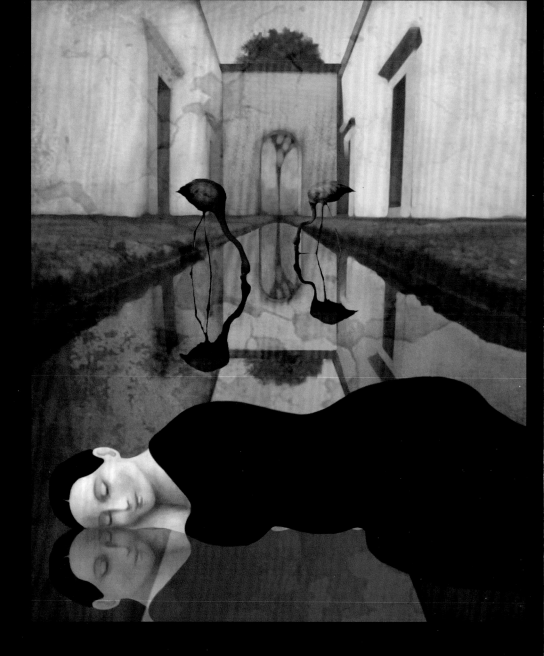

MERIT *Daria Petrilli*

192

MERIT *Zara Picken*

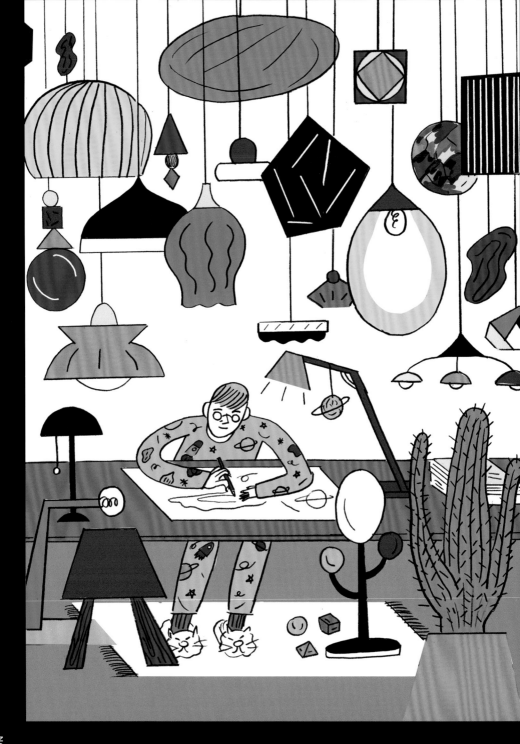

MERIT *Abigail Goh*

MERIT *Tyler Gross*

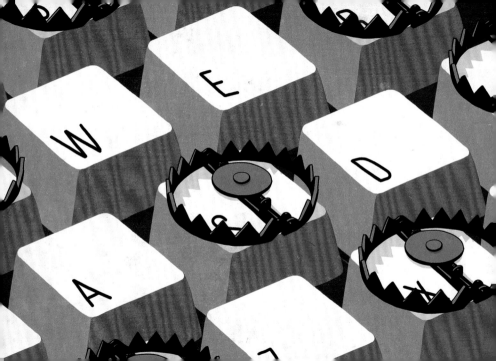

MERIT *Johan Keslassy*

MERIT *Olaf Hajek*

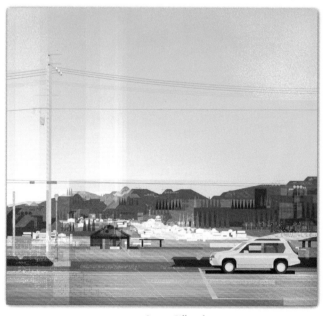

SILVER *James Gilleard*

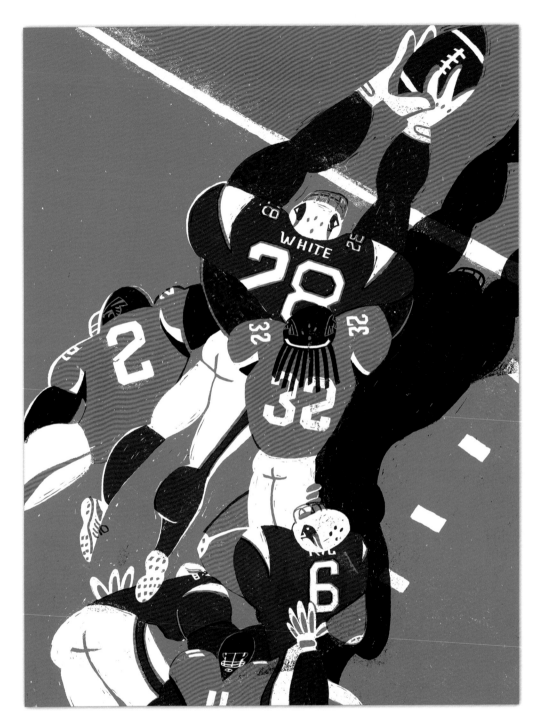

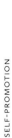

MERIT *Igor Gnedo*

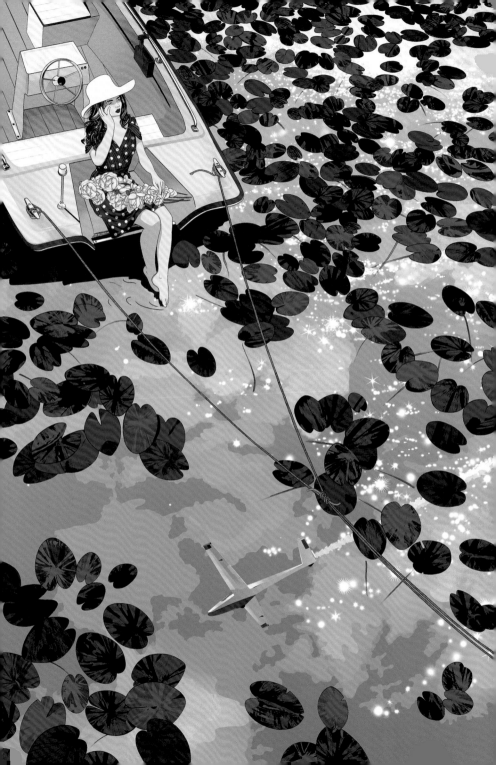

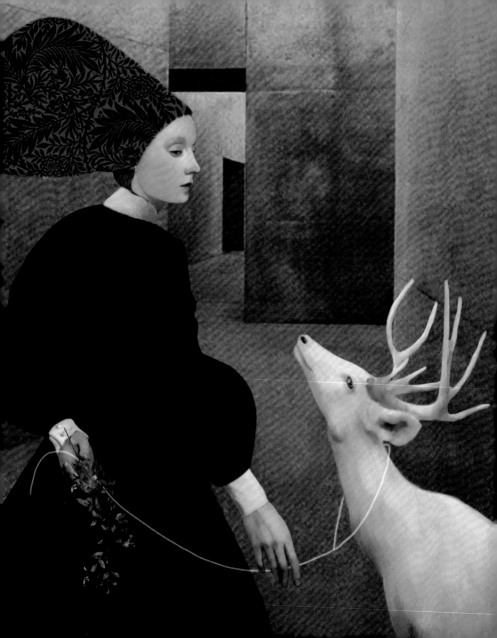

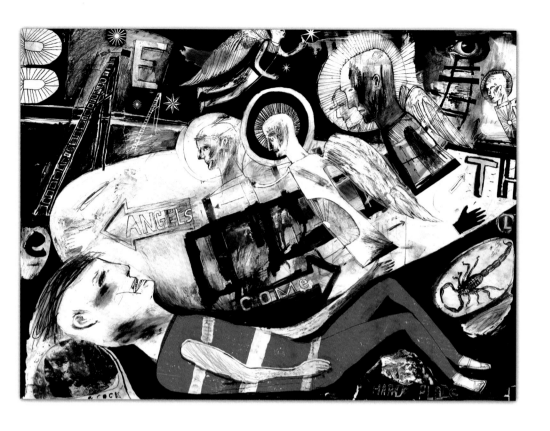

MERIT *Christopher Harper*

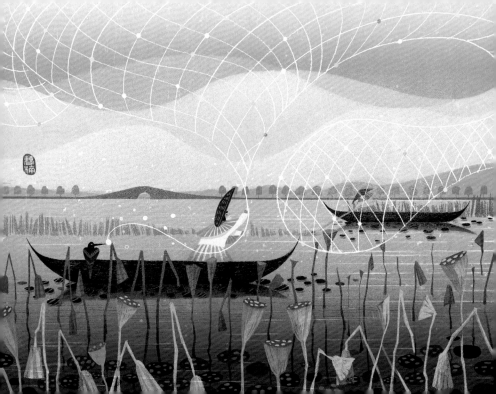

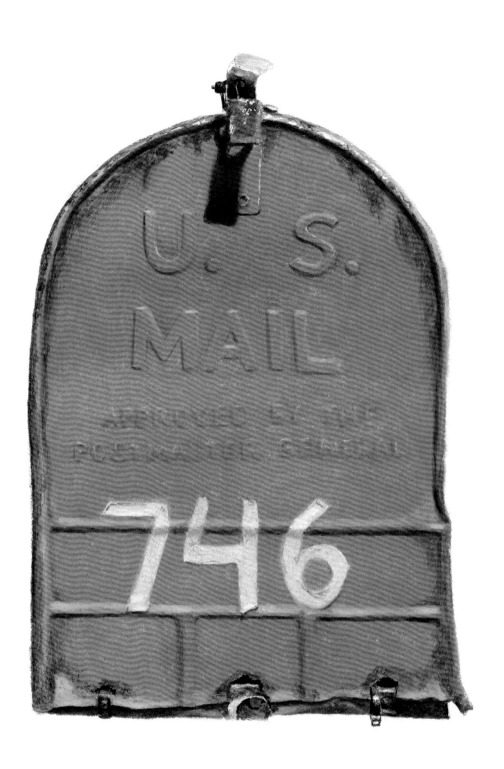

MERIT *Heather Heckel*

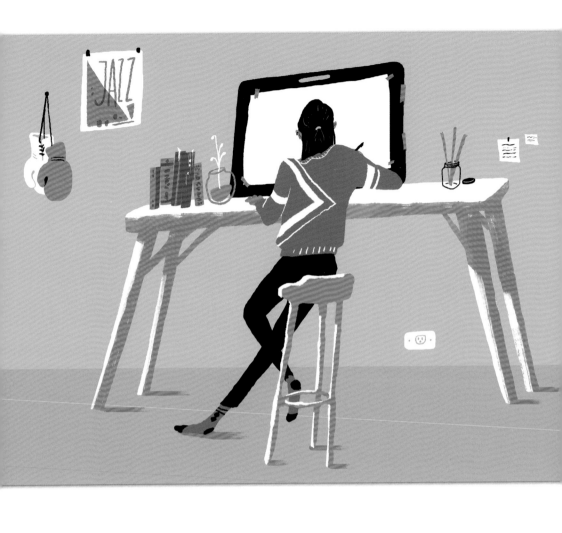

MERIT *Angel Chang*

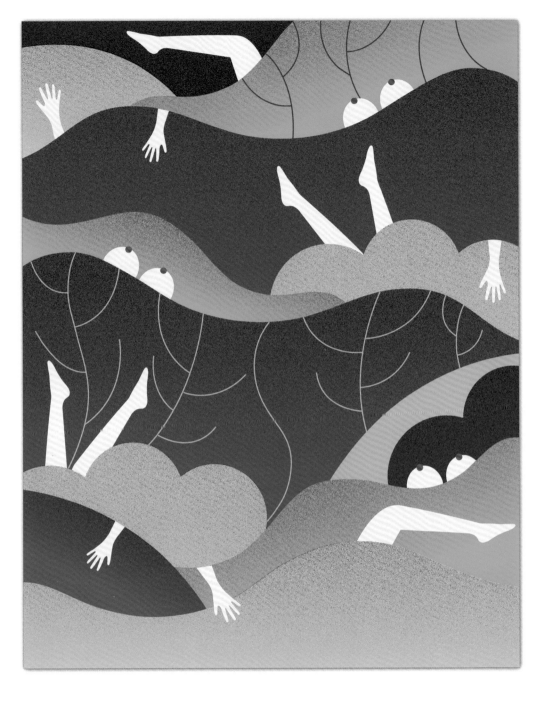

MERIT *Stuart McReath*

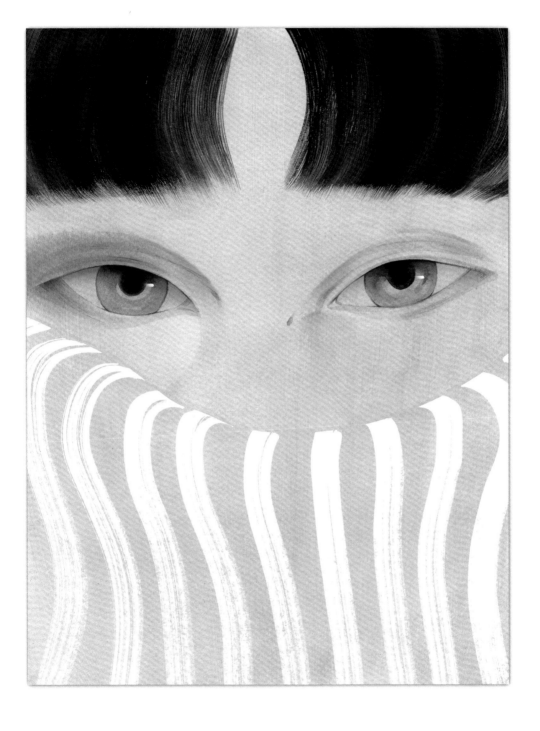

MERIT *Ahn Na Lim*

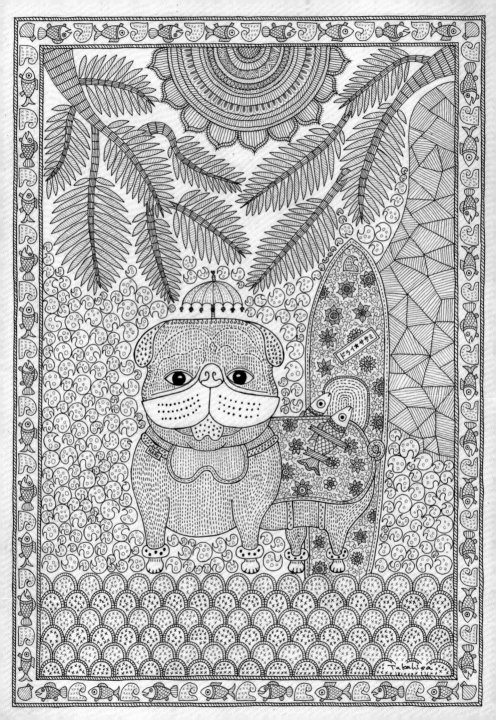

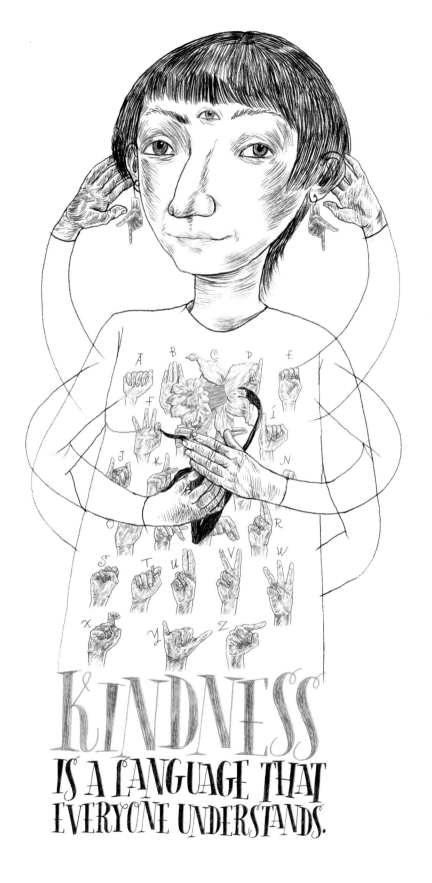

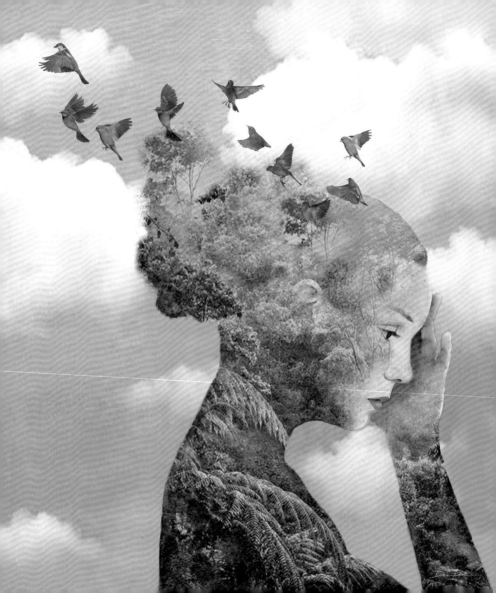

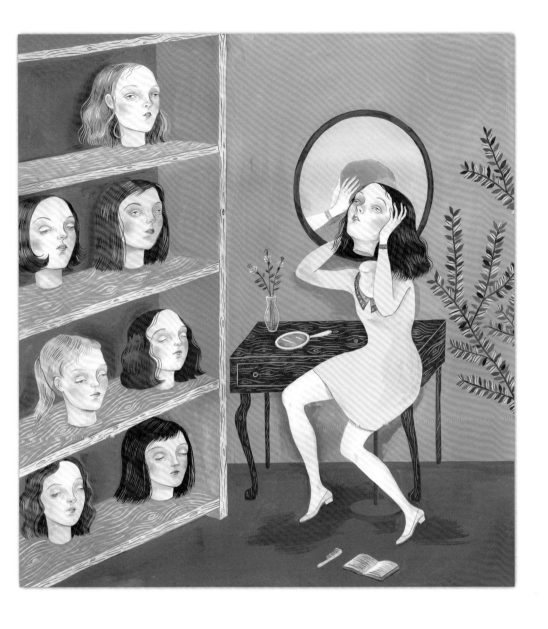

MERIT *Helena Perez Garcia*

215

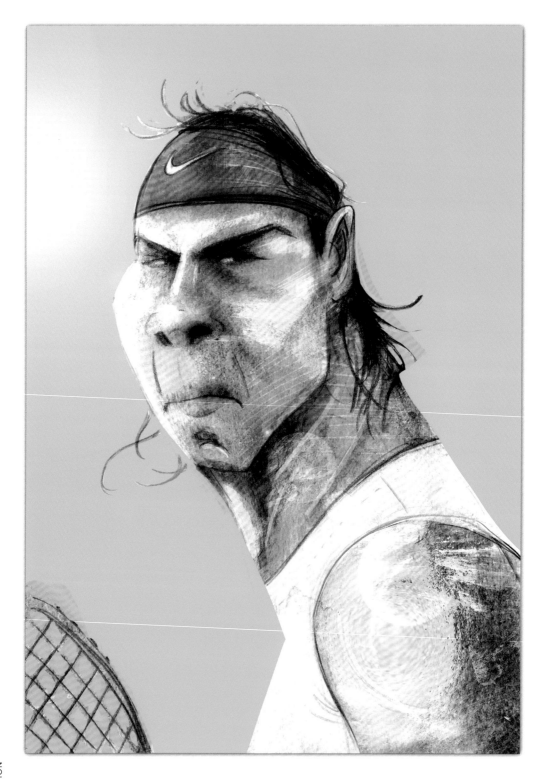

MERIT *Manuel Romero*

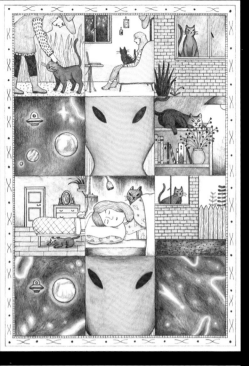
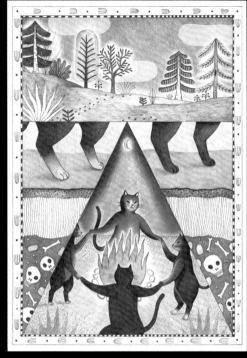
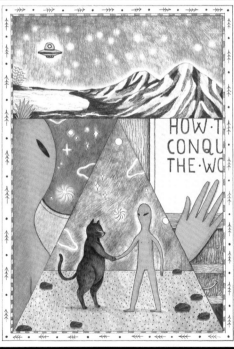
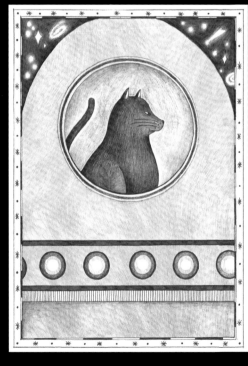

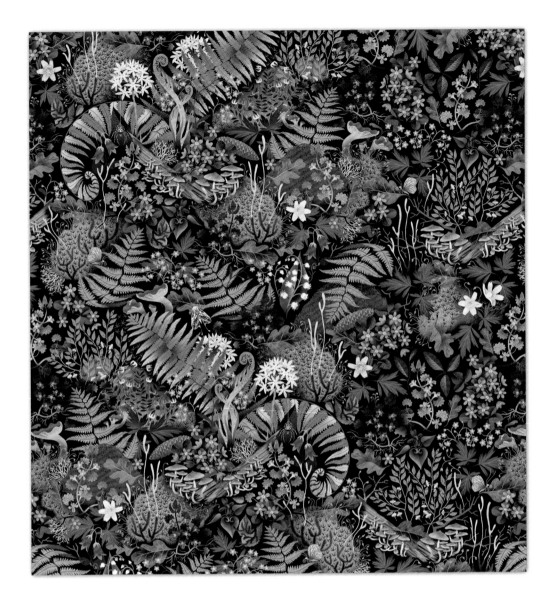

(L) GOLD *Katarzyna Bogdańska* (R) MERIT *Allison Cole*

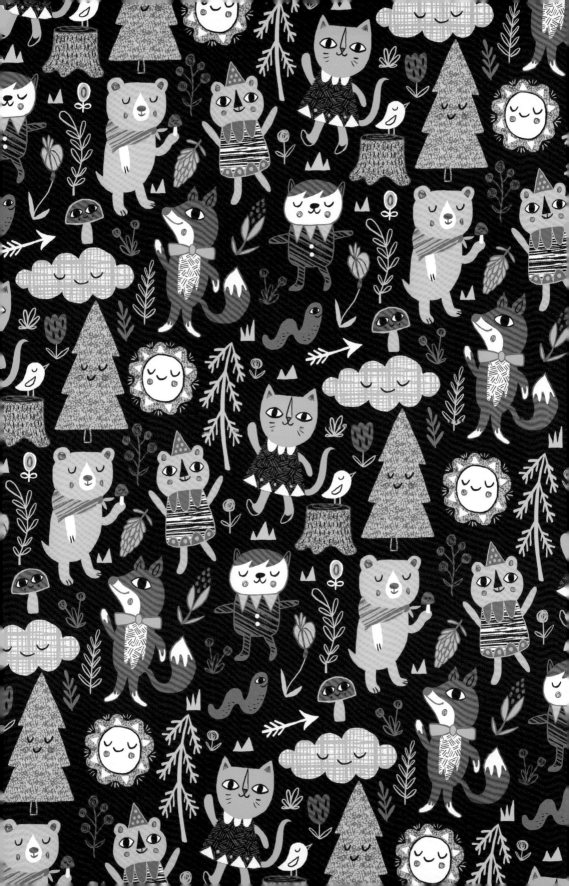

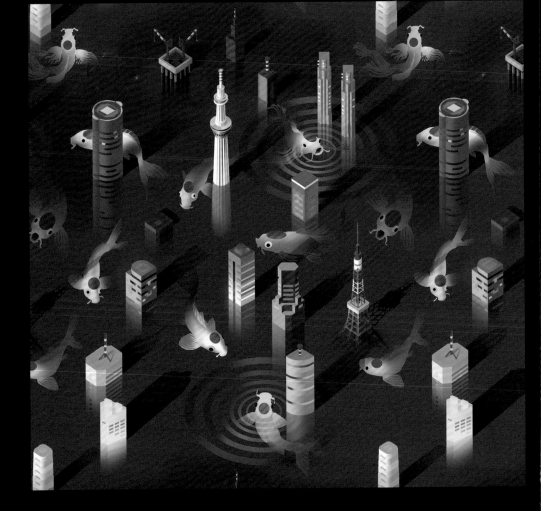

MERIT *Emilio Rolandi*

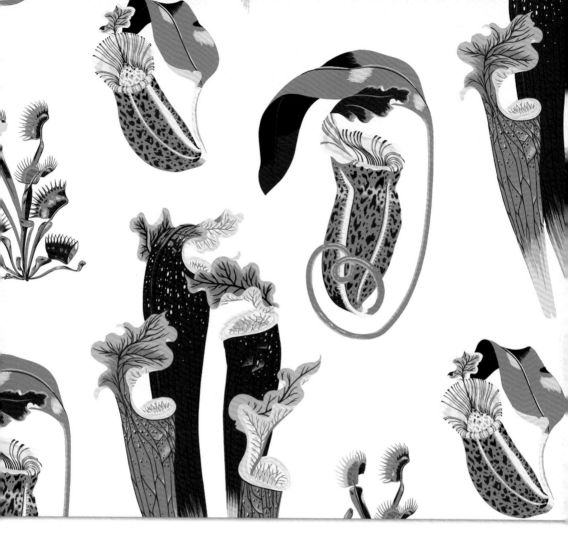

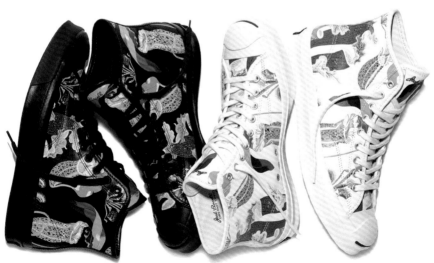

MERIT *Allison Bamcat*

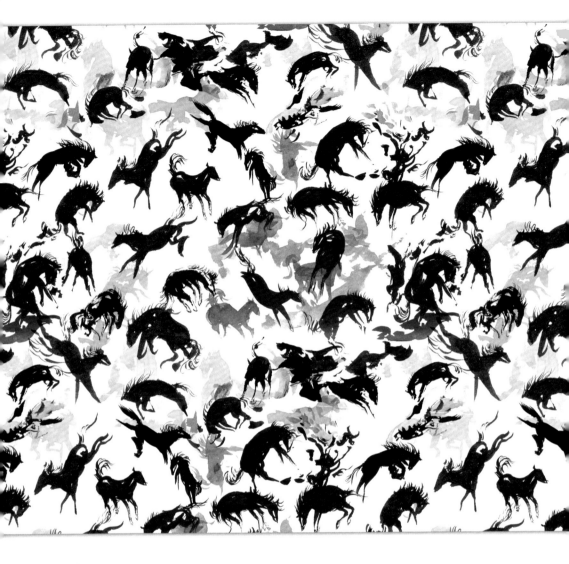

MERIT *Jacqueline Tam*

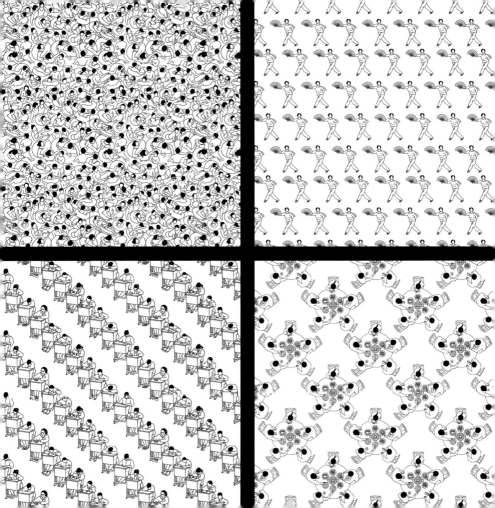

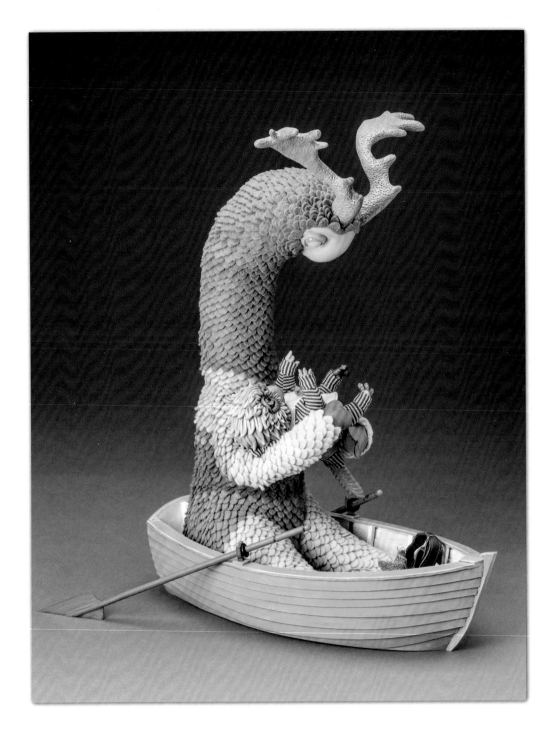

MERIT *Tanya Marriott*

CITY PAGES

FRINGE

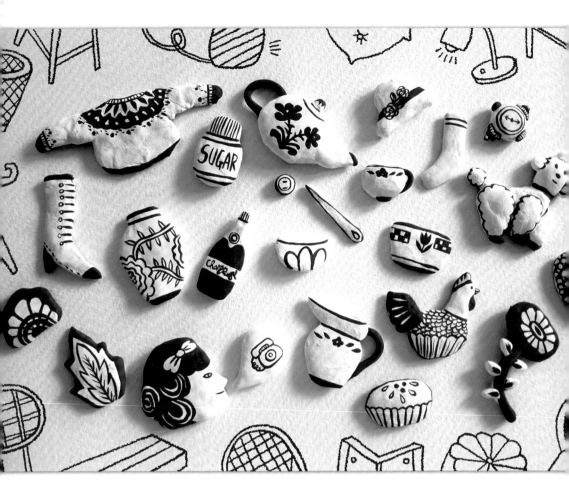

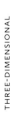

MERIT *Aya Kakeda*

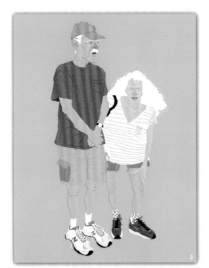

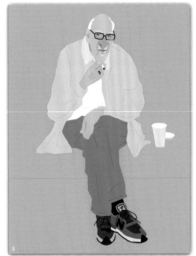

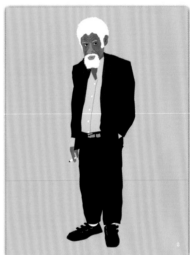

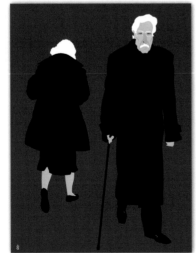

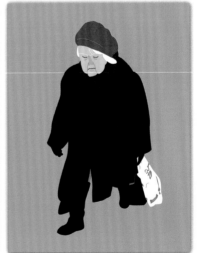

MERIT *Joe Whang*

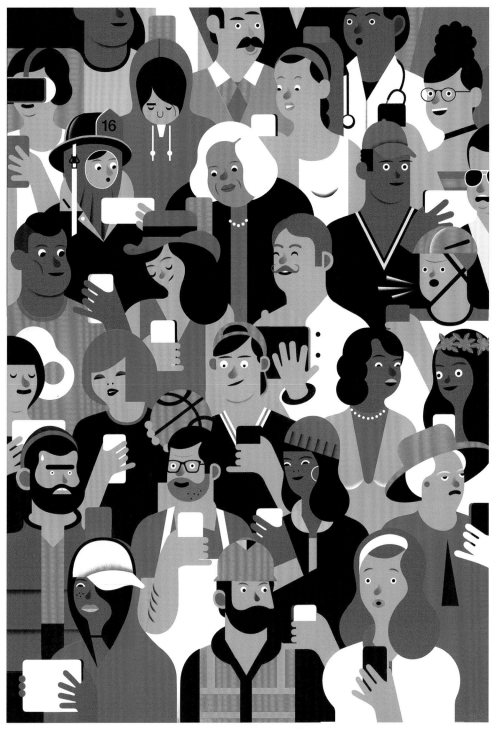

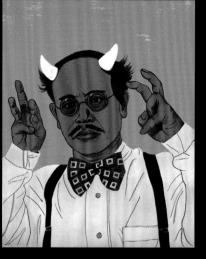
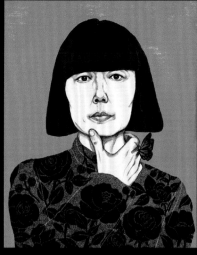
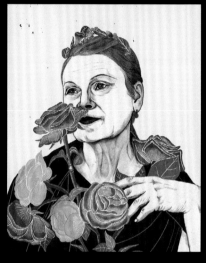
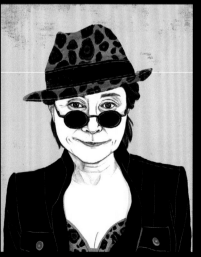
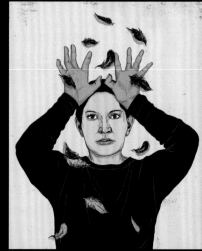

MERIT *Jing Li*

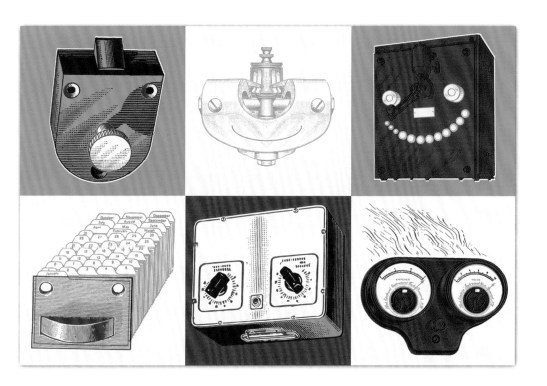

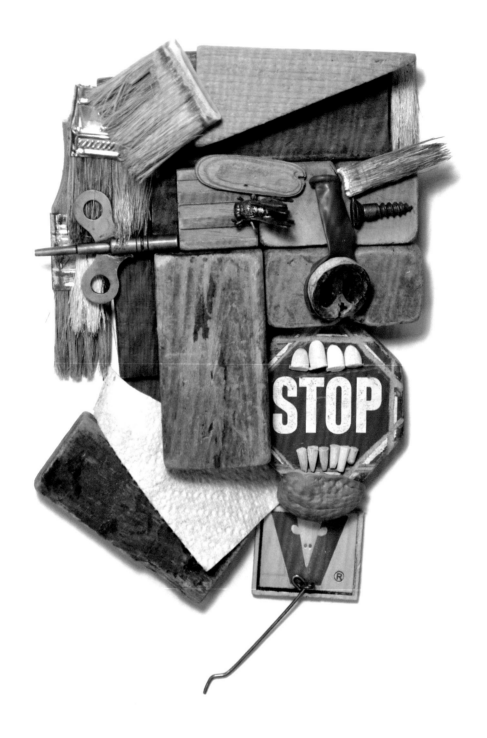

MERIT *Nick Levesque*

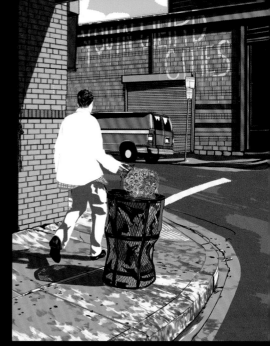

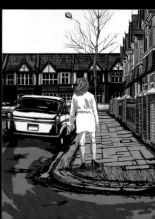

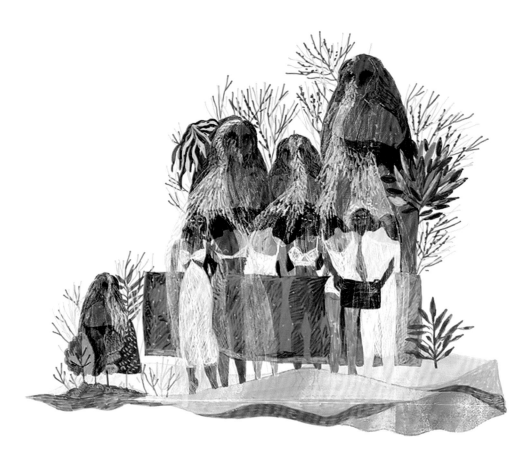

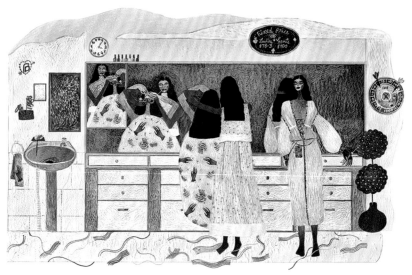

MERIT *Manuja Waldia*

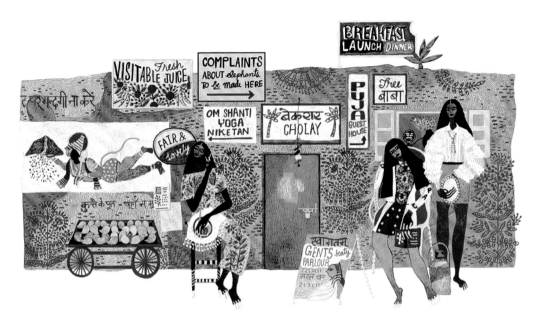

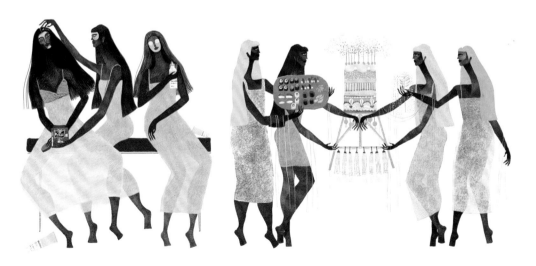

235

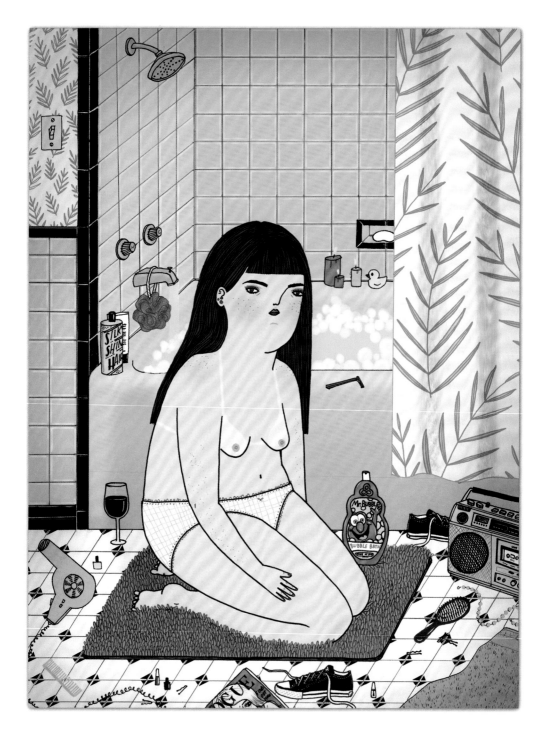

MERIT *Mai Ly Degnan*

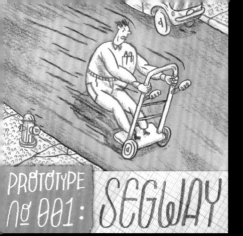

PROTOTYPE № 001: SEGWAY

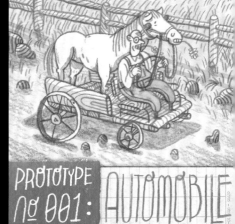

PROTOTYPE № 001: AUTOMOBILE

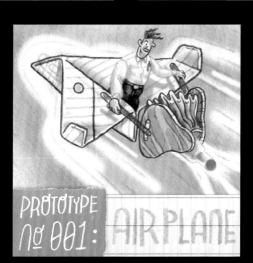

PROTOTYPE № 001: AIRPLANE

PROTOTYPE № 001: HANG GLIDER

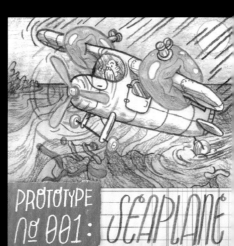

PROTOTYPE № 001: SEAPLANE

SILVER *Ileana Soon*

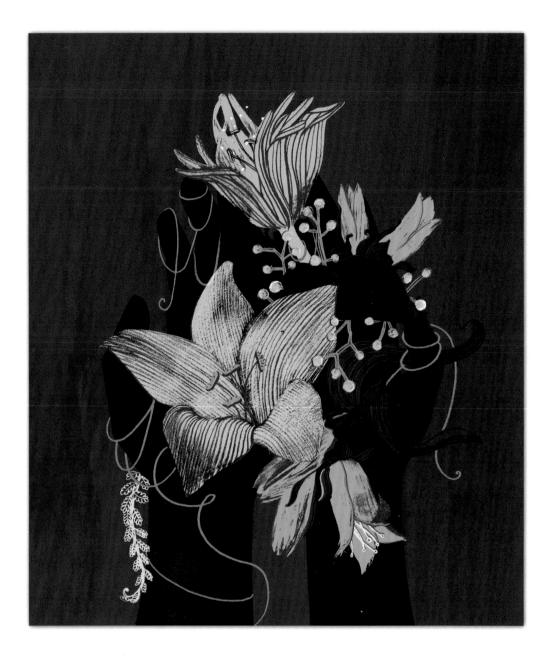

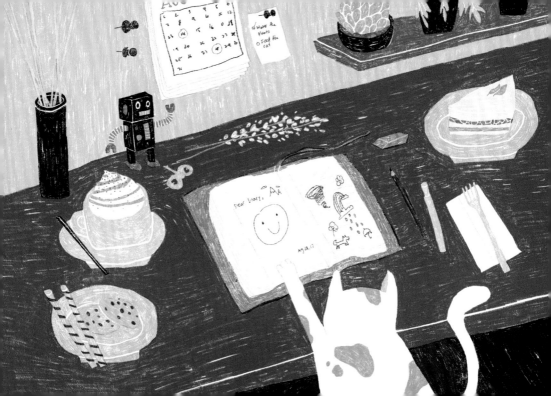

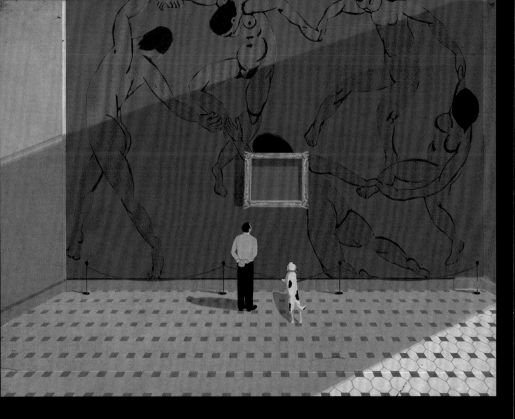

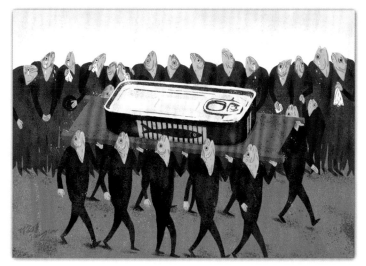

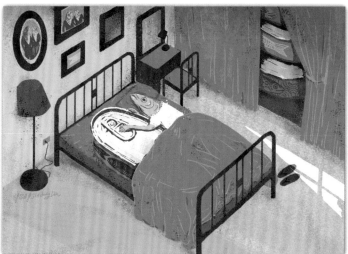

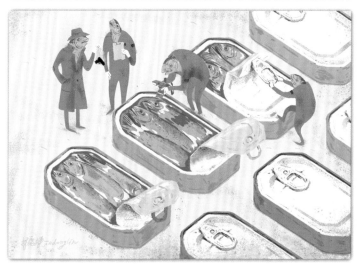

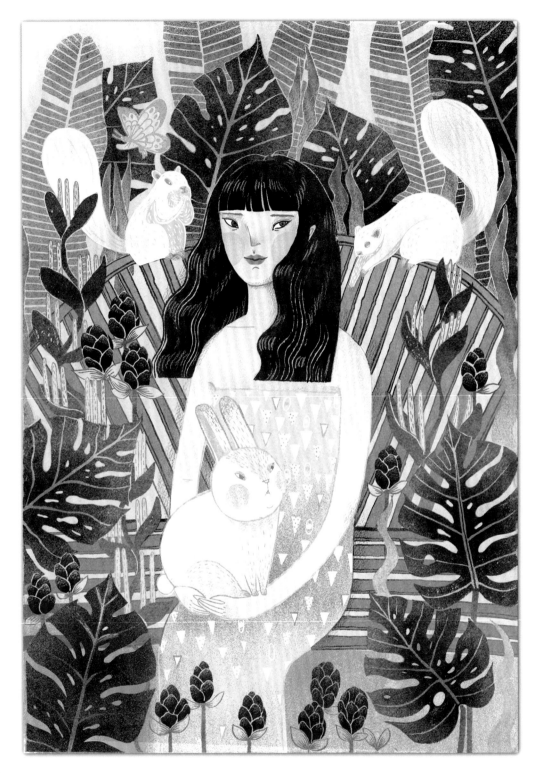

MERIT *Hanrou Li*

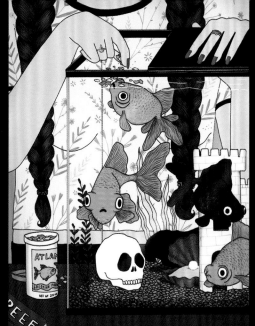
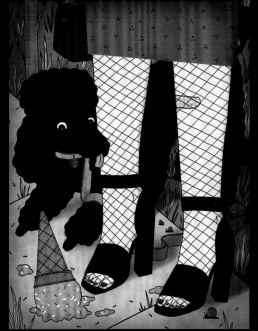
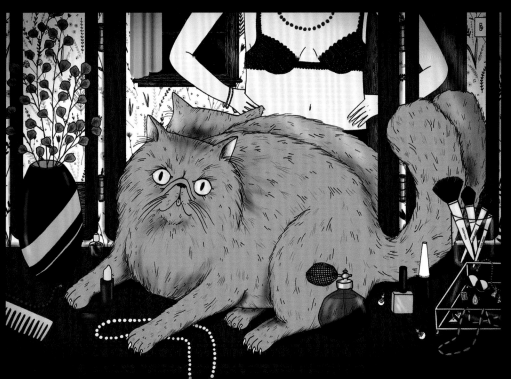

MERIT *Mai Ly Degnan*

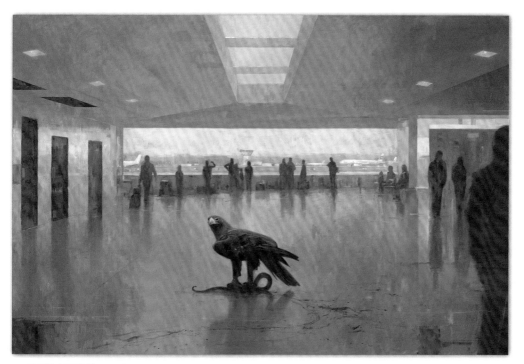

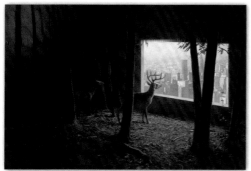 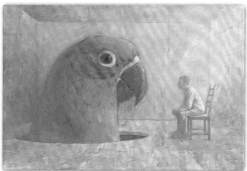

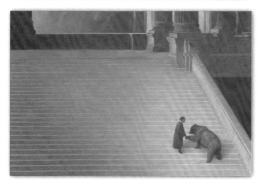 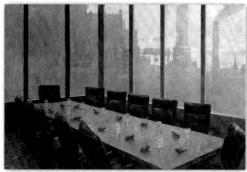

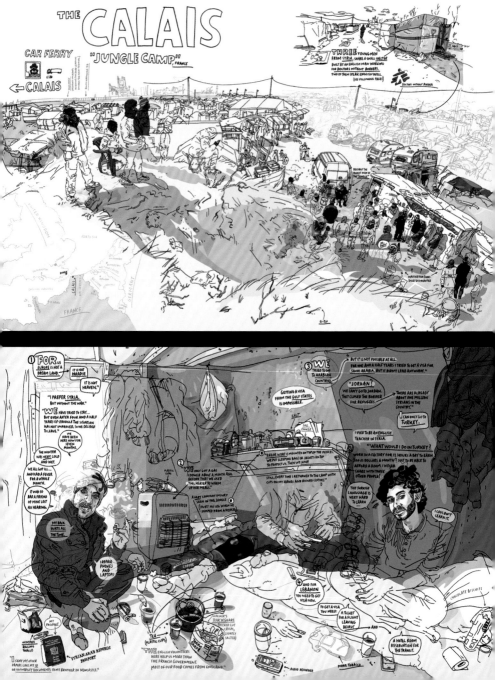

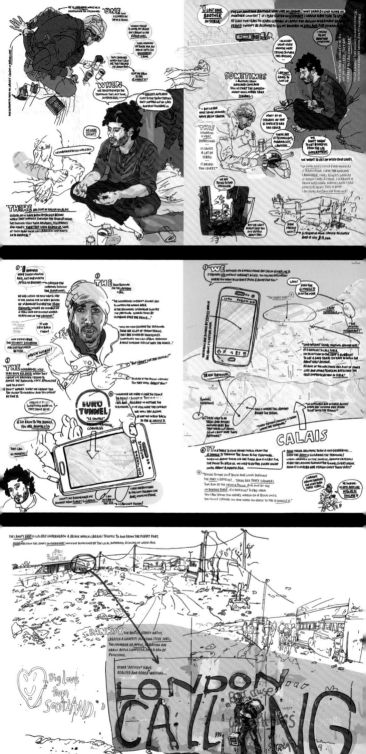

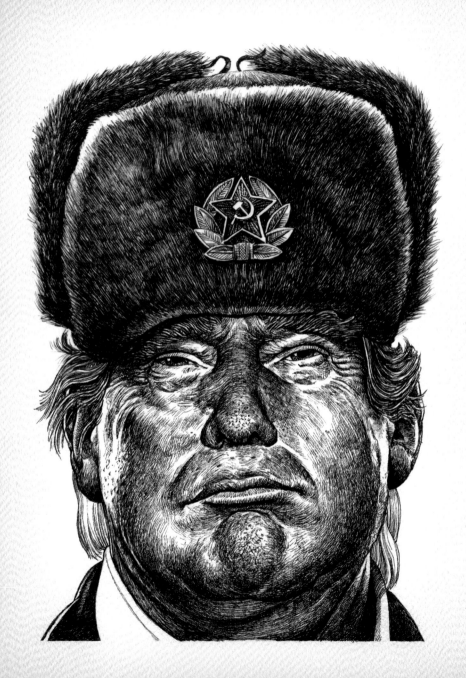

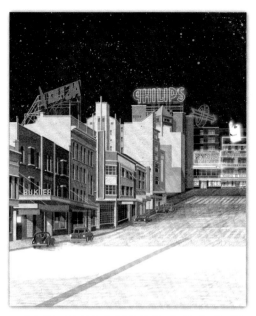

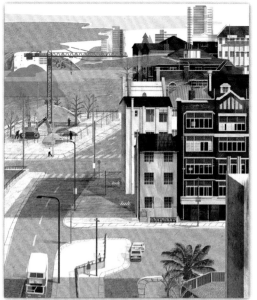

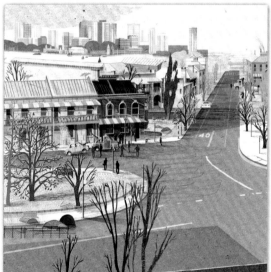

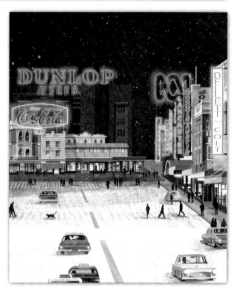

MERIT *Nancy Liang*

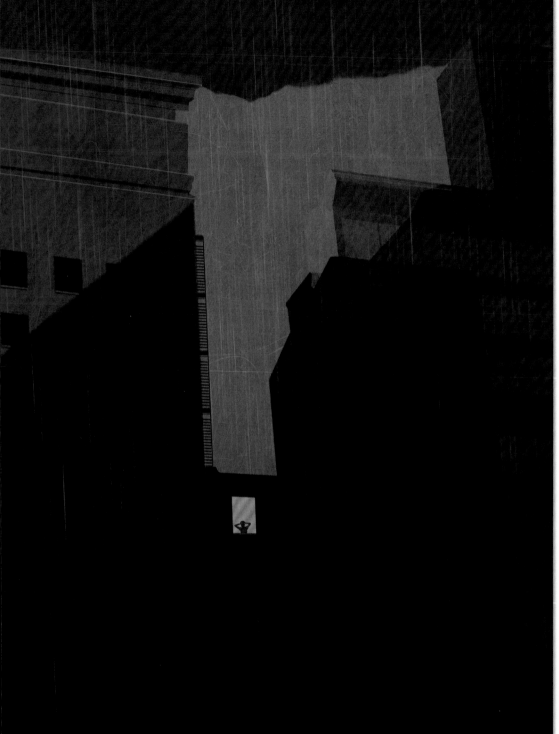

MERIT *Andrea Ucini*

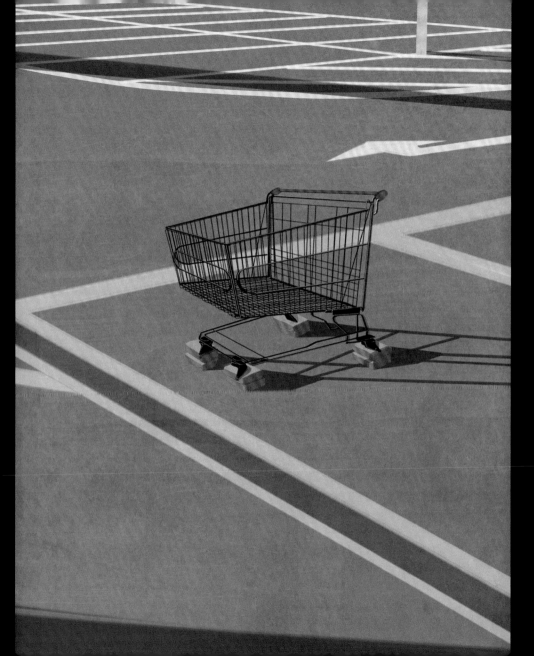

ET IN ARCADIA EGO

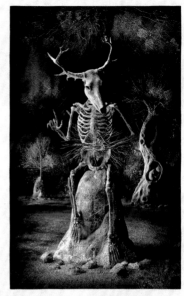

DOLOR HIC TIBI PRODERIT OLIM

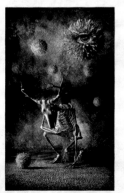

QUOD ME NUTRIT ME DESTRUIT

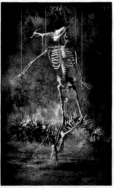

NEMO LIBER EST QUI CORPORI SERVIT

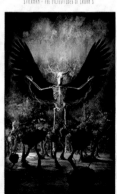

NULLAM DOLOREM SENTIRE

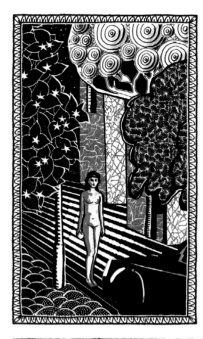
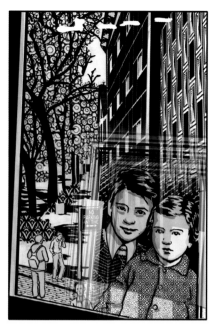
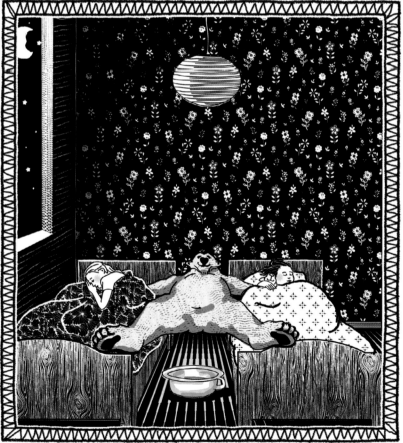

MERIT *Katja Weikenmeier*

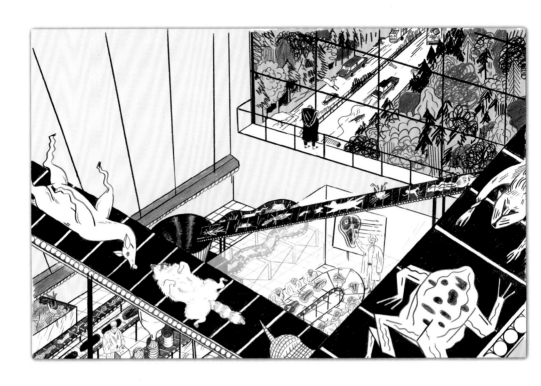

MERIT *Kati Szilagyi*

3X3 PICTURE BOOK SHOW

258 BOOK COVERS

260 BOOKS PUBLISHED

282 BOOKS UNPUBLISHED

283 ILLUSTRATION PUBLISHED

288 ILLUSTRATION UNPUBLISHED

297 EDUCATIONAL MATERIALS

298 EDITORIAL

299 YOUNG ADULT

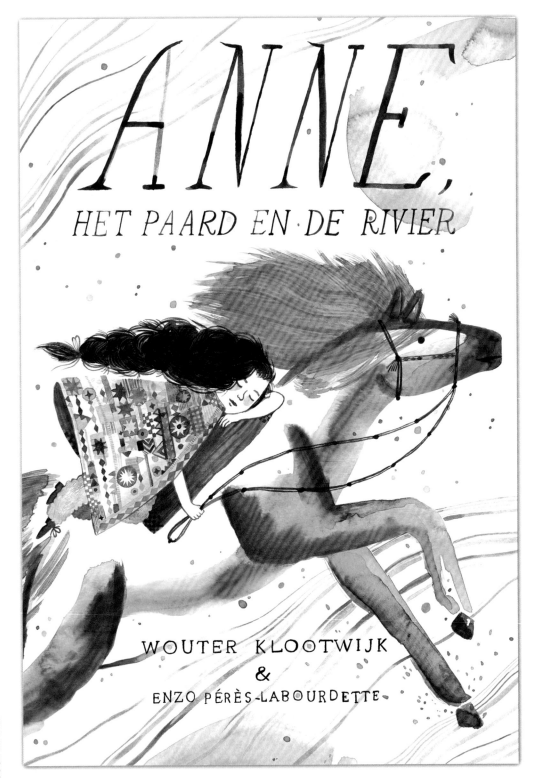

ANNE,
HET PAARD EN·DE RIVIER

WOUTER KLOOTWIJK
&
ENZO PÉRÈS-LABOURDETTE

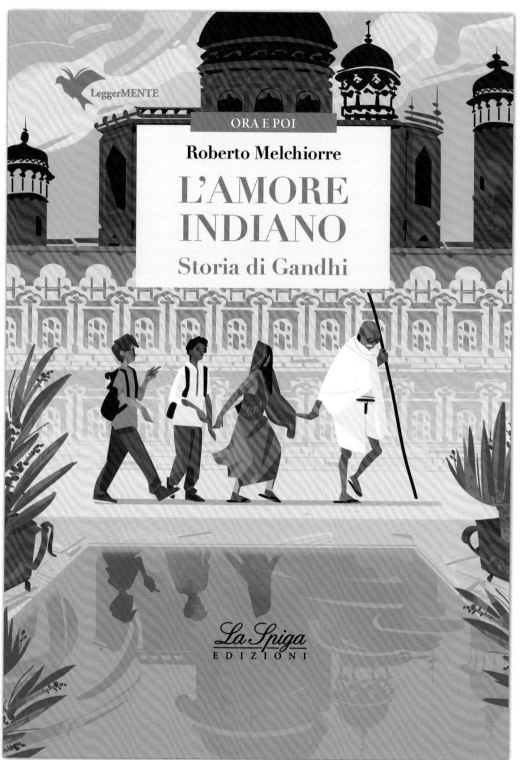

LeggerMENTE

ORA E POI

Roberto Melchiorre

L'AMORE INDIANO

Storia di Gandhi

La Spiga
E D I Z I O N I

MERIT *Giovanni Da Re*

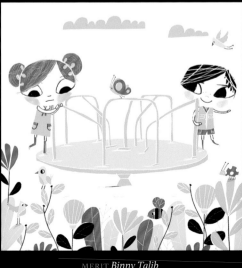

MERIT *Binny Talib*

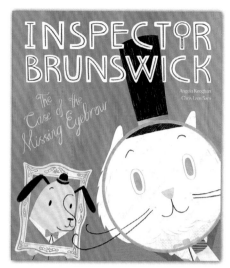

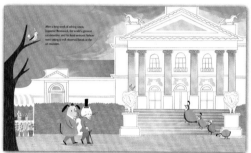

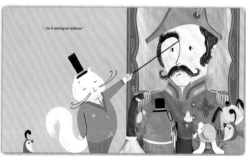

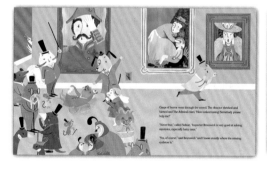

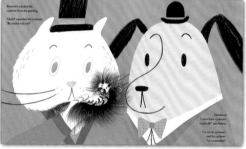

MERIT *Angela Keoghan*

261

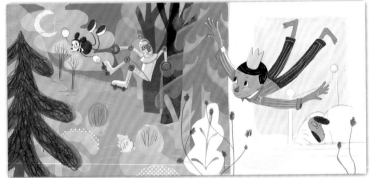

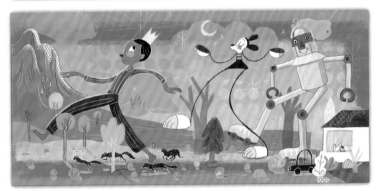

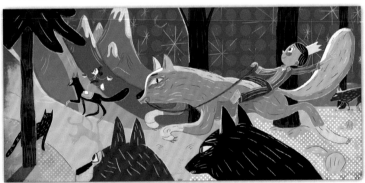

MERIT *Orit Bergman*

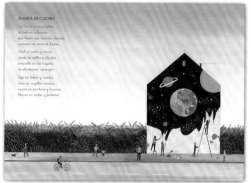

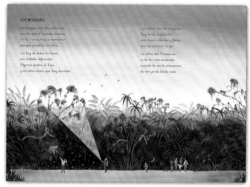

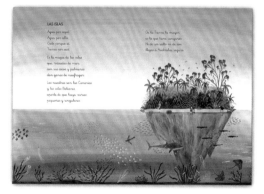

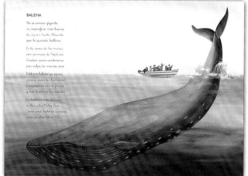

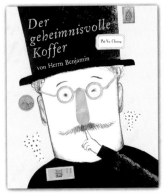

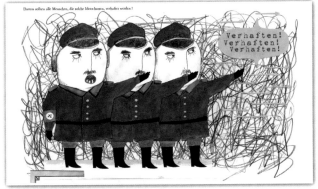

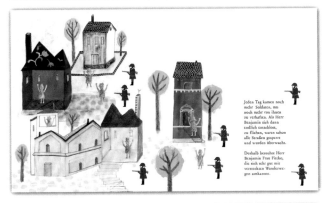

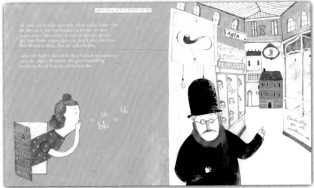

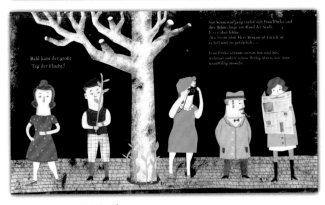

SILVER *Pei-Yu Chang*

264

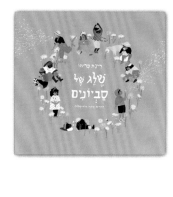
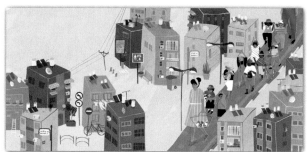
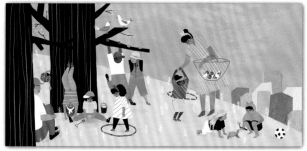

MERIT *Maya Ish-Shalom*

265

abitare sottosopra

MERIT *Valeria Petrone*

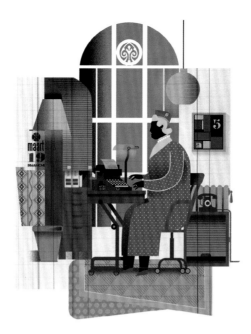

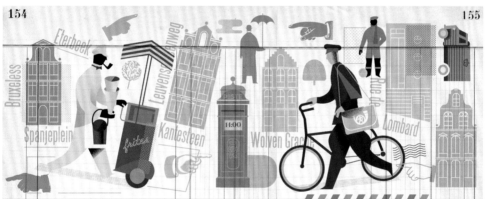

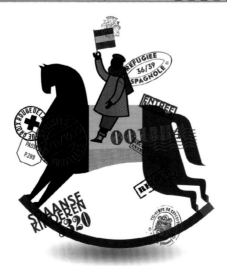

MERIT *José María Lema de Pablo*

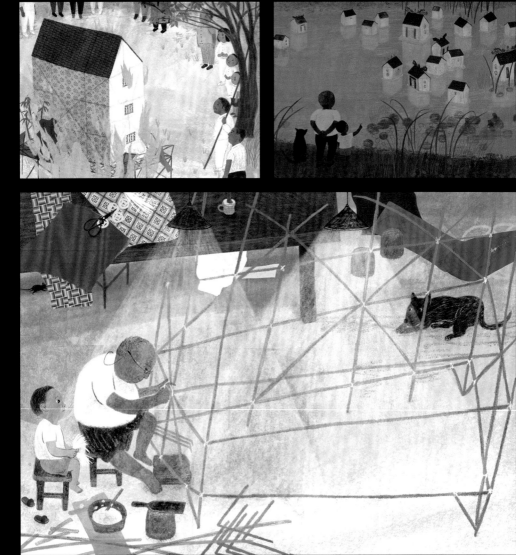

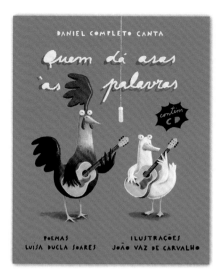

MERIT *João Vaz de Carvalho*

271

דַּפְנָה בֶּן־צְבִי
כָּכָה־כָּכָה, זוּזִי שֶׁמֶשׁ
אִיּוּרִים: עָפְרָה עָמִית

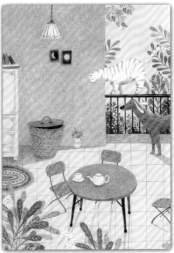

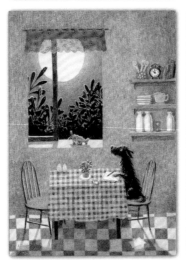

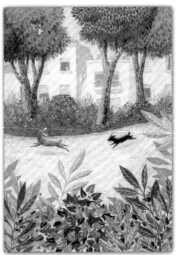

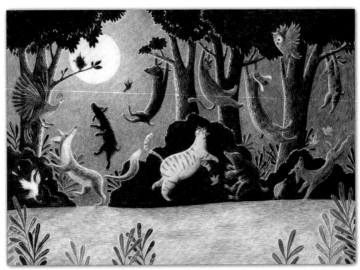

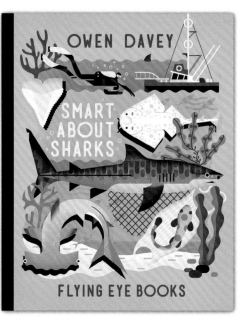

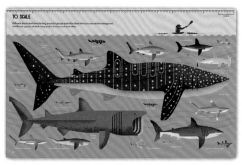

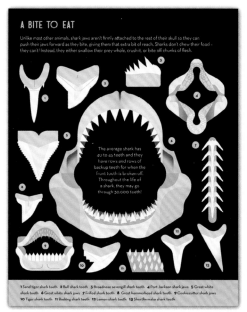

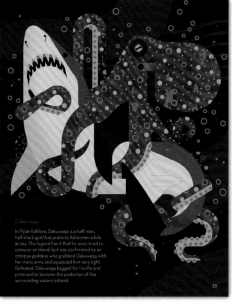

GOLD *Owen Davey*

273

תמר מאיר

חֲנוּת הַגְּלִידָה שֶׁל פְרַנְצֶ'סְקוֹ טִירְלִי

איורים: יעל אלברט

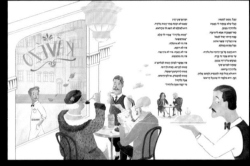

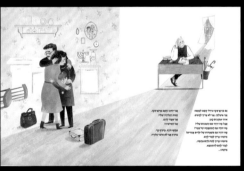

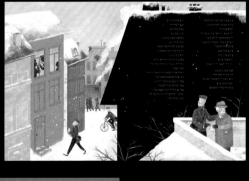

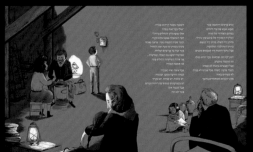

MERIT *Mark Hoffmann*

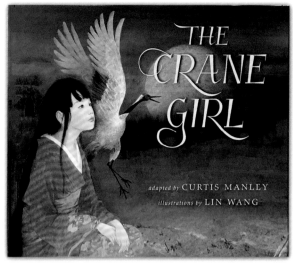

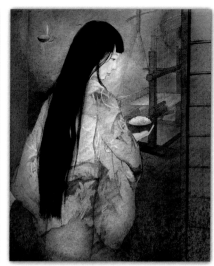

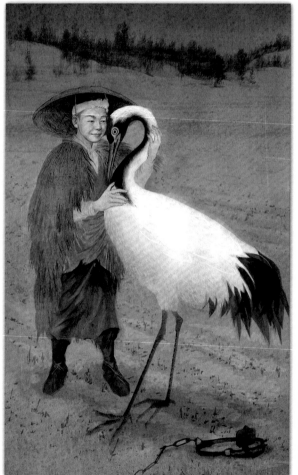

MERIT *Lin Wang*

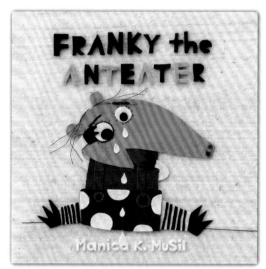

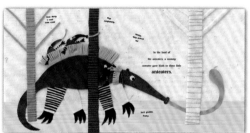

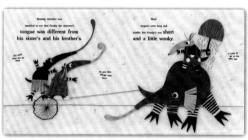

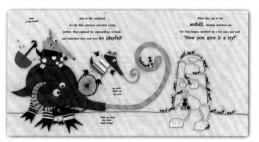

MERIT *Manica K. Musil*

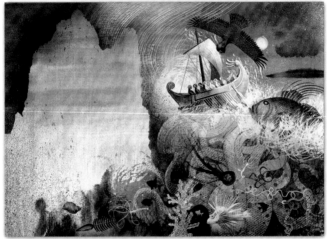

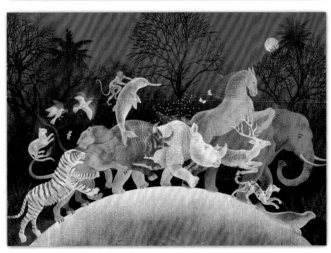

MERIT *Anna and Elena Balbusso Twins*

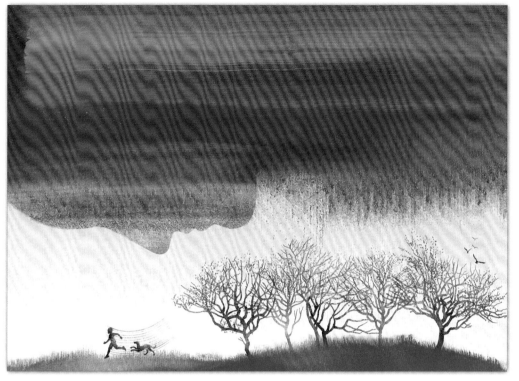

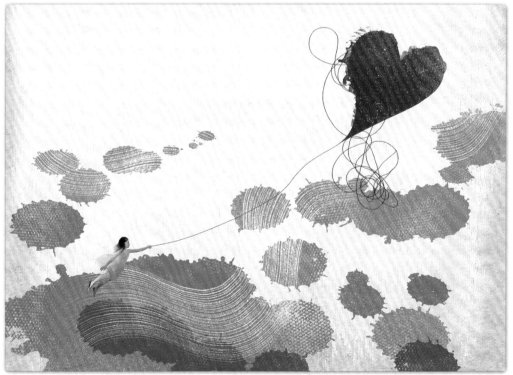

279

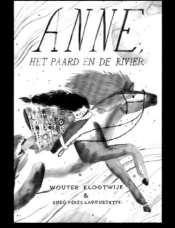

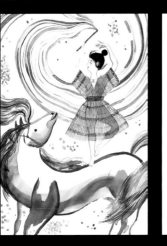

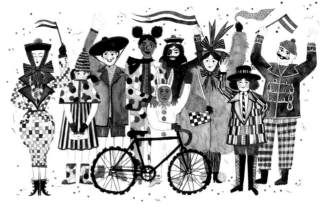

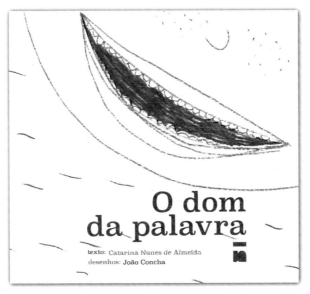

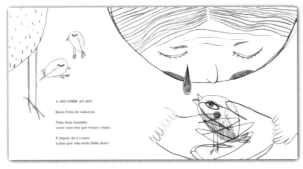

GOLD *João Concha*

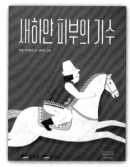

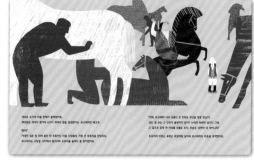

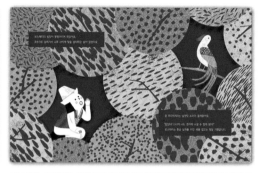

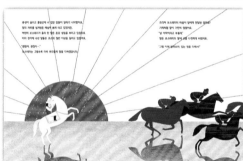

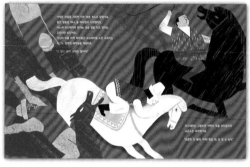

MERIT *Ahra Kwon*

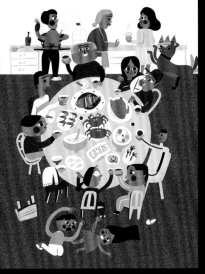
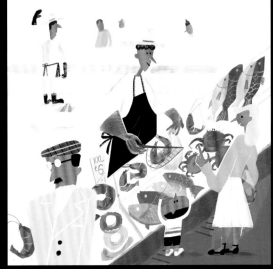
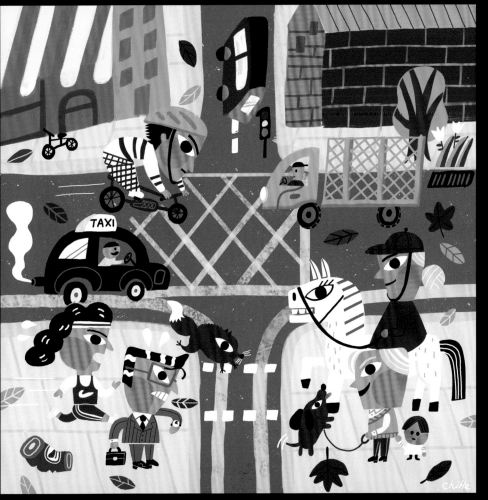

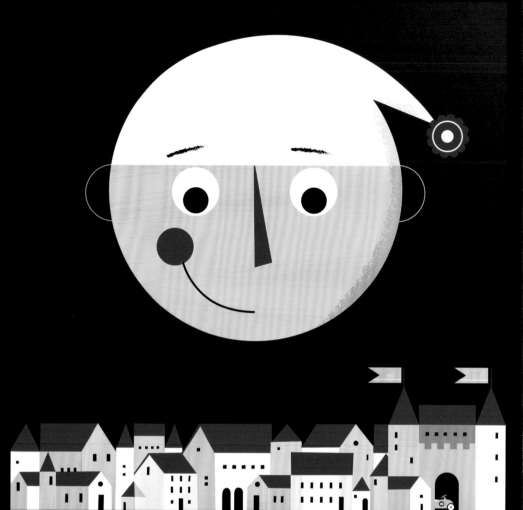

MERIT *Julien Chung*

284

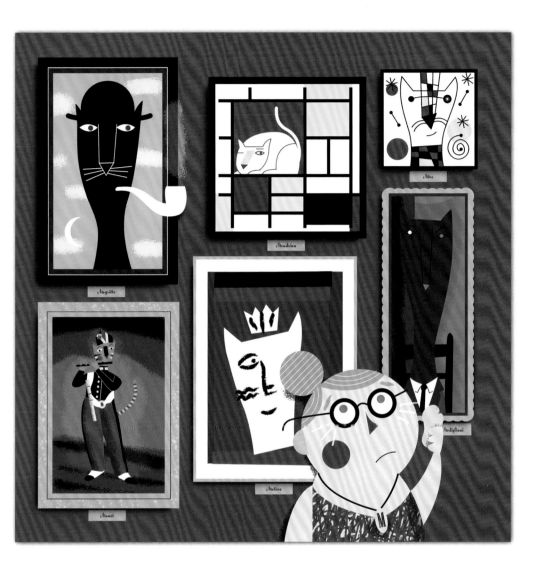

Eggs are good for your body

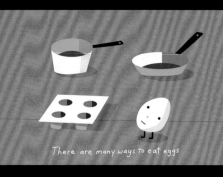

There are many ways to eat eggs

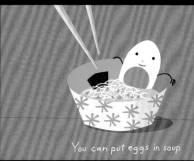

You can put eggs in soup

Scrambled eggs on toast is yummy.

You can even eat sushi eggs

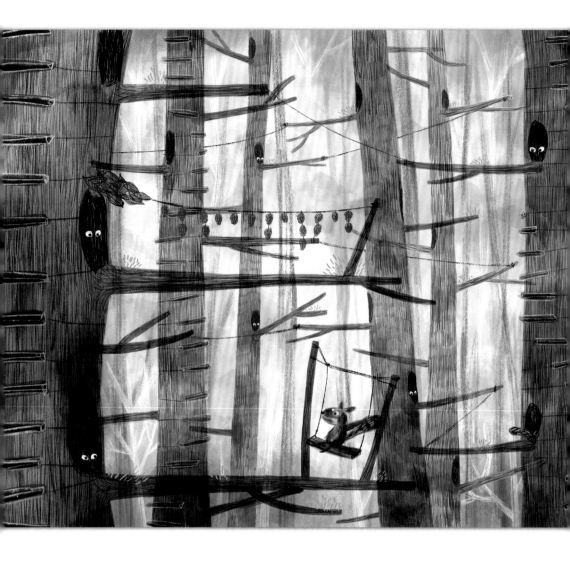

GOLD *Sally Soweol Han*

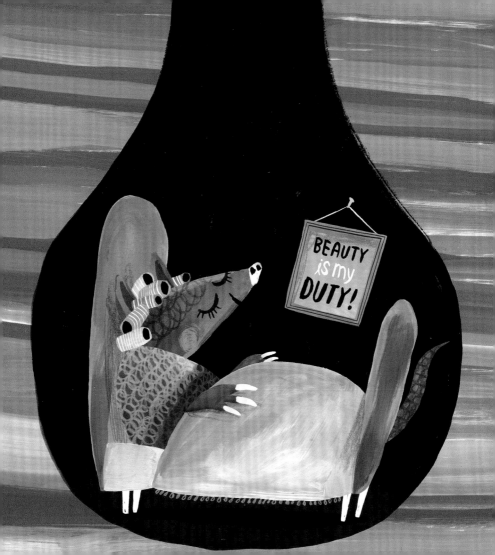

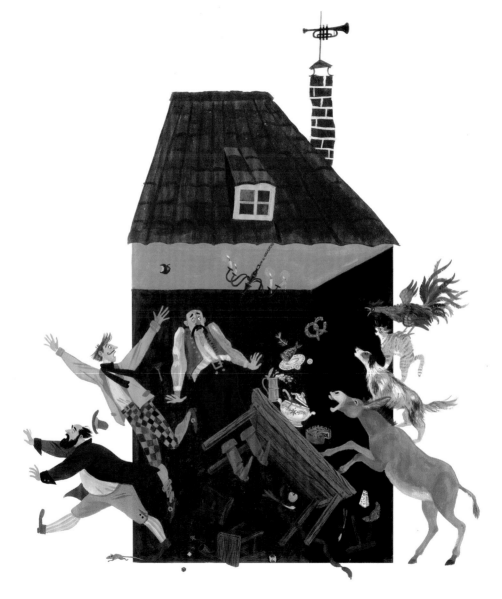

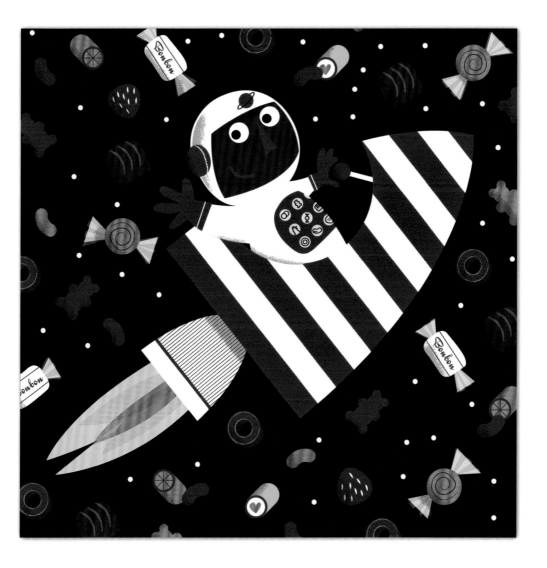

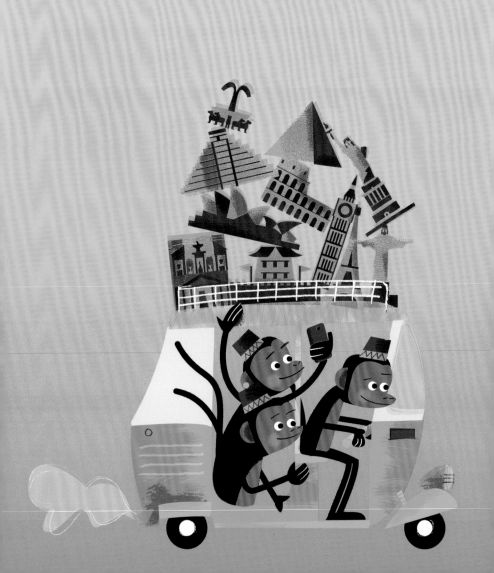

sad cat

bad cat

sox cat

lox cat

nook cat

book cat

MERIT *Maria Carluccio*

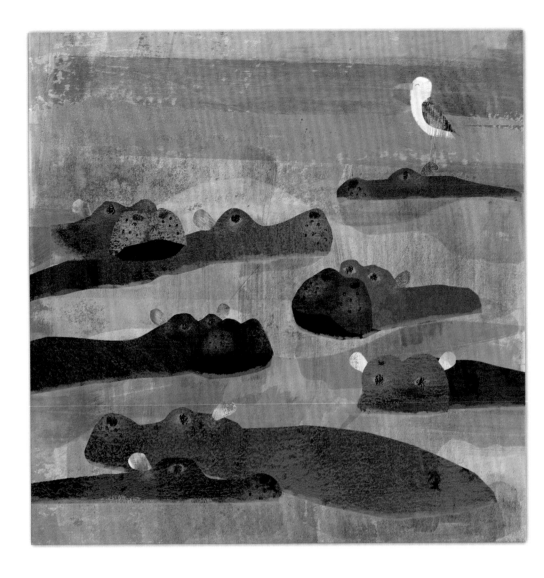

MERIT *Amy Schimler-Safford*

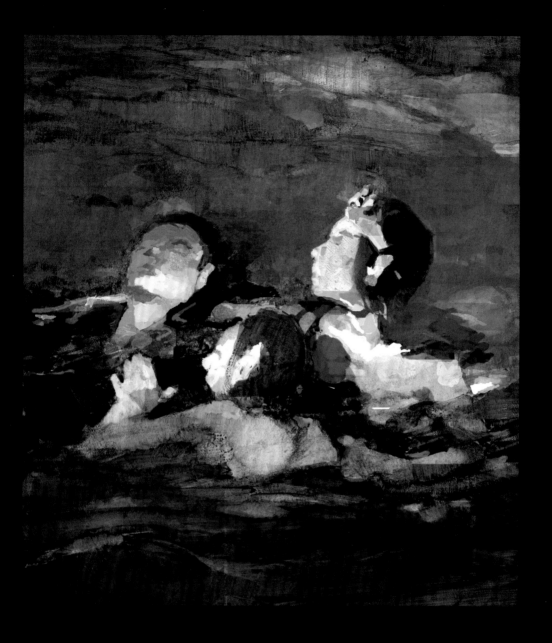

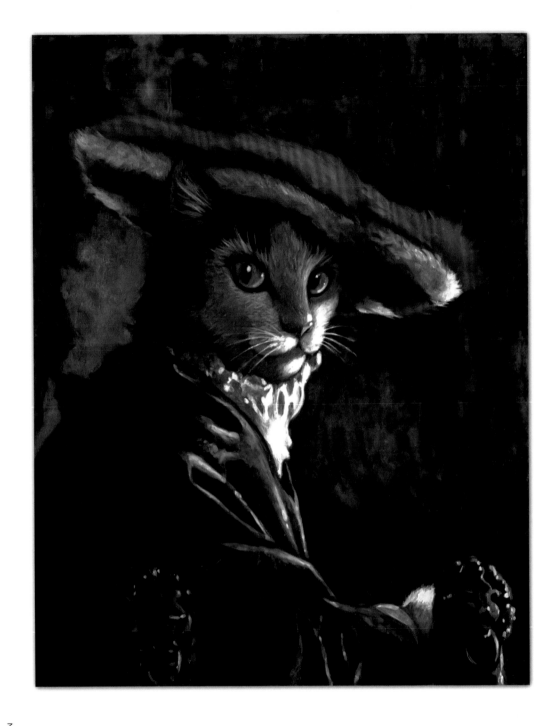

MERIT *Mary Jane Begin*

A COME AVVENIRE

Glossario Illustrato
sulla Resistenza Italiana 1943-1945

Anna Pini

isiautbino
Istituto Superiore
per le Industrie Artistiche

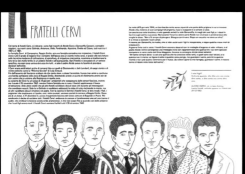

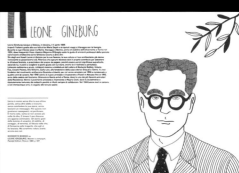

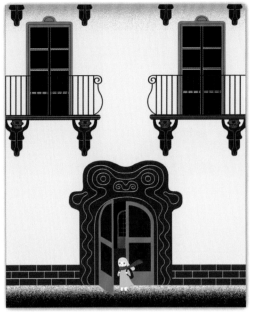
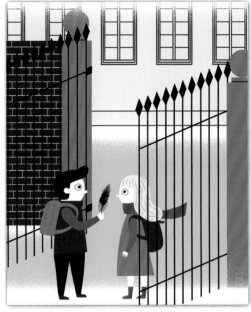
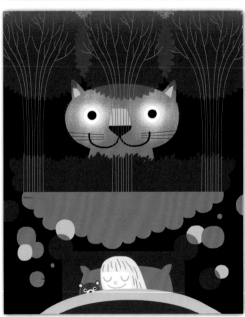
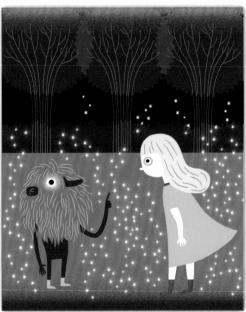

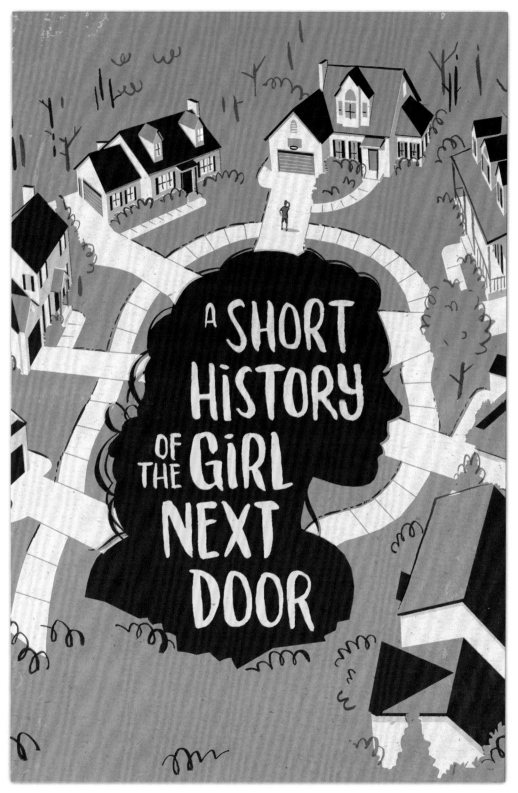

A SHORT HISTORY OF THE GIRL NEXT DOOR

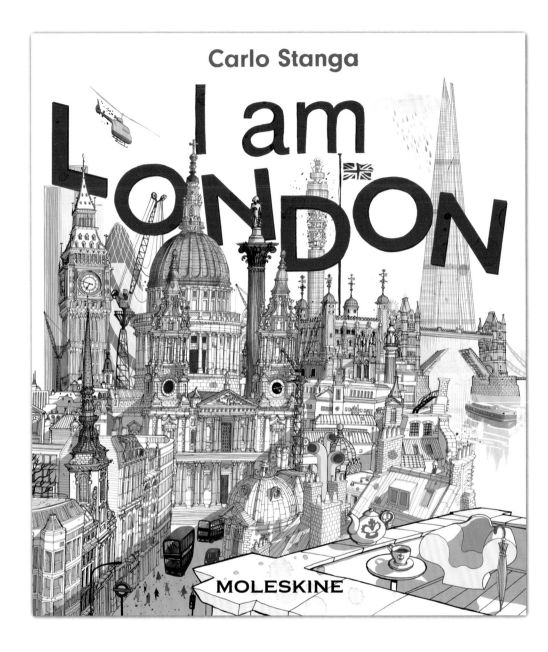

MERIT *Carlo Stanga*

Gracias y desgracias
del ojo del culo

Francisco de Quevedo

Ilustraciones de
José María Lema
Prólogo de
José Luis Cuerda

[pepitas de calabaza ed.]

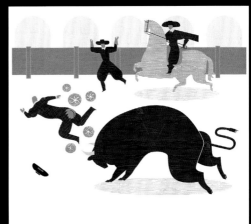

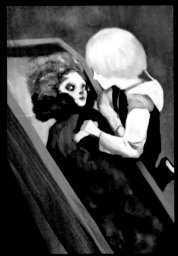

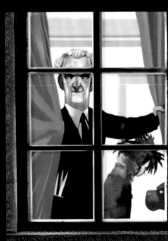

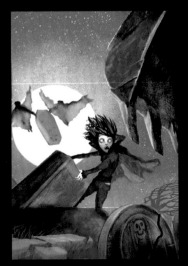

SILVER *Paolo d'Altan*

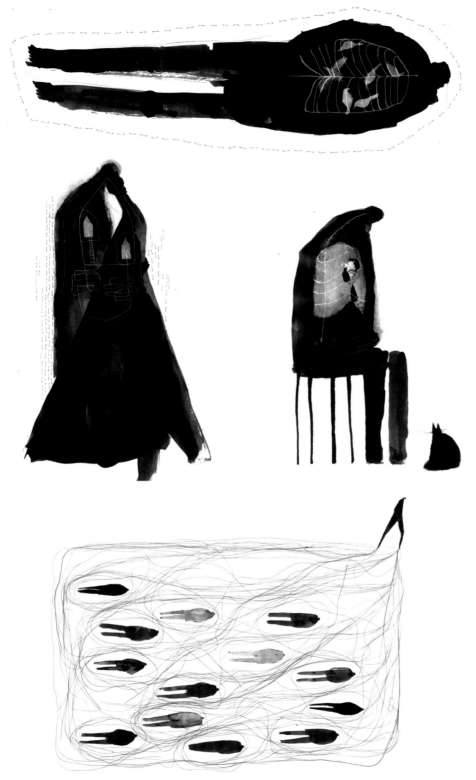

DISTINGUISHED MERIT *Catalina Silva Guzmán*

303

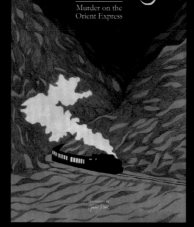

Murder on the
Orient Express

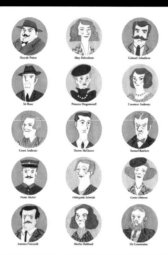

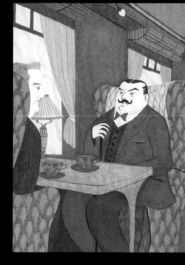

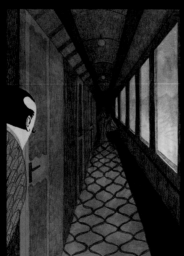

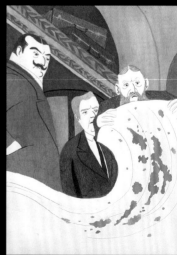

DISTINGUISHED MERIT *Giulia Rossi*

3X3 STUDENT SHOW

338 BEST OF SHOW

306 GOLD

311 GOLD

334 GOLD

379 GOLD

310 SILVER

314 SILVER

368 SILVER

374 SILVER

317 BRONZE

344 BRONZE

345 BRONZE

362 BRONZE

369 BRONZE

373 BRONZE

384 BRONZE

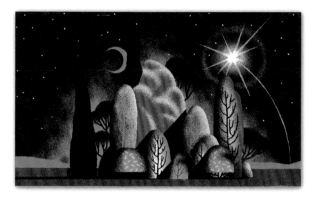

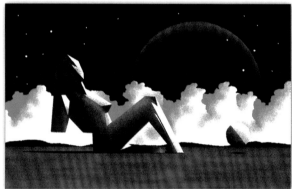

GOLD *Max Loeffler*

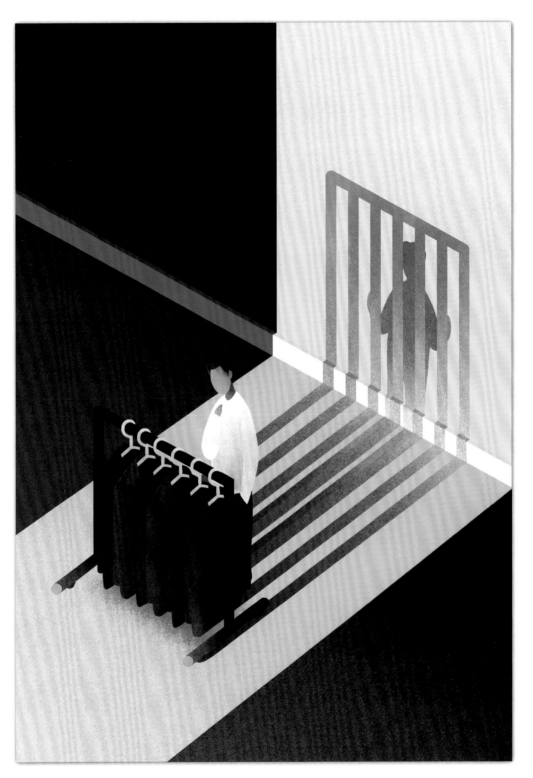

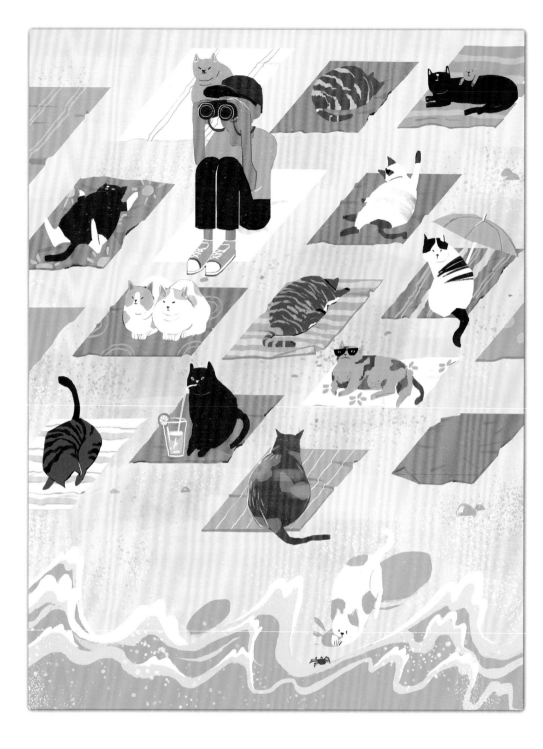

MERIT *Alice Yu Deng*

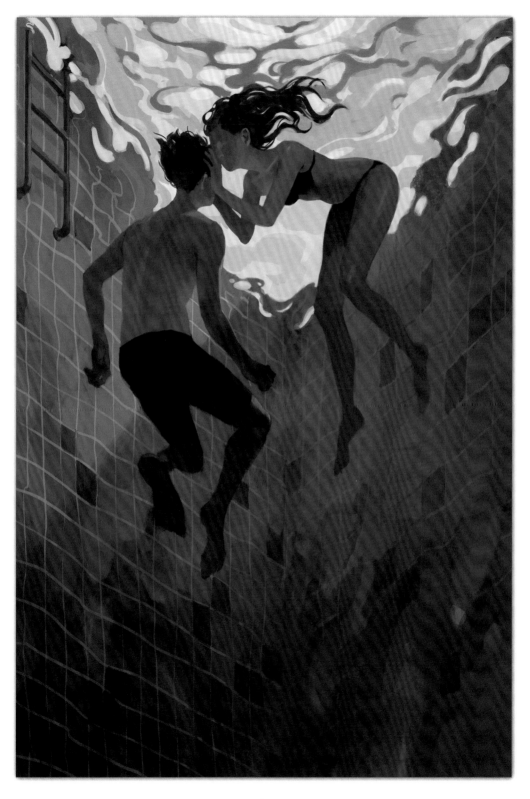

MERIT *Hokyoung Kim*

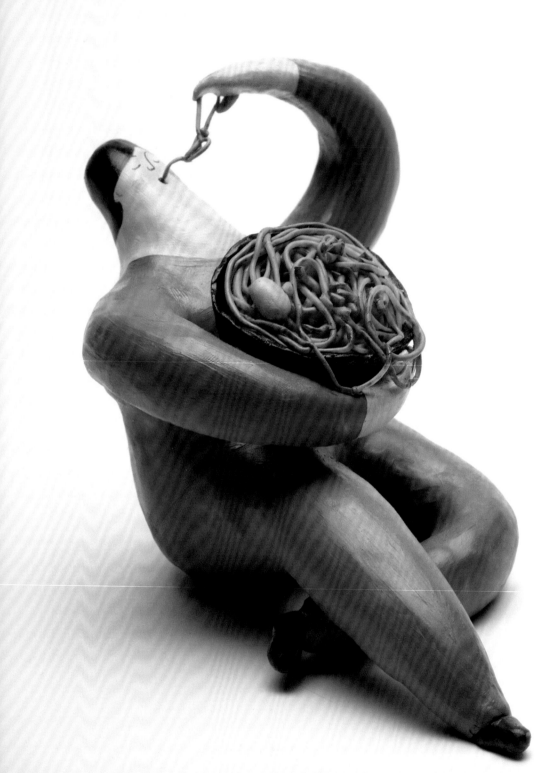

SILVER *Janice Chang*

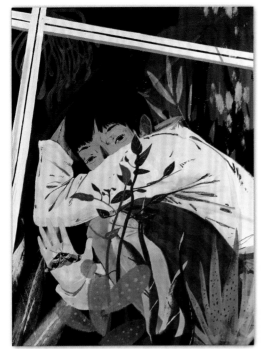
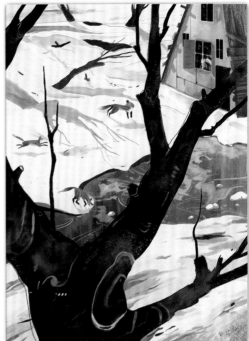
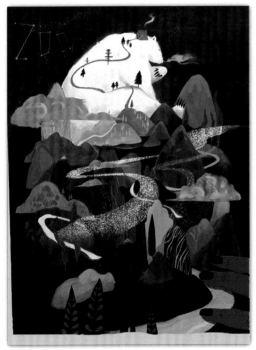
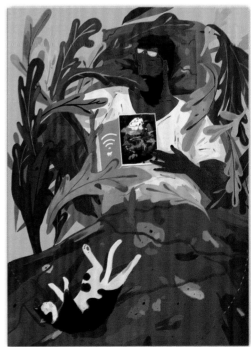

GOLD *Xin Ren*

311

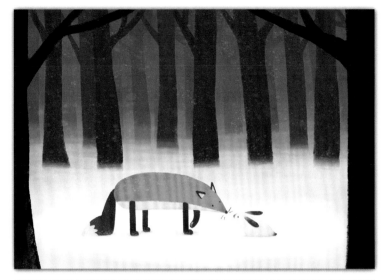

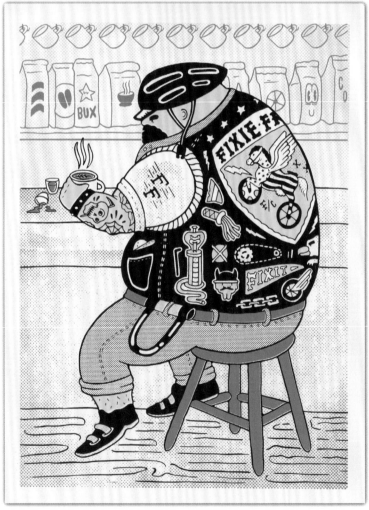

(T) MERIT *Jenna Nahyun Chung* (B) MERIT *Cameron Miller*

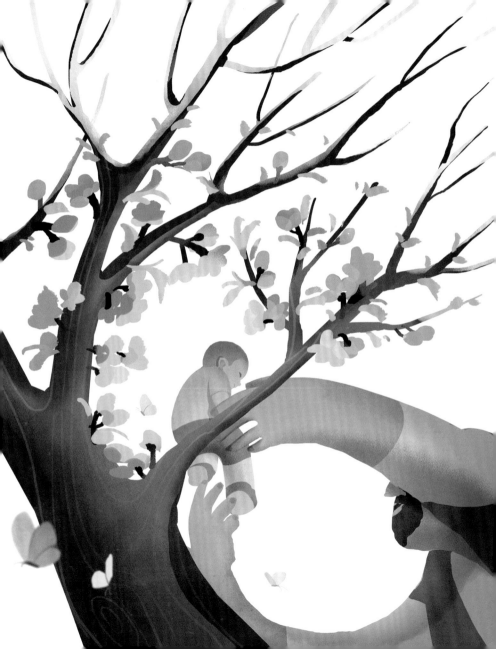

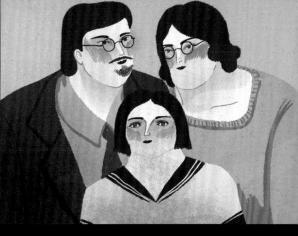
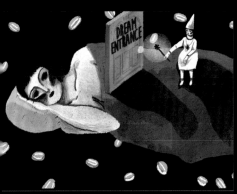

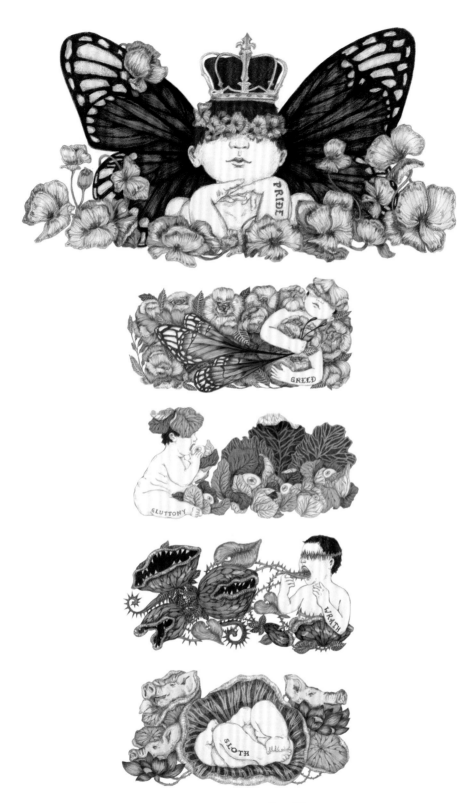

DISTINGUISHED MERIT *Dora Wang*

315

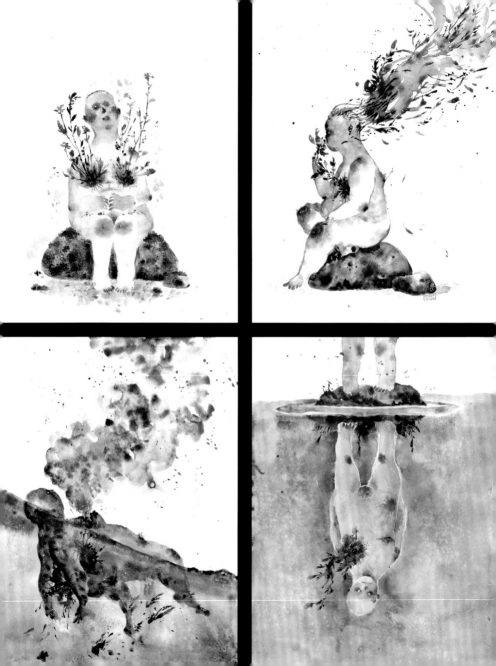

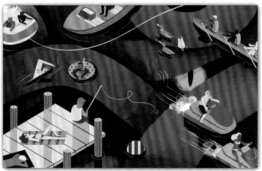

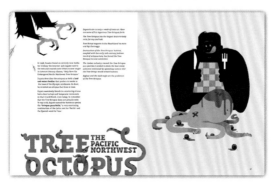

BRONZE *Sara Wong*

317

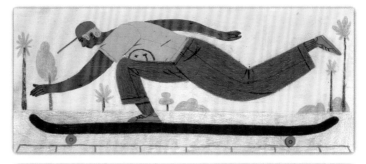

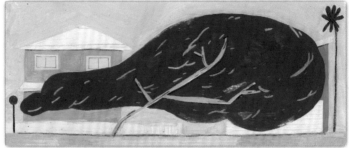

DISTINGUISHED MERIT *Celia Jacobs*

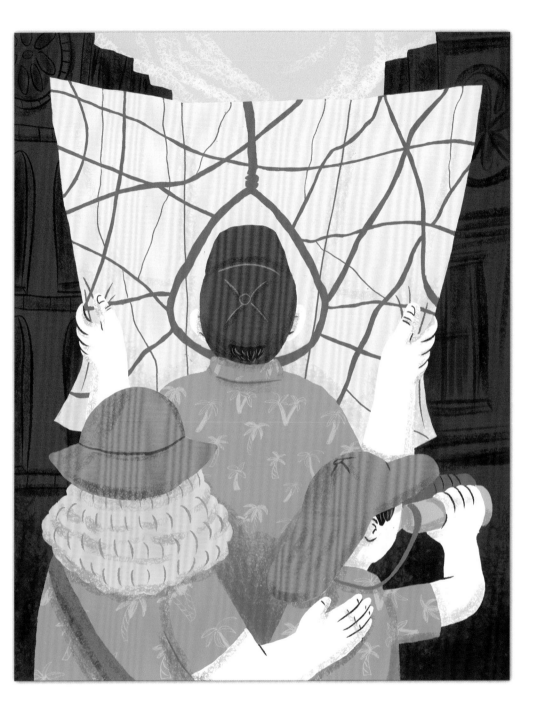

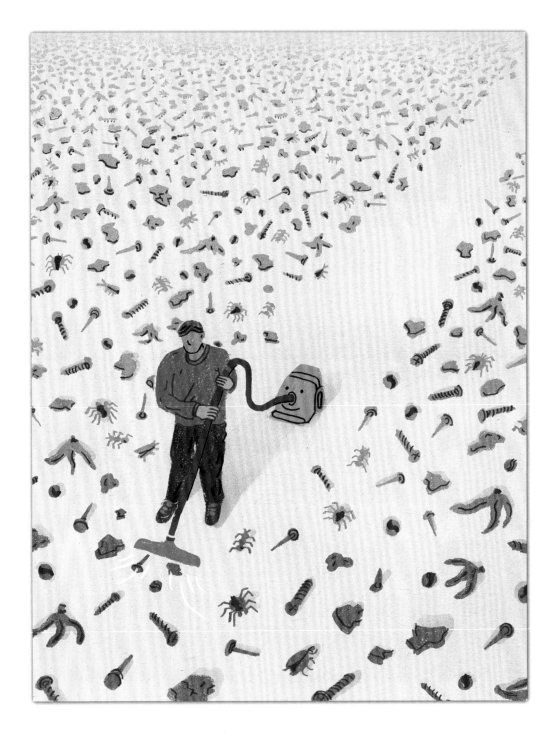

MERIT *David Huang*

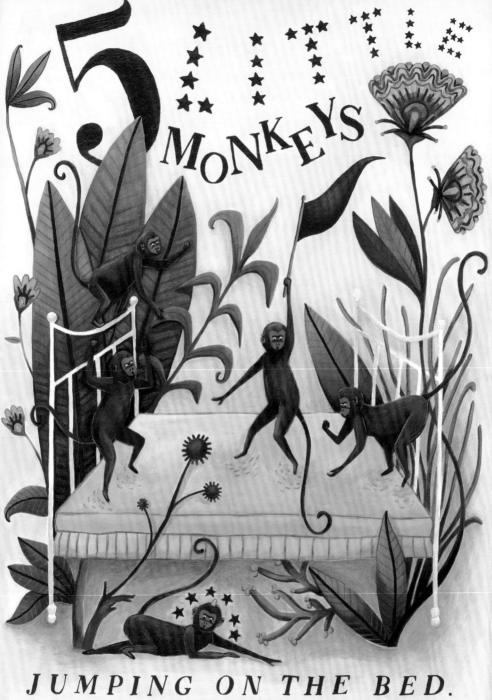

5 LITTLE MONKEYS

JUMPING ON THE BED.

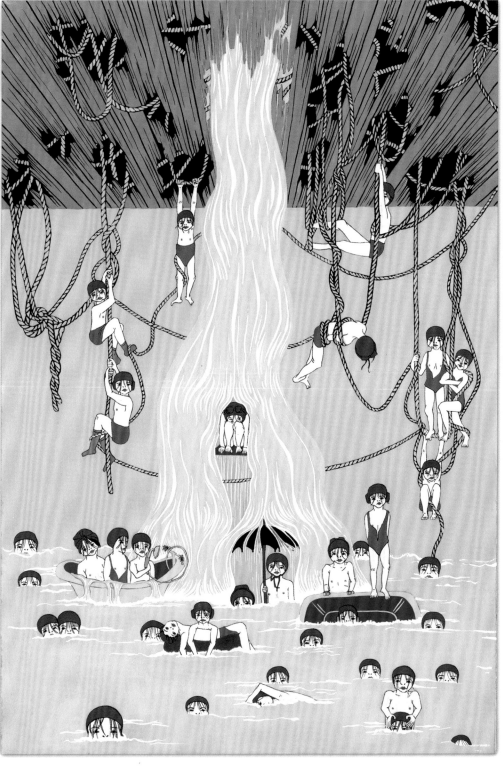

MERIT *Hyun Jung Ji*

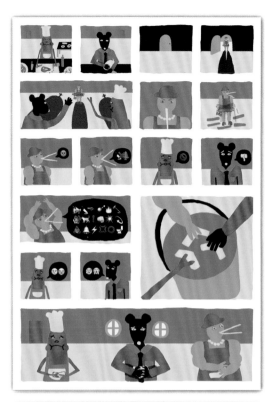
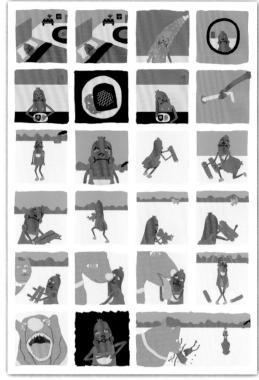
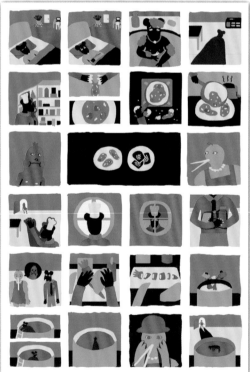

MERIT *Keiko Nabila Yamazaki*

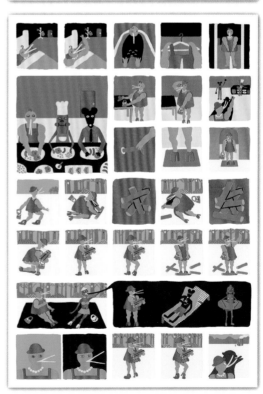

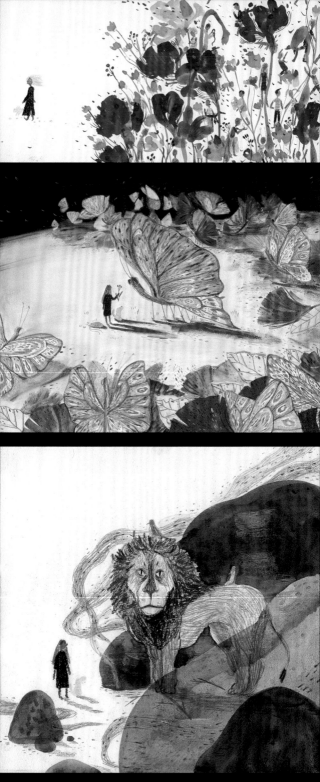

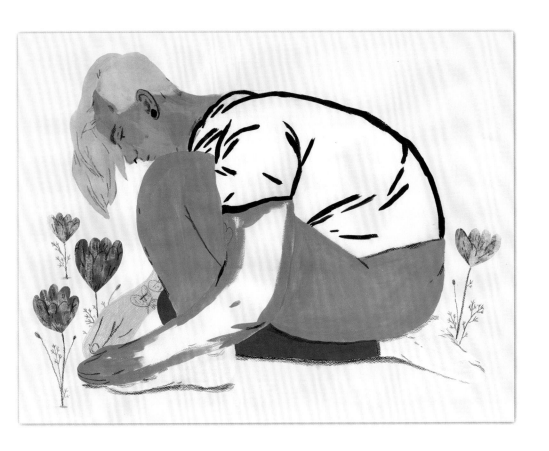

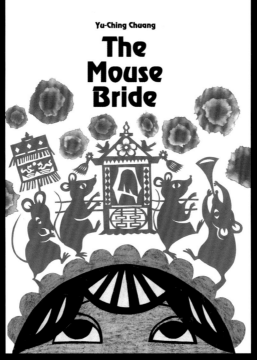

Yu-Ching Chuang

The Mouse Bride

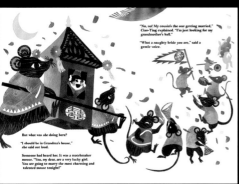

"No, no! My cousin's the one getting married," Ciao-Ting explained. "I'm just looking for my grandmother's ball."

"What a naughty bride you are," said a gentle voice.

But what was she doing here?

"I should be in Grandma's house," she said out loud.

Someone had heard her. It was a matchmaker mouse. "You, my dear, are a very lucky girl. You are going to marry the most charming and talented mouse tonight!"

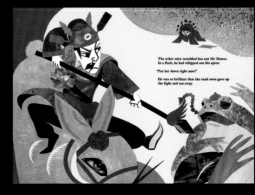

The other mice trembled but not Mr Mouse. In a flash, he had whipped out his spear.

"Put her down right now!"

He was so brilliant that the toad soon gave up the fight and ran away.

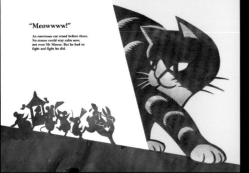

"Meowwww!"

As enormous cat stood before them. No mouse could stay calm now, not even Mr Mouse. But he had to fight and fight he did.

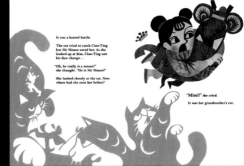

It was a hunted battle.

The cat tried to catch Ciao-Ting but Mr Mouse saved her. As she looked up at him, Ciao-Ting saw his face change...

"Oh, he really is a mouse!" she thought. "He is Mr Mouse!"

She looked closely at the cat. Now where had she seen her before?

"Mimi!" she cried.

It was her grandmother's cat.

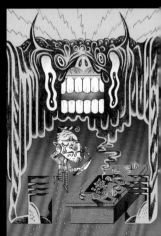

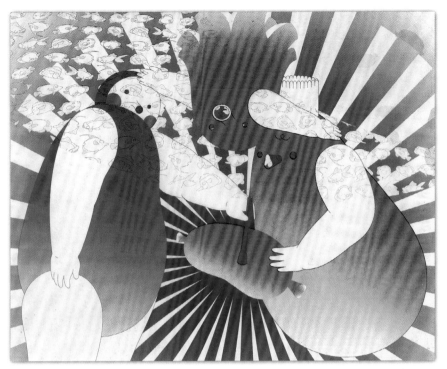

(L) MERIT *Kuri Huang* (R) MERIT *Qiaoyi Shi*

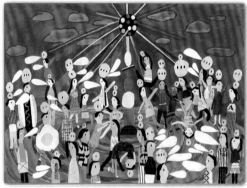

MERIT *Luyi Wang*

GOLD *Enzo Lo Re*

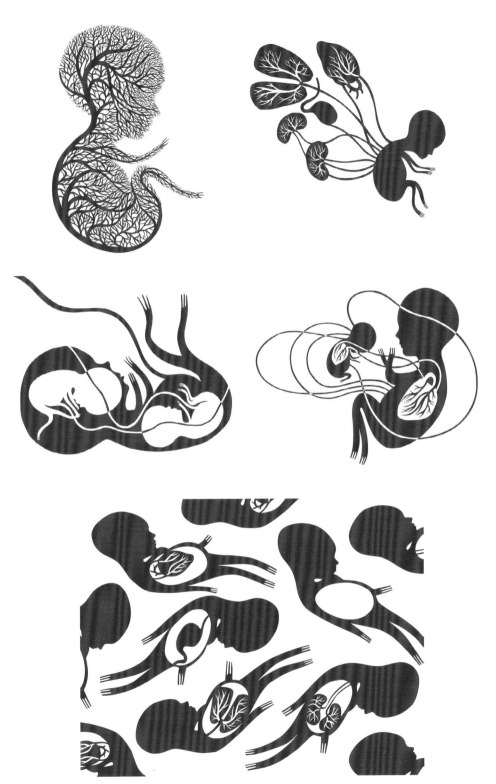

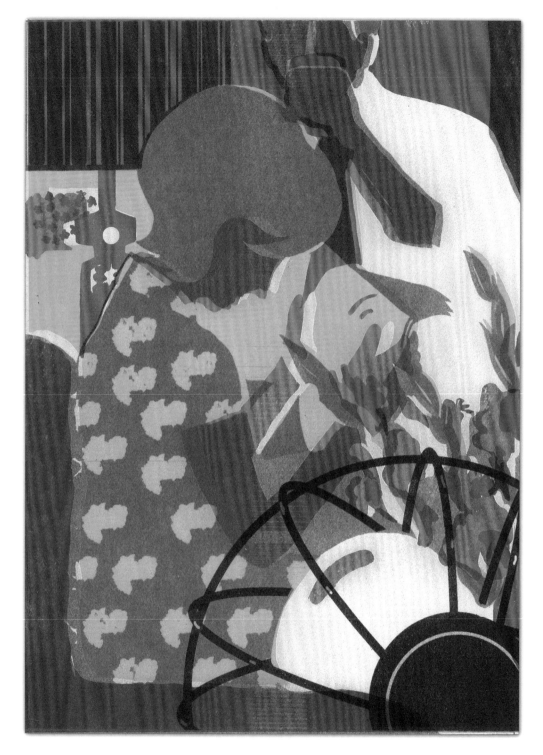

MERIT *Xiao Mei*

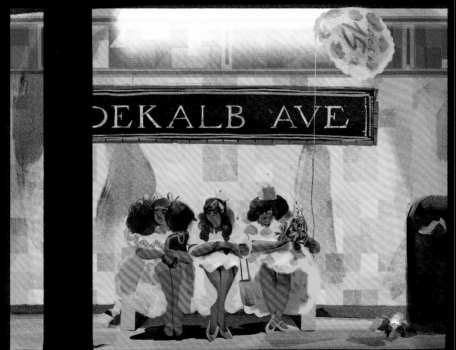

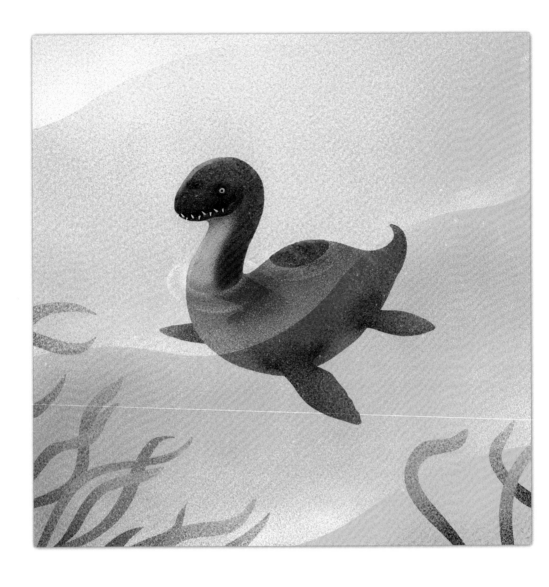

BEST OF SHOW *Chenfu Hsing*

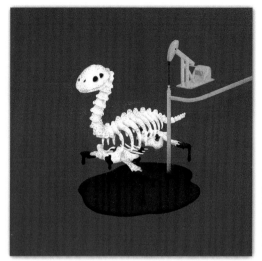
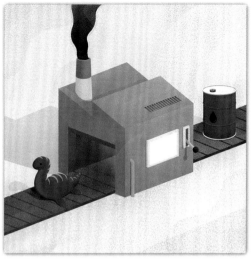

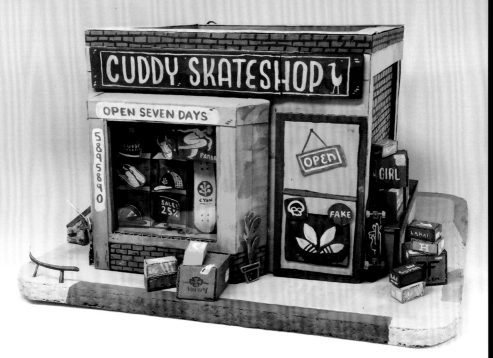

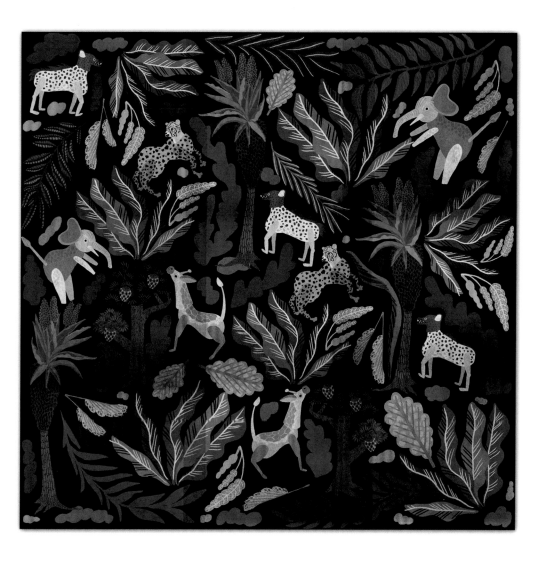

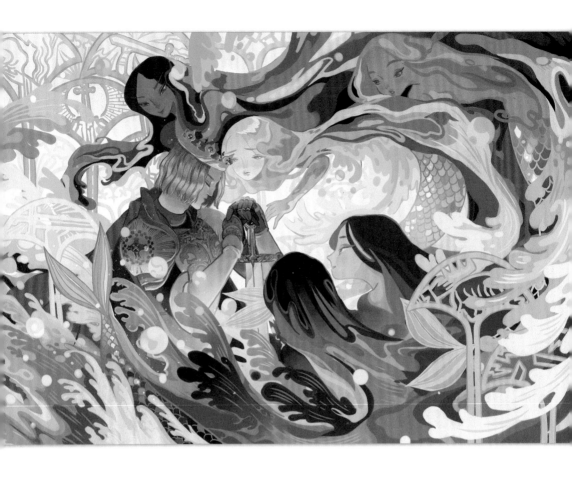

MERIT *Kuri Huang*

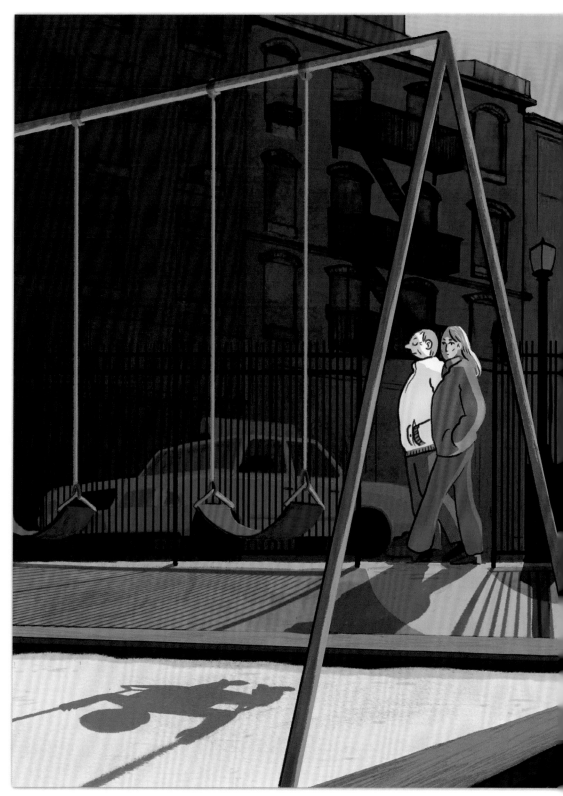

DISTINGUISHED MERIT *Adam de Souza*

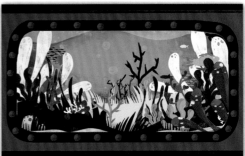

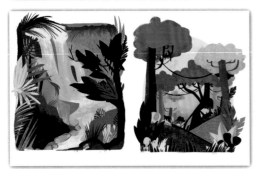

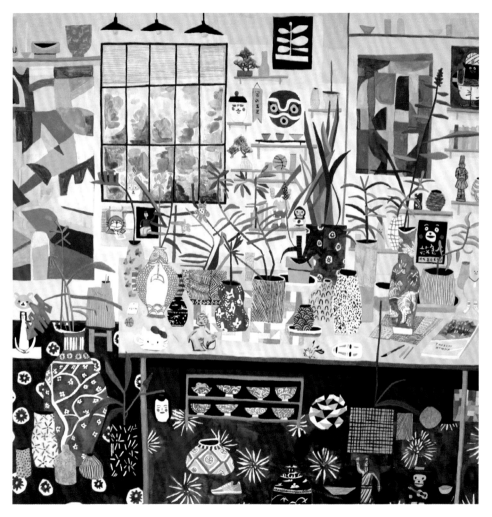

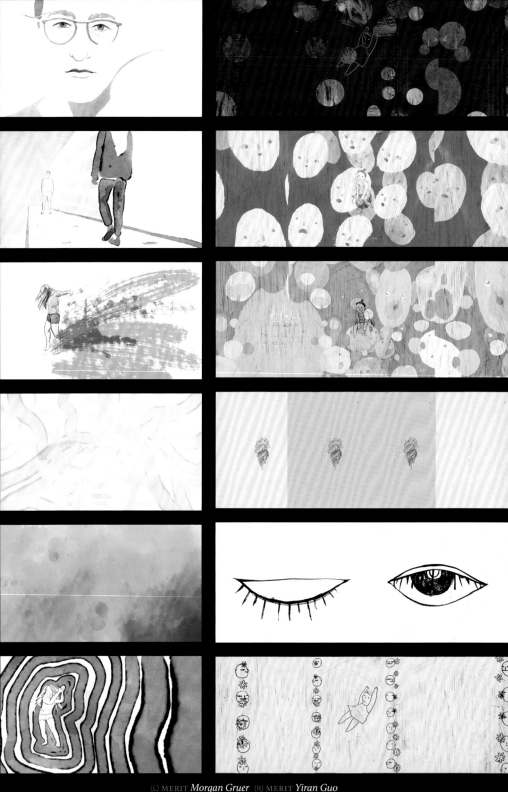

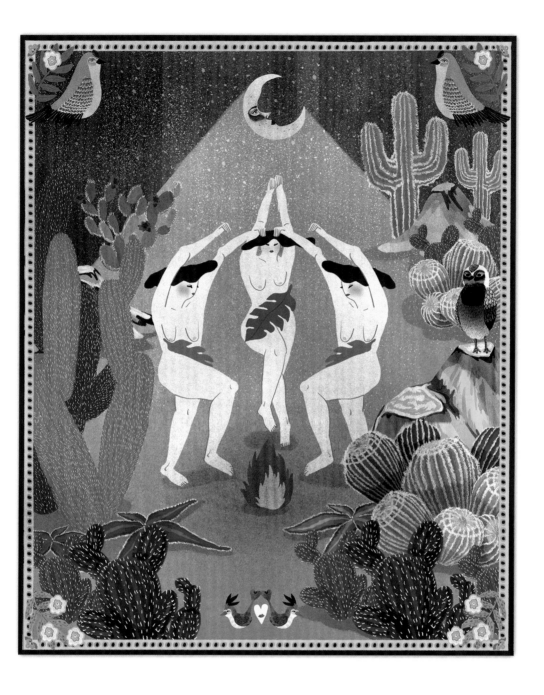

DISTINGUISHED MERIT *Eunjoo Lee*

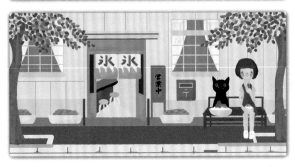

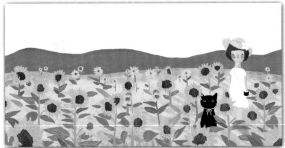

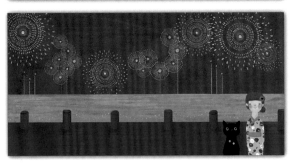

MERIT *Kun-Sen Chiang*

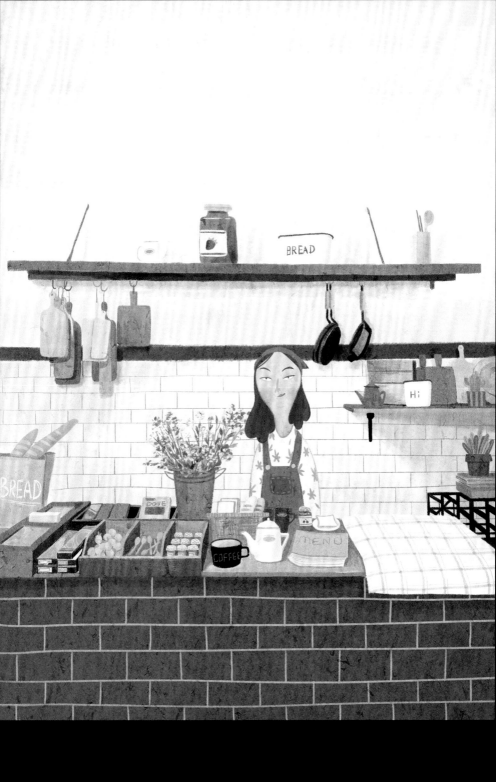

THE
AWAKENING
KATE CHOPIN

MERIT *Grace Heejung Kim*

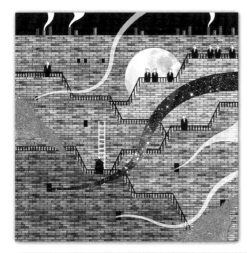
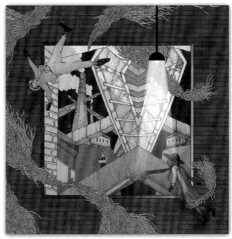
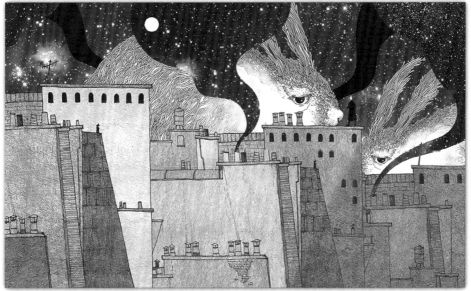
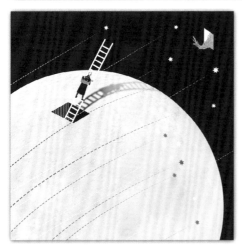
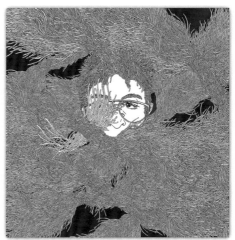

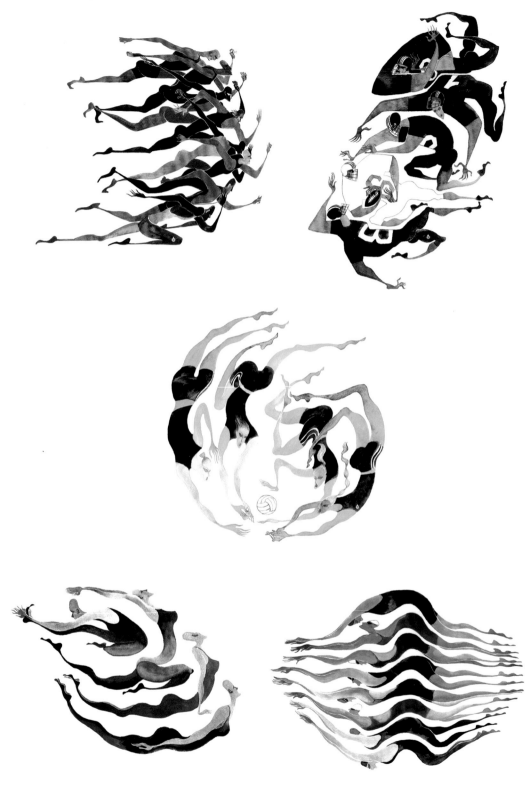

MERIT *Jianrong Lin*

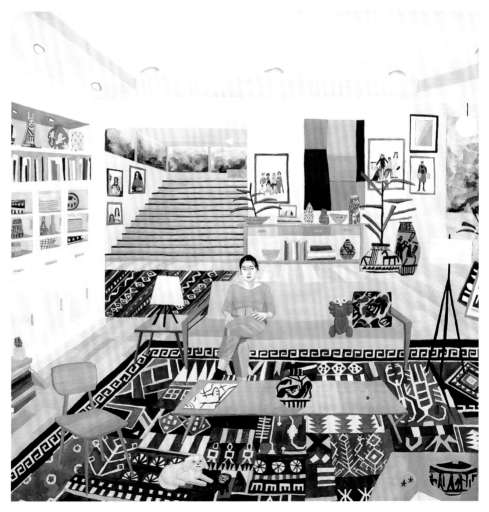

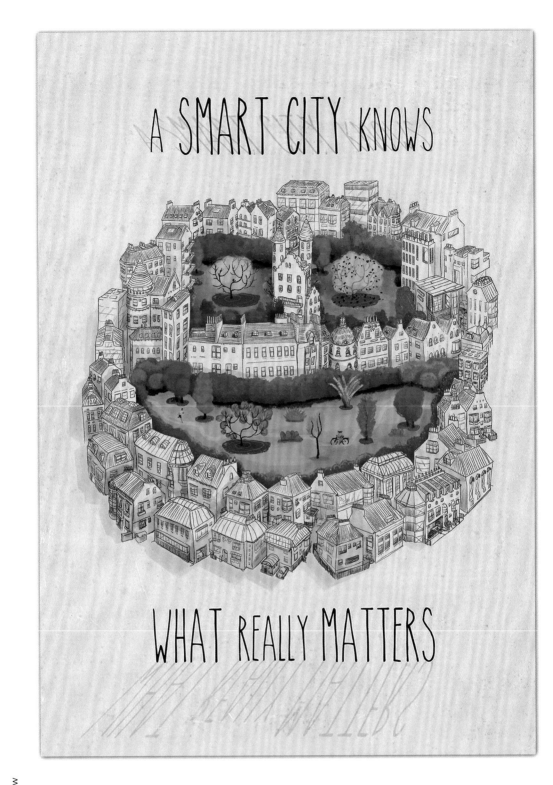

A SMART CITY KNOWS

WHAT REALLY MATTERS

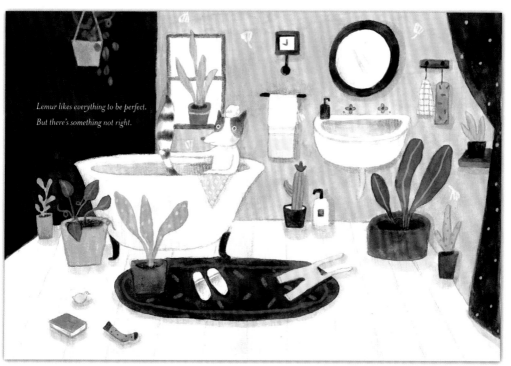

Lemur likes everything to be perfect.
But there's something not right.

Sometimes
I wish I was born with a better tail.
Look at these colorful,
fluffy and useful tails!

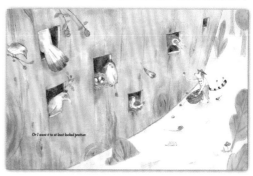

Or I want it to at least looked prettier.

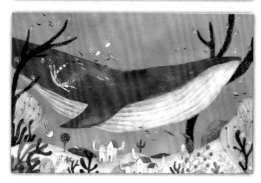

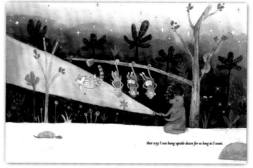

that way I can hang upside down for as long as I want.

MERIT *Mago Huang*

355

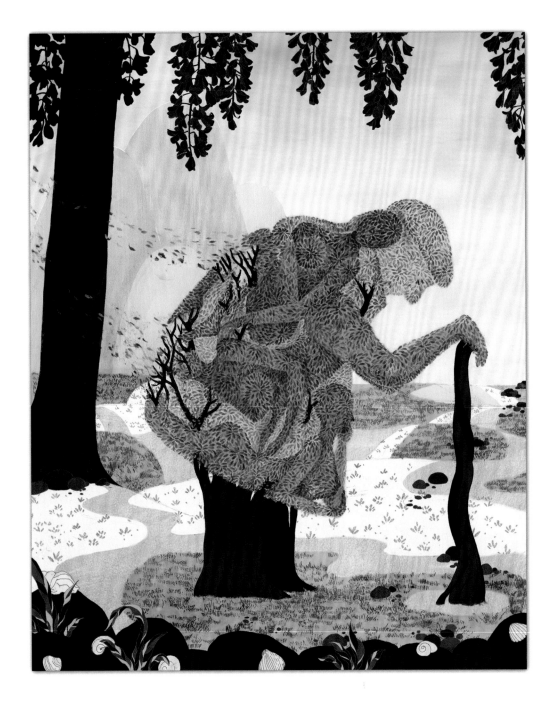

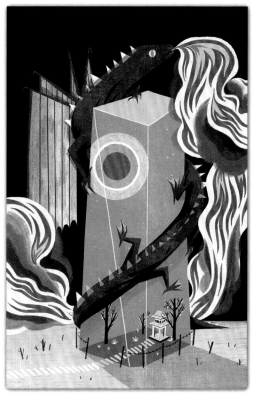
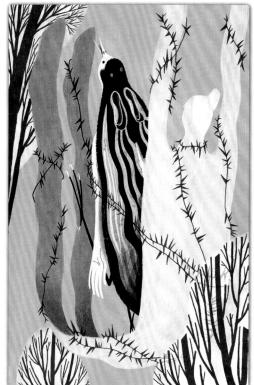
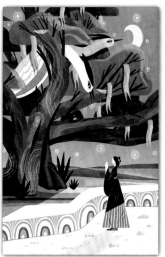
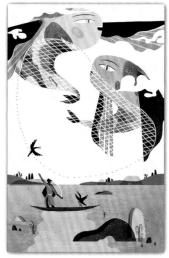
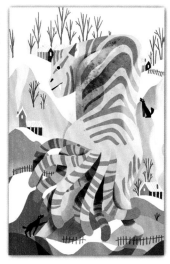

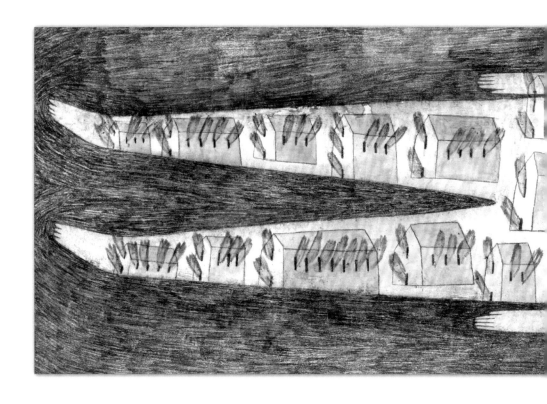

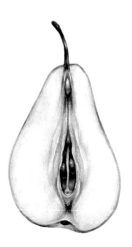 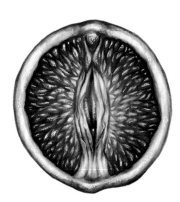

MERIT *Rodrigo Cordeiro*

361

1 Voitlang Prominent 50 mm (Voitlang Prominent 50 mm) 5a Voitlang Lens Unit front (Voitang Lens Unit, front)
2 Kodak Retina IIa (Kodak Retina II a) 5b Voitlang Lens Unit back (Voitang Lens Unit, back)
3 Pentax super F1 50 mm (Pentax super F1 50 mm) 6 Lens 18-50 mm (Lens 18 - 50 mm)
4 Case for Voitlang Lens (Case for Voitlang Lens Unit) 7 Sepia filter (Sepia Filter)

the
SEAMONSTER MONGER
GUILDHALL

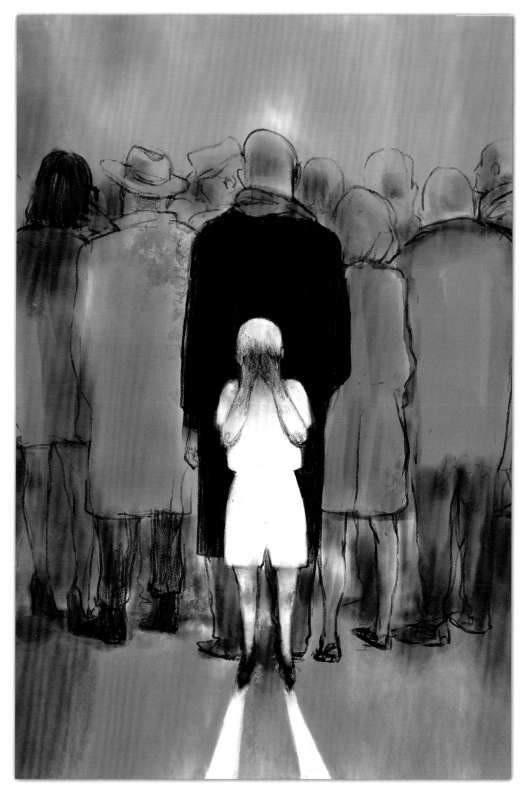

(L) MERIT *Wei-Ming Leong* (R) MERIT *May Ta*

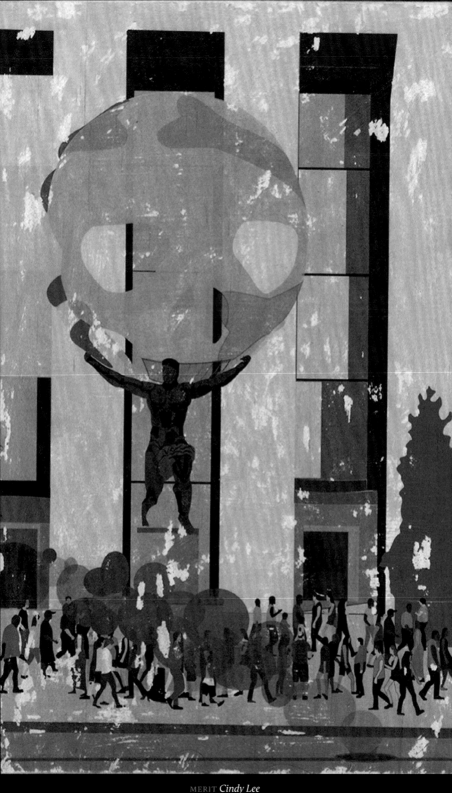

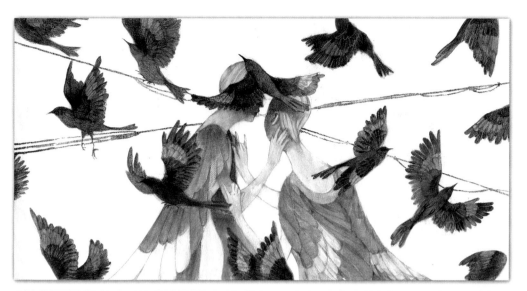

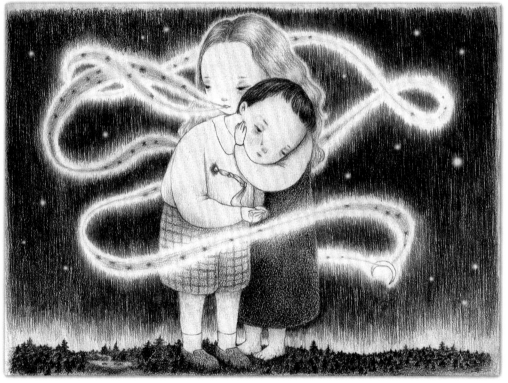

(T) MERIT *Ann Sheng* (B) MERIT *Pei-Hsin Cho*

367

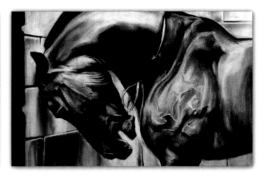

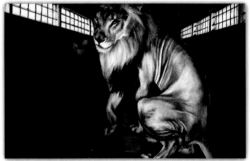

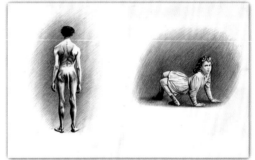

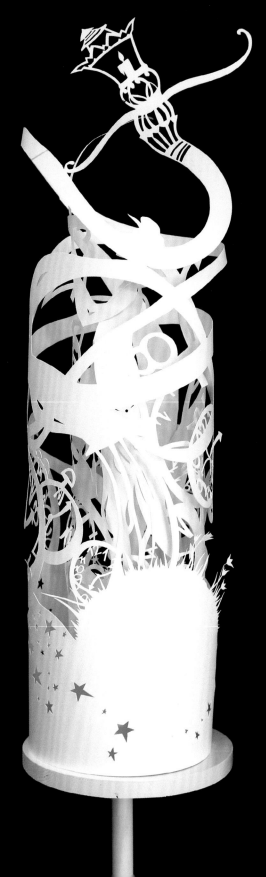

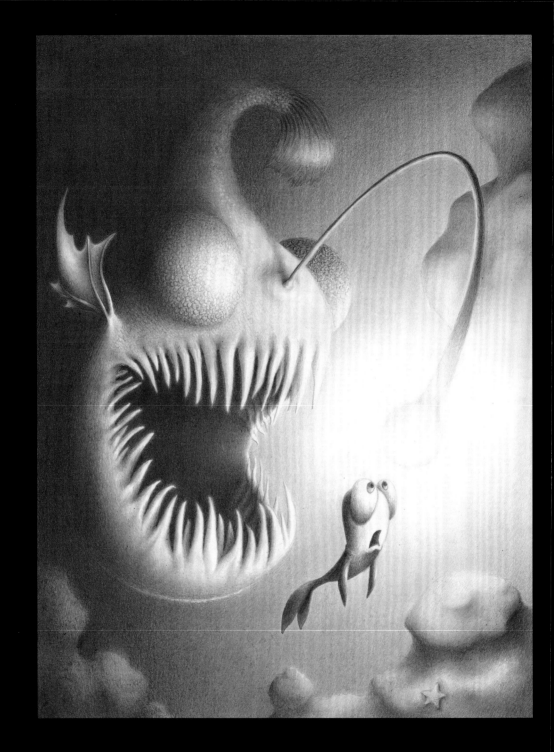

MERIT *Nick A. Erickson*

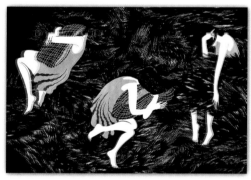
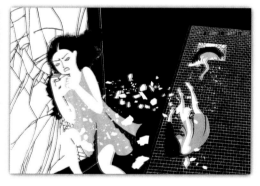

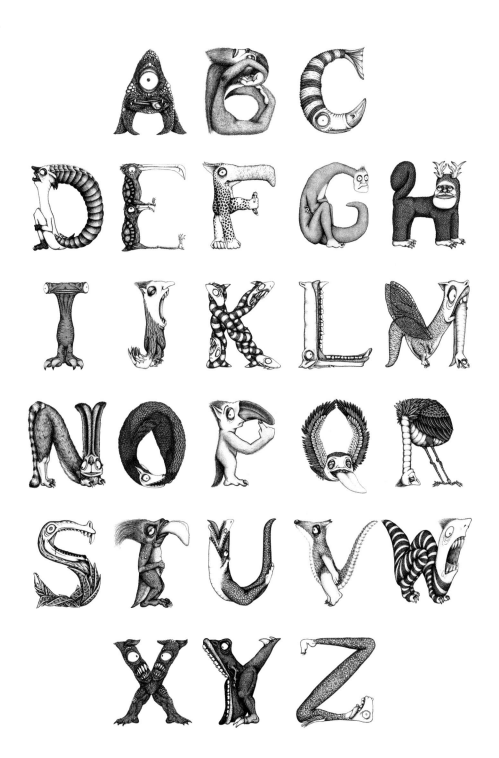

SILVER *Hannah Cunningham*

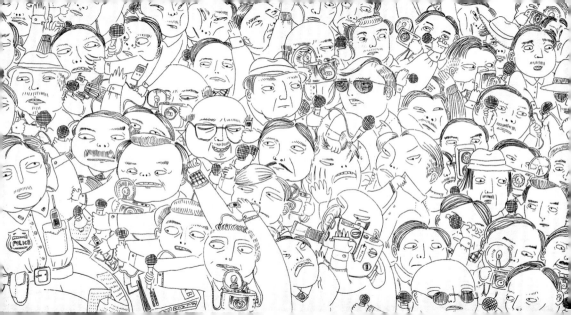

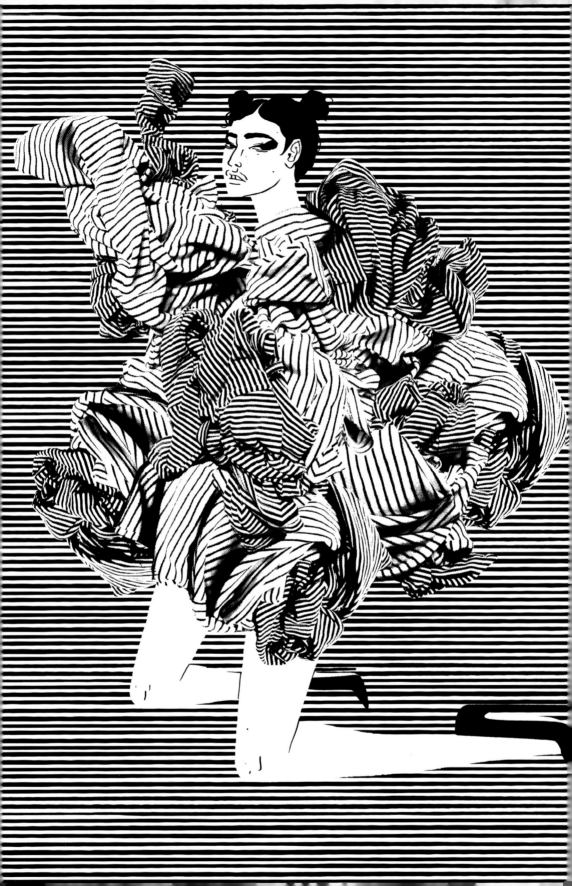

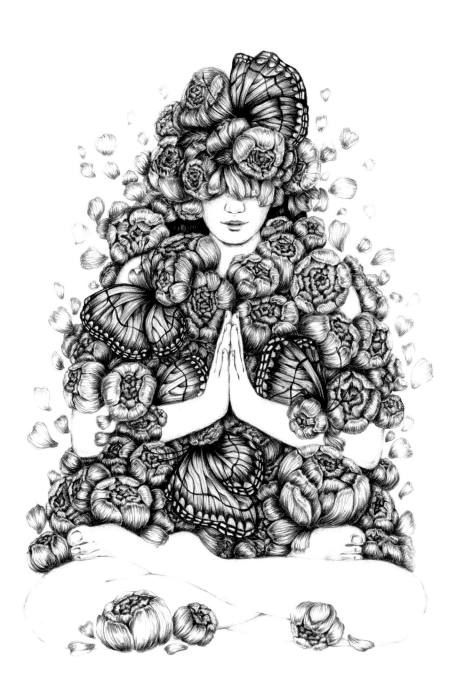

(L) DISTINGUISHED MERIT *Jasjyot Singh Hans* (R) MERIT *Dora Wang*

MERIT *Wenkai Mao*

378

and then there were none

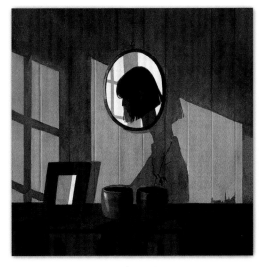

GOLD *Katherine Lam*

379

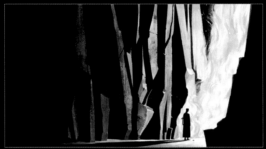

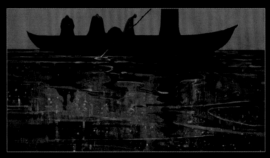

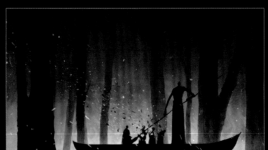

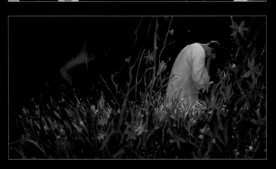

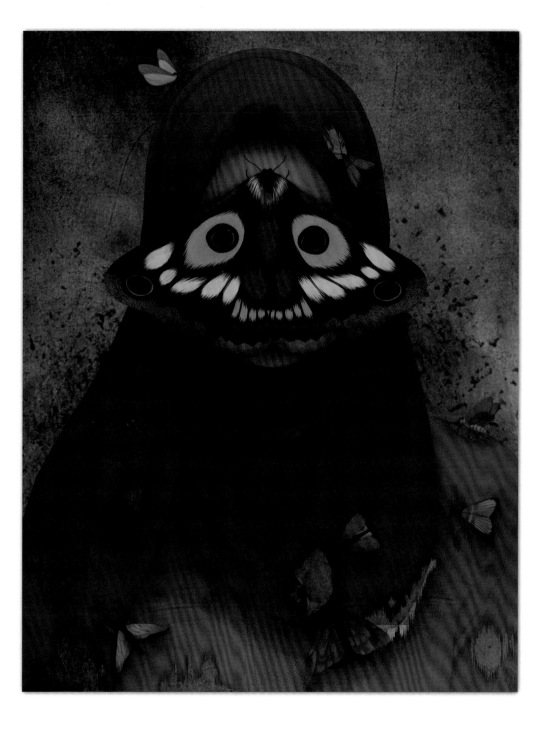

SPIRIT ANIMALS

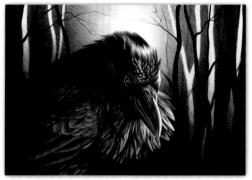

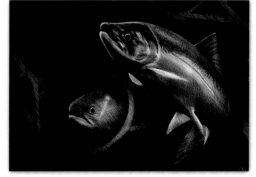

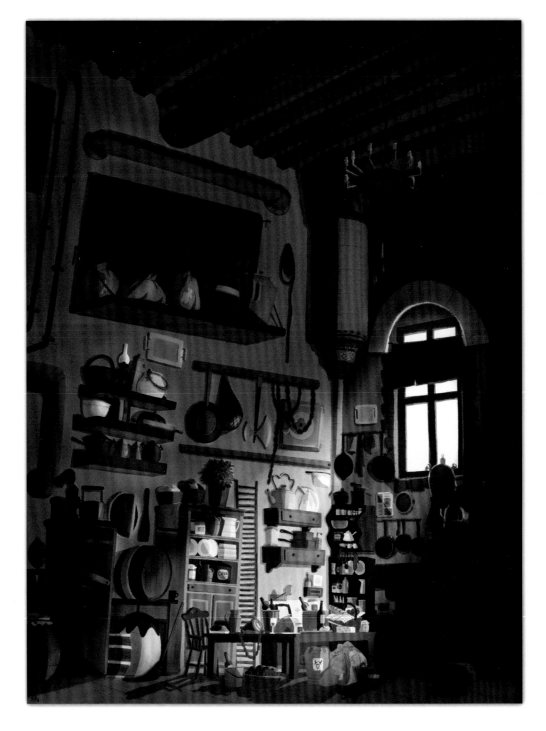

BRONZE *Sunny B. Yazdani*

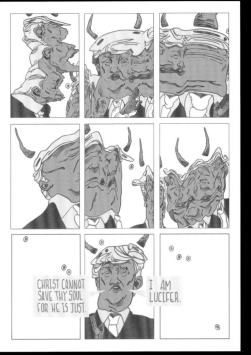

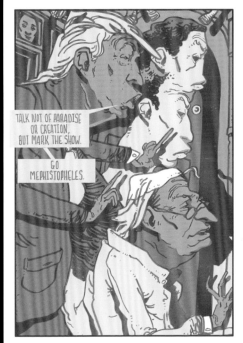

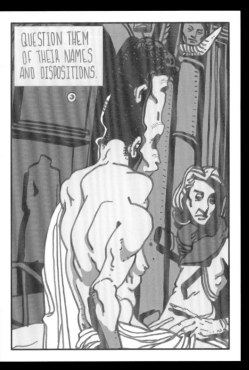

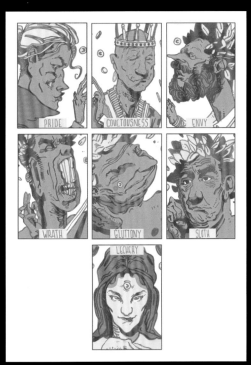

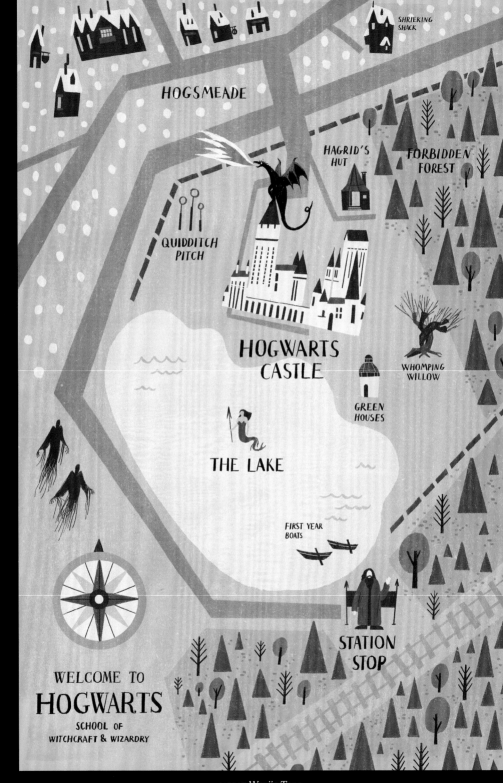

SHRIEKING
SHACK

HOGSMEADE

HAGRID'S
HUT

FORBIDDEN
FOREST

QUIDDITCH
PITCH

HOGWARTS
CASTLE

WHOMPING
WILLOW

GREEN
HOUSES

THE LAKE

FIRST YEAR
BOATS

STATION
STOP

WELCOME TO
HOGWARTS
SCHOOL OF
WITCHCRAFT & WIZARDRY

3X3 ANNUAL NO.14

388 INDEX

396 HONORABLE MENTIONS

400 COLOPHON

GARY AAGAARD
aagz@msn.com
www.garyaagaard.com
p 25 MERIT
DESIGN DIRECTOR: Michael Fenlason
CLIENT: Tubac Center of the Arts

YAEL ALBERT
contact@yaelalbert.com
www.yaelalbert.com
p 274 SILVER
ART DIRECTOR: Ada Vardi
PUBLISHER: Keter Publishing House

SONIA ALINS
sonia@soniaalins.com
www.soniaalins.com
p 154 MERIT

OFRA AMIT
ofraamit1@gmail.com
www.ofra-amit.com
p 272 GOLD
DESIGNER: Michal Magen
PUBLISHER: Hakibbutz Hameuchad
Publishers

LAURA ANASTASIO
hellothisislalala@gmail.com
www.thisislalala.com
p 34 MERIT
ART DIRECTOR: Vita Raykhman
CLIENT: Amika Styleblow Brooklyn

SCOTT ANDERSON
scott@scottandersonstudio.com
www.scottandersonstudio.com
p 113 MERIT
ART DIRECTOR: Darrick Rainey
CLIENT: LA Weekly

SCOTT BAKAL
info@scottbakal.com
www.scottbakal.com
p 163 MERIT
GALLERY: Helikon Gallery
p 186 MERIT
CLIENT: Society of Illustrators of Los
Angeles

**ANNA AND ELENA BALBUSSO
TWINS**
balbusso.twins@gmail.com
www.balbusso.com
p 278 MERIT
ART DIRECTOR: Rita Marshall
PUBLISHER: Creative Editions, Creative
Company

ALLISON BAMCAT
allison.bamcat@gmail.com
www.bamcatart.com
p 221 MERIT
ART DIRECTOR: Matthew Sleep
DESIGN DIRECTOR: Darren Johnson
DESIGNER: Allison "Bamcat" Frederiksen
DESIGN FIRM: Converse Art Department
CLIENT: Converse Inc.

MELINDA BECK
studio@melindabeck.com
www.melindabeck.com
p 62 MERIT
DESIGN DIRECTOR: David Plunkert
CLIENT: Directory of Illustration
p 82 MERIT
ART DIRECTOR: Audrey Razgaitis
p 110 MERIT
ART DIRECTOR: Catherine Gilmore-
Barnes
CLIENT: The New York Times
p 144 MERIT
ART DIRECTOR: Bambi Nicklen
CLIENT: Stanford Magazine
p 182 BRONZE
DESIGN DIRECTOR: Charles Hively
DESIGN FIRM: HivelyDesigns

CLIENT: 3x3, The Magazine of
Contemporary Illustration

BECKY M
remiberi@gmail.com
www.becky-m.com
p 373 BRONZE
INSTITUTION: University of Applied
Sciences and Arts, Hanover

MARY JANE BEGIN
mjbegin@cox.net
www.new.maryjanebegin.com
p 296 MERIT

DAN BEJAR
dabejar@gmail.com
www.bejarprints.com
p 139 MERIT
ART DIRECTOR: Mark Gabrenya
CLIENT: Northeastern Law

ROBERTA BEREZOSCHI
robertaberezoschi@gmail.com
www.behance.net/robertaberezoschi
p 370 MERIT
INSTITUTION: Faculty of Arts and
Design, Timisoara
INSTRUCTOR: Vica Tila-Adorian

ORIT BERGMAN
orit.bergman@gmail.com
www.oritbergman.com
p 262 MERIT
ART DIRECTOR: Naama Tobias
PUBLISHER: PJ Library
IMPRINT: Mizrachi Media

KATARZYNA BOGDAŃSKA
bogdanska.kasia@gmail.com
www.katarzynabogdanska.blogspot.com
p 128 MERIT
ART DIRECTOR: Anna Dyakowska
CLIENT: Wysokie Obcasy Magazine
p 218 GOLD
CLIENT: Hopsa

SKYE BOLLUYT
skye@skyebolluyt.com
www.skyebolluyt.com
p 200 MERIT

DAVIDE BONAZZI
info@davidebonazzi.com
www.davidebonazzi.com
p 63 MERIT
CLIENT: Sharitaly
p 96 MERIT
p 168 MERIT
p 169 MERIT
AD AGENCY: Rosso Amaranto
CLIENT: Enoitalia

JENS BONNKE
jb@jensbonnke.de
www.jensbonnke.com
p 117 MERIT
ART DIRECTOR: Torsten Laaker
CLIENT: GEO Magazine

RICHARD BORGE
contact@richardborge.com
www.richardborge.com
p 104 MERIT
ART DIRECTOR: Kerstin Diehn
CLIENT: The Progressive
p 171 MERIT
DESIGN DIRECTOR: Warren Haynes
CLIENT: Govt. Mule

JOANA ROSA BRAGANÇA
joanarosa.b@gmail.com
www.joanarosab.com
p 57 MERIT
CLIENT: Beija-Flor

DIETER BRAUN
dieter@brauntown.com
www.dieterbrauntown.com
p 161 MERIT
GALLERY: Juniqe

NIGEL BUCHANAN
nigel@nigelbuchanan.com
www.nigelbuchanan.com
p 75 MERIT
ART DIRECTOR: Robert Priest
DESIGN DIRECTOR: Grace Lee
DESIGN FIRM: Priest + Grace
p 135 MERIT
ART DIRECTOR: Kate Elazegui
CLIENT: ESPN
p 137 MERIT
DESIGN DIRECTOR: Matt Cooley
CLIENT: Rolling Stone

JILL CALDER
jill@jillcalder.com
www.jillcalder.com
p 87 MERIT
ART DIRECTOR: Sarah Habershon
CLIENT: The Guardian

NAN CAO
nancaoart@gmail.com
www.nancaoart.com
p 206 MERIT

SIYU CAO
siyu.cao.design@gmail.com
www.siyucao.com
p 223 BRONZE

MARIA CARLUCCIO
mariacarluccio@verizon.net
www.mariacarluccio.com
p 293 MERIT

ANDRÉ CARRILHO
mail@andrecarrilho.com
www.andrecarrilho.com
p 97 MERIT
ART DIRECTOR: Steven Banks
CLIENT: Los Angeles Magazine
p 108 MERIT
ART DIRECTOR: Pedro Fernandes
CLIENT: Diário de Notícias
p 143 MERIT
ART DIRECTOR: Pedro Fernandes
CLIENT: Diário de Notícias
p 148 MERIT
ART DIRECTOR: Pedro Fernandes
CLIENT: Diário de Notícias

ALBERTO CASTILLO
castillo.alberto@hotmail.com
www.castilloalberto.com
p 362 BRONZE
INSTITUTION: California State
University, Fullerton

ANGEL CHANG
angelchangart@gmail.com
www.angelchangart.com
p 208 MERIT

JANICE CHANG
janicechangart@gmail.com
www.janicechangart.com
p 310 SILVER
INSTITUTION: Art Center College of
Design
INSTRUCTOR: Adam Ross

PEI-YU CHANG
info@peiyuchang.de
www.peiyuchang.de
p 264 SILVER
DESIGNER: Pei-Yu Chang
PUBLISHER: NordSüd Verlag

ESZTER CHEN
eszterchenart@gmail.com
www.eszterchen.com
p 22 MERIT
DESIGN FIRM: TBWA / Media Arts Lab
AD AGENCY: TBWA
CLIENT: Apple Inc

JORO CHEN
joro.tw@gmail.com
www.joro.tv
p 45 MERIT
DESIGNER: Joro Chen

LIDAN CHEN
lichendan.illustration@gmail.com
www.lichendan.com
p 313 MERIT
INSTITUTION: Savannah College of Art
and Design

YING-HSIU CHEN
behumanstudio@gmail.com
www.behuman.design
p 180 MERIT
DESIGNERS: Ying-Hsiu Chen, Hsiang-
Ying Chen
DESIGN FIRM: Be Human Design

MARIANNE CHEVALIER
info@mariannechevalier.com
www.mariannechevalier.com
p 157 MERIT

KUN-SEN CHIANG
mori7852@gmail.com
www.behance.net/mrmori
p 348 MERIT
INSTITUTION: National Chiao Tung
University
INSTRUCTORS: Wen-Shu Lai, Chu-li
Chen, Wen-Ting Hsu

PEI-HSIN CHO
peihsincho@gmail.com
www.behance.net/peihsincho
p 367 MERIT
INSTITUTION: Taipei National
University of the Arts
INSTRUCTOR: Chi-Sui Wang

RYAN CHO
info@ryanchoart.com
www.ryanchoart.com
p 340 MERIT
INSTITUTION: Art Center College of
Design
p 369 BRONZE
INSTITUTION: Art Center College of
Design

YU-CHING CHUANG
as30228@yahoo.com.tw
www.annysartwork.weebly.com
p 328 DISTINGUISHED MERIT
INSTITUTION: Anglia Ruskin University,
Cambridge School of Art
INSTRUCTOR: Martin Salisbury

JENNA NAHYUN CHUNG
nchung01@alumni.risd.edu
jennahyunchung.myportfolio.com
p 312 MERIT
INSTITUTION: Rhode Island School of
Design

JULIEN CHUNG
julienchung@hotmail.com
www.julienchung.com
p 284 MERIT
PUBLISHER: Auzou Canada
p 285 MERIT
PUBLISHER: Auzou Canada
p 291 MERIT
p 292 MERIT

LIVIA CIVES
livciv@gmail.com
www.liviacives.com
p 203 MERIT

JIM COHEN
jim@jimcohenillustration.com
www.jimcohenillustration.com
p 65 MERIT
ART DIRECTOR: Jim Cohen
p 189 MERIT
ART DIRECTOR: Jim Cohen

ALLISON COLE
allison@allisoncoleillustration.com
www.allisoncoleillustration.com
p 219 MERIT

JOÃO CONCHA
conchajoao@gmail.com
www.behance.net/joao_concha
p 281 GOLD
DESIGNER: Zoom
PUBLISHER: Não (edições)

SANDRA CONEJEROS FUENTES
sandra.conejeros@gmail.com
www.sandraconejeros.com
p 129 MERIT
CLIENT: Caras Tema Chile Magazine

RODRIGO CORDEIRO
contact.rodrigocordeiro@gmail.com
www.rodrigocordeiro.net
p 361 MERIT
INSTITUTION: Savannah College of Art
and Design

INÊS COSTA
inescosta.illustration@gmail.com
inescostaillustration.tumblr.com
p 183 MERIT

CAMERON COTTRILL
camcottrill@gmail.com
www.camcottrill.com
p 149 MERIT
DESIGN DIRECTOR: Paul Alexander
CLIENT: Tampa Bay Times

MIRKO CRESTA
mirkocresta@gmail.com
www.mirkocresta.com
p 54 MERIT
AUTHOR: Dmitrij Gawrisch

HANNAH CUNNINGHAM
hannah@oddjobart.com
www.oddjobart.com
p 374 SILVER
INSTITUTION: Savannah College of Art
and Design

PAOLO D'ALTAN
info@daltan.com
www.daltan.com
p 302 SILVER
ART DIRECTOR: Laura Rota
DESIGN FIRM: Studio Rebelot
PUBLISHER: Giunti Junior

GIOVANNI DA RE
info@giovannidare.com
www.giovannidare.com
p 127 MERIT
ART DIRECTOR: Bettina Theuerkauf
CLIENT: Die Zeit
p 146 MERIT
CLIENT: NovantaNove
p 259 MERIT
ART DIRECTOR: Marco Mercatali
PUBLISHER: LaSpiga Edizioni

OWEN DAVEY
info@folioart.co.uk
www.folioart.co.uk/owen-davey
p 173 DISTINGUISHED MERIT

ART DIRECTOR: Megan McCarthy
DESIGN FIRM: Hatch Design
CLIENT: SmashMallow
p 273 GOLD
ART DIRECTOR: Sam Arthur
PUBLISHER: Nobrow
IMPRINT: Flying Eye Books

ALESSANDRA DE CRISTOFARO
decristofaro.ale@gmail.com
www.alessandradecristofaro.com
p 217 MERIT
CLIENT: Toast Zine

ADAM DE SOUZA
kumerish@gmail.com
www.kumerish.com
p 343 DISTINGUISHED MERIT
INSTITUTION: OCAD University
INSTRUCTOR: Lauchie Reid

MAI LY DEGNAN
mailyillustration@gmail.com
www.mailydegnan.com
p 236 MERIT
p 245 MERIT

ALICE YU DENG
aliceyudeng@gmail.com
www.alicedy.com
p 308 MERIT
INSTITUTION: Maryland Institute
College of Art
INSTRUCTOR: Rebecca Bradley

SANDRA DIONISI
sandra@sandradionisi.com
www.sandradionisi.com
p 246 MERIT
ART DIRECTOR: Sandra Dionisi

SEAN DOCKERY
seandockery1@gmail.com
www.seandock.com
p 28 MERIT
ART DIRECTOR: John Ferguson
AD AGENCY: Adcom Group
CLIENT: Ridgid

PATRICK DOYON
doiion@hotmail.com
www.doiion.com
p 43 SILVER
ART DIRECTOR: Jeff Hamada
DESIGNER: Patrick Doyon
CLIENT: Red Bull Music Academy
ANIMATOR: Patrick Doyon

YUKAI DU
yukaidu.doralice@gmail.com
www.yukaidu.com
p 44 DISTINGUISHED MERIT
DESIGN DIRECTOR: Yukai Du
CLIENT: TED-Ed

JOHN S. DYKES
john@jsdykes.com
www.jsdykes.com
p 36 MERIT
ART DIRECTOR: Rachel Stevens
AD AGENCY: Mercury
CLIENT: First Interstate Bank

LEON EDLER
hello@leillo.com
www.leillo.com
p 112 DISTINGUISHED MERIT
ART DIRECTOR: Tom Hislop
CLIENT: Time Out New York
p 145 MERIT
ART DIRECTOR: Sara Ramsbottom
DESIGN DIRECTOR: Chris Clarke
CLIENT: The Guardian

MINA ELISE
minaelise@yahoo.com
www.minaelise.com

p 358 MERIT
INSTITUTION: University of Hartford

ELLAKOOKOO
ellakookoo@gmail.com
www.ellakookoo.com
p 172 DISTINGUISHED MERIT
ART DIRECTOR: Katherine Wong
CLIENT: Viction:ary
p 229 MERIT
ART DIRECTOR: Emily Mohr
DESIGN FIRM: BBDO

PETE ELLIS
pete@drawgood.com
www.drawgood.com
p 24 MERIT
DESIGN DIRECTOR: Dean Gomilsek-Cole
CLIENT: Turnbull & Asser

NICK A. ERICKSON
www.nickaerickson.com
p 372 MERIT
INSTITUTION: Savannah College of Art
and Design

FABULO
fabulo.illustratore@gmail.com
www.fabuloworld.tumblr.com
p 181 MERIT
CLIENT: Sharitaly

MAIA FADDOUL
faddoulmaia@gmail.com
www.maiafaddoul.com
p 344 BRONZE
INSTITUTION: Université du Québec à
Montréal
INSTRUCTOR: Michelle Champagne

LOGAN FAERBER
loganfaerber@gmail.com
www.loganfaerberdesign.com
p 67 DISTINGUISHED MERIT
PUBLISHER: Albatross Funny Books
p 179 MERIT
CLIENT: Riverside Municipal
Auditorium

AARON FERNANDEZ
aarontheillustrator@gmail.com
www.aarontheillustrator.com
p 79 MERIT
ART DIRECTORS: Fabian Greve, Cyrill
Kuhlmann
CLIENT: Neon Magazine

CHRIS FERRANTELLO
chris@chrisferrantello.com
www.chrisferrantello.com
p 142 MERIT
ART DIRECTOR: Patrick JB Flynn
CLIENT: The Baffler

TOM FROESE
hello@tomfroese.com
www.tomfroese.com
p 33 MERIT
ART DIRECTORS: Mitch & Dylan
Ballentine
DESIGN FIRM: Ballentine Media
AD AGENCY: 123W
CLIENT: Stong's Market

NORBERT FUCKERER
illustration@norbertfuckerer.de
www.norbertfuckerer.com
p 185 MERIT

RYAN GARCIA
bmb.ryangarcia@gmail.com
www.torontoillustrator.com
p 107 BRONZE
DESIGN DIRECTOR: Miroslav Tomoski
CLIENT: The Plaid Zebra

ALIYA GHARE
aliyaghare@gmail.com
www.aliyaghare.com
p 381 MERIT
INSTITUTION: OCAD University
INSTRUCTOR: Dushan Milic

BEPPE GIACOBBE
bgiacobbe@me.com
www.beppegiacobbe.com
p 87 MERIT
ART DIRECTOR: Piero Ratto
CLIENT: La Lettura, Corriere della Sera
p 134 MERIT
ART DIRECTOR: Mary Lees
CLIENT: Wired UK
p 147 MERIT
ART DIRECTOR: Alessandro Cannavò
CLIENT: Corriere della Sera

JAMES GILLEARD
info@folioart.co.uk
www.folioart.co.uk/james-gilleard
p 138 MERIT
ART DIRECTOR: Nick Ditmore
CLIENT: Foreign Affairs Magazine
p 201 SILVER

IGOR GNEDO
igor@igorgnedo.com
www.igorgnedo.com
p 202 MERIT

ABIGAIL GOH
abigaitor@gmail.com
www.abigoh.com
p 195 MERIT

ESTHER GOH
hello@esthergoh.co
www.esthergoh.co
p 32 DISTINGUISHED MERIT
ART DIRECTOR: Esther Goh
CLIENT: National Arts Council,
Singapore

AAD GOUDAPPEL
aad@aadgoudappel.com
www.aadgoudappel.com
p 152 MERIT
ART DIRECTOR: Chris Logan
DESIGN FIRM: Touch
CLIENT: Majedie

CHRISTIAN GRALINGEN
studio@gralingen.de
www.gralingen.de
p 94 MERIT
ART DIRECTOR: Max Nelles
CLIENT: Lufthansa Magazine

TYLER GROSS
tyler@grossillustration.com
www.grossillustration.com
p 196 MERIT

MORGAN GRUER
morgangruer@gmail.com
www.morgangruer.com
p 346 MERIT
INSTITUTION: Pratt Institute
INSTRUCTOR: Kelly Denato
ANIMATOR: Morgan Gruer

JOEY GUIDONE
hello@joeyguidone.com
www.joeyguidone.com
p 49 MERIT
ART DIRECTOR: Yajaira St. Fleurant
PUBLISHER: Frances-Lincoln
p 116 MERIT
ART DIRECTOR: Pamela Li
CLIENT: Johns Hopkins Health Review

YIRAN GUO
yguoeva@gmail.com
www.yiranguoart.com

p 346 MERIT
INSTITUTION: Maryland Institute
College of Art
INSTRUCTOR: Whitney Sherman
ANIMATOR: Yiran Guo

SHREYA GUPTA
shreya@shreyaillustrations.com
www.shreyaillustrations.com
p 356 MERIT
INSTITUTION: School of Visual Arts
INSTRUCTORS: Lisel Jane Ashlock, David
Sandlin

ELIZABETH HAIDLE
elizabeth.ireland@catapult.co
www.ehaidle.com
p 167 MERIT
PUBLISHER: Catapult
IMPRINT: Black Balloon

OLAF HAJEK
mail@olafhajek.com
www.olafhajek.com
p 159 MERIT
GALLERY: Whatiftheworld Gallery, Cape
Town, South Africa
p 199 MERIT
DESIGN DIRECTOR: Olaf Hajek

SALLY SOWEOL HAN
info@sallyhanillustration.com
www.sallyhanillustration.com
p 288 GOLD

JASJYOT SINGH HANS
jasjyotsinghhans@gmail.com
www.jasjyotsinghhans.tumblr.com
p 376 DISTINGUISHED MERIT
INSTITUTION: Maryland Institute
College of Art

ERON HARE
eron@eronhare.com
www.eronhare.com
p 237 MERIT

CHRISTOPHER HARPER
charper@deletedmanual.com
www.deletedmanual.com
p 205 MERIT

TAKAHISA HASHIMOTO
contact@takahisahashimoto.com
www.takahisahashimoto.com
p 212 MERIT

KELLEN HATANAKA
kellen.hatanaka@gmail.com
www.kellenhatanaka.com
p 31 MERIT
ART DIRECTOR: Kellen Hatanaka
CLIENT: Cask Days Beer Festival

CHI HE
beenery@hotmail.com
www.chihe.co.uk
p 283 DISTINGUISHED MERIT
ART DIRECTOR: Cathy Olmedillas
AD AGENCY: Anorak Magazine
PUBLISHER: Studio Anorak

HEATHER HECKEL
heather.heckel@gmail.com
www.heatherheckel.com
p 207 MERIT

CALEB HEISEY
heiseycb@gmail.com
www.goodbonesstudio.com
p 175 MERIT
DESIGNER: Caleb Heisey
DESIGN FIRM: Good Bones Studio
CLIENT: Tony's Farm Table

LARS HENKEL
lars@reflektorium.de
www.larshenkel.com
p 38 MERIT

JEF HINCHEE
jahinchee@gmail.com
www.jeffhinchee.com
p 299 MERIT
DESIGNER: Ray Shappell

MARK HOFFMANN
mh@studiohoffmann.com
www.studiohoffmann.com
p 275 MERIT
ART DIRECTOR: Teresa Bubela
DESIGNER: Jenn Playford
PUBLISHER: Orca Book Publishers
p 289 MERIT

FRANK HOPPMANN
email@frankhoppmann.de
www.behance.net/hoppmann
p 150 MERIT
ART DIRECTOR: Frank Hoppmann
CLIENT: Los Angeles Times

ØIVIND HOVLAND
oivind@oivindhovland.com
www.oivindhovland.com
p 30 MERIT
DESIGN DIRECTOR: Janne Nerheim
AD AGENCY: Hjerterommet
CLIENT: Skaanevik Fjord Hotel
p 120 MERIT
ART DIRECTOR: Lynsey Irvine
CLIENT: The Observer
p 136 MERIT
ART DIRECTOR: Steinar Hunskaar
CLIENT: University of Bergen

CHENFU HSING
hsingchenfu@gmail.com
www.chenfuhsing.com
p 338 BEST OF SHOW
INSTITUTION: Toyo Institute Of Art and
Design
INSTRUCTOR: Motohiro Murakami

DAVID HUANG
omguac@gmail.com
www.david-huang.com
p 320 MERIT
INSTITUTION: Rhode Island School of
Design
INSTRUCTOR: Chris Buzelli

KURI HUANG
huangshalvliu@gmail.com
www.kurihuang.com
p 330 MERIT
INSTITUTION: Syracuse University
INSTRUCTOR: Tim Bower
p 342 MERIT
INSTITUTION: Syracuse University
INSTRUCTOR: Tim Bower

MAGO HUANG
magohuang@gmail.com
www.magosart.com
p 355 MERIT
INSTITUTION: Maryland Institute
College of Art
INSTRUCTOR: David Sandlin

ROD HUNT
rod@rodhunt.com
www.rodhunt.com
p 23 GOLD
ART DIRECTOR: Kris Pito
AD AGENCY: R/GA
p 191 MERIT
DESIGN FIRM: Bernstein & Andriulli

PHILIP HUNTINGTON
info@dogboy.co
www.dogboy.co

p 188 MERIT
ART DIRECTOR: Lisa Christophel
DESIGN FIRM: Studio Buró
CLIENT: Petit Bains

ENRIQUE IBANEZ
quibay@gmail.com
www.enriqueibanez.myportfolio.com
p 354 MERIT
INSTITUTION: Edinburgh College
INSTRUCTOR: Glen McBeth

IC4DESIGN
info@ic4design.com
www.ic4design.com
p 26 MERIT
ART DIRECTOR: Andreas Schwitter
DESIGN DIRECTOR: Hande Guler
AD AGENCY: DDB Dubai
CLIENT: UN Women
p 29 BEST OF SHOW
ART DIRECTOR: IC4Design
CLIENT: 5Corporation

**SERGIO INGRAVALLE
(MAIVISTO)**
info@maivisto.de
www.maivisto.de
p 197 MERIT

MAYA ISH-SHALOM
ishalomm@gmail.com
www.mayaishshalom.com
p 265 MERIT
DESIGNER: Michal Magen
PUBLISHER: Yediot Sfarim

CELIA JACOBS
celialenorejacobs@gmail.com
www.celiaj.com
p 318 DISTINGUISHED MERIT
INSTITUTION: Art Center College of
Design
p 327 MERIT
INSTITUTION: Art Center College of
Design
INSTRUCTOR: Chris Clayton

PHILLIP JANTA
info@janta-island.de
www.janta-island.de
p 177 MERIT
ART DIRECTOR: Phillip Janta
DESIGN FIRM: Janta Island
CLIENT: Jucifer Band

HYUN JUNG JI
hyunjung0807@gmail.com
www.hyunjungji.com
p 323 MERIT
INSTITUTION: Art Center College of
Design

RINA JOST
rina.jost@me.com
www.rinajost.ch
p 40 MERIT
ANIMATOR: Rina Jost

GAYLE KABAKER
gaylekabaker@gmail.com
www.gkabaker.com
p 126 MERIT
ART DIRECTOR: Françoise Mouly
CLIENT: The New Yorker

JOHN KACHIK
kachikart@comcast.net
www.johnkachik.com
p 250 MERIT

AYA KAKEDA
akakeda@gmail.com
www.ayakakeda.com
p 225 MERIT
ART DIRECTOR: Emily Utne

p 226 MERIT CLIENT: City Pages

SIMONE KARL
mail@simonekarl.de
www.simonekarl.de
p 335 MERIT
INSTITUTION: Hochschule für
angewandte Wissenschaften Hamburg
INSTRUCTOR: Alexandra Kardinar

ANGELA KEOGHAN
angela@thepicturegarden.co.nz
www.thepicturegarden.co.nz
p 261 MERIT
DESIGN DIRECTOR: Holly Tonks
DESIGNER: Roanne Marner
PUBLISHER: Tate Publishing
p 287 BRONZE
DESIGN DIRECTOR: Jodi Wicksteed
DESIGN FIRM: Bolster Design
CLIENT: The New Zealand School
Journal

JOHAN KESLASSY
keslassy@hotmail.fr
www.jkeslassy.tumblr.com
p 198 MERIT

MANUEL KILGER
manuel.kilger@gmx.de
www.manuelkilger.com
p 158 MERIT
GALLERY: Gallery1988

GRACE HEEJUNG KIM
heejung.gracekim@gmail.com
www.graceheejungkim.com
p 350 MERIT
INSTITUTION: Pratt Institute

HOKYOUNG KIM
hkykim307@gmail.com
www.hokyoungkim.com
p 309 MERIT
INSTITUTION: Ringling College of Art
and Design
INSTRUCTOR: Scott Gordley
p 380 MERIT
INSTITUTION: Ringling College of Art
and Design
INSTRUCTOR: Scott Gordley

SOOMYEONG KIM
isoomyeong@gmail.com
viaasurface.tumblr.com
p 55 MERIT
p 58 MERIT
DESIGNER: Younggeun Byun

RICHARD KLIPPFELD
office@richardklippfeld.com
www.richardklippfeld.com
p 100 MERIT
ART DIRECTORS: Carina Brestian,
Carmela Migliozzi
CLIENT: Progress Magazine

BARTOSZ KOSOWSKI
bartosz.kosowski@gmail.com
www.bartoszkosowski.com
p 187 MERIT
ART DIRECTOR: Bartosz Kosowski
CLIENT: Re Studio

MENELAOS KOUROUDIS
mk2@k2design.gr
www.k2design.gr
p 71 BRONZE
PUBLISHER: K Magazine
p 170 MERIT
CLIENT: Korres

OLIVIER KUGLER
olivier@olivierkugler.com
www.olivierkugler.com
p 84 MERIT

ART DIRECTOR: Stacey Clarkson James
CLIENT: Harper's Magazine
p 248 MERIT

ANNA KWAN
mail@akwanster.com
www.akwanster.com
p 319 MERIT
INSTITUTION: OCAD University

AHRA KWON
hokidoki0709@naver.com
www.ahrakwon.com
p 282 MERIT

KATHERINE LAM
itskatherinelam.com
www.katherinelam.com
p 379 GOLD
INSTITUTION: Ringling College of Art
and Design
INSTRUCTOR: Scott Gordley

TILL LAUER
info@till-lauer.ch
www.till-lauer.ch
p 176 MERIT
DESIGNER: Till Lauer
CLIENT: Neubad, Alright Gandhi

CINDY LEE
cll13mk@student.ocadu.ca
www.cdyillustration.com
p 366 MERIT
INSTITUTION: OCAD University

EUNJOO LEE
eunuinthemoon@gmail.com
www.polarbluebird.com
p 314 SILVER
INSTITUTION: Glasgow School of Art
INSTRUCTOR: Brian Cairns
p 341 MERIT
INSTITUTION: Glasgow School of Art
INSTRUCTOR: Brian Cairns
p 347 DISTINGUISHED MERIT
INSTITUTION: Glasgow School of Art
INSTRUCTOR: Brian Cairns

KALIZ LEE
kalizleee@gmail.com
www.kalizlee.com
p 77 MERIT
PUBLISHER: Breakthrough
IMPRINT: Breakazine

VIC LEE
viclee@me.com
www.viclee.co.uk
p 59 MERIT
ART DIRECTOR: Vic Lee
CLIENT: Ruder Finn Design
p 174 MERIT
ART DIRECTOR: Vic Lee
CLIENT: The Tate Enterprises

JOSÉ MARÍA LEMA DE PABLO
josemarialema@gmail.com
nomparella.blogspot.com.es
p 269 MERIT
DESIGN DIRECTOR: Carlos Muntion
PUBLISHER: Piedra de Rayo
IMPRINT: Gráficas Castuera
p 301 MERIT
DESIGN DIRECTOR: Julián Lacalle
PUBLISHER: Pepitas de Calabaza
Editorial
IMPRINT: Gráficas Castuera

WEI-MING LEONG
weidashming@gmail.com
www.mingleong.com
p 364 MERIT
INSTITUTION: Rhode Island School of
Design
INSTRUCTOR: Fred Lynch

RICKY LEUNG
ricky.leung32@hotmail.com
www.rickyleungart.com
p 241 MERIT

NICK LEVESQUE
nick@nlevesque.com
www.nlevesque.com
p 232 MERIT

JENNIFER LEWIS
jennifer.lewis.rome@gmail.com
www.jenniferlewis.co.uk
p 363 DISTINGUISHED MERIT
INSTITUTION: University of the West of
England, Bristol

JON LEZINSKY
jon@jonlezinsky.com
www.jonlezinsky.com
p 89 MERIT
ART DIRECTOR: Mary Ann Steiner
CLIENT: Catholic Health Association
p 102 MERIT
ART DIRECTOR: Mary Ann Steiner
CLIENT: Catholic Health Association

HANNAH LI
p 244 hannah@hannahliart.com
www.hannahliart.com
MERIT

HELEN LI
hello@helenofkoi.com
www.helenofkoi.com
p 329 MERIT
INSTITUTION: School of Visual Arts
INSTRUCTOR: David Sandlin

JING LI
jingli132@gmail.com
www.jinglistudio.com
p 230 MERIT
ART DIRECTOR: Rick Lovell

NANCY LIANG
nanc.kliang@gmail.com
www.cargocollective.com/nliang
p 251 MERIT

VANYA LIANG
vanyaliang@hotmail.com
www.vanyaliang.com
p 349 MERIT
INSTITUTION: Savannah College of Art
and Design

AHN NA LIM
write@ahnnalim.com
www.ahnnalim.com
p 211 MERIT

DONGHYUN LIM
neoloa3@gmail.com
www.behance.net/donghyun-lim
p 74 MERIT
ART DIRECTOR: Grace Bird
PUBLISHER: Global Blue
p 93 MERIT
ART DIRECTOR: Jess Campe
CLIENT: Modus Magazine

JIA DONG LIN
cobaltvioletlight@gmail.com
www.behance.net/cobaltviol42a0
p 243 MERIT
DESIGNER: Jia Dong Lin

JIANRONG LIN
jl@jianronglin.com
www.jianronglin.com
p 125 SILVER
p 153 MERIT
p 352 MERIT
INSTITUTION: Fashion Institute of
Technology

NICK LITTLE
nick@littleillustration.com
www.nicholaslittleillustration.com
p 41 MERIT
ART DIRECTOR: Bryan Fountain
CLIENT: MIT Technology Review
p 42 MERIT
ART DIRECTOR: Aviva Michaelov
CLIENT: The New Yorker

ENZO LO RE
infoenzolore@gmail.com
www.enzolore.net
p 43 SILVER
p 334 GOLD
INSTITUTION: Brera Academy Milan
INSTRUCTORS: Gianfilippo Pedote, Luca
Mosso
ANIMATOR: Enzo Lo Re

MAX LOEFFLER
max.loeffler@gmx.net
www.maxloeffler.com
p 306 GOLD
INSTITUTION: Hochschule Darmstadt
INSTRUCTOR: Frank Philipin

MIREN ASIAIN LORA
misiain@hotmail.com
www.miaslo.com
p 263 MERIT
DESIGN DIRECTOR: Teresa Tellechea
PUBLISHER: Ediciones SM

CHRIS LYONS
chris@chrislyonsillustration.com
www.chrislyonsillustration.com
p 131 MERIT
DESIGN DIRECTOR: Matthew Lennert
DESIGN FIRM: Deloitte University Press
CLIENT: MIT

AMBER MA
amberma@amberma.com
www.amberma.com
p 316 MERIT
INSTITUTION: School of Visual Arts

PAULIINA MÄKELÄ
pauliina.makela@gmail.com
www.pauliinamakela.com
p 122 MERIT
ART DIRECTOR: Pauliina Makela
CLIENT: YLE (Finnish Broadcasting
Company)

DIEGO MALLO
diegomallo@gmail.com
www.diegomallo.es
p 76 MERIT
ART DIRECTOR: Ferran López
DESIGNER: Carlos Aranda
DESIGN FIRM: Tusquets editores
PUBLISHER: Planeta

WENKAI MAO
wenkaimaoart@gmail.com
www.wenkaimao.com
p 378 MERIT
INSTITUTION: School of Visual Arts
INSTRUCTOR: Ruth Marten

TANYA MARRIOTT
t.marriott@massey.ac.nz
www.tanyamarriott.co.nz
p 224 MERIT
ART DIRECTOR: Tanya Marriott
PUBLISHER: White Cloud Worlds

BISTRA MASSEVA
contact@bistramasseva.com
www.bistramasseva.com
p 290 MERIT

CAITLIN MAVILIA
caitlin.mavilia@gmail.com
www.caitlinmavilia.com

p 322 MERIT
INSTITUTION: Massachusetts College of
Art and Design
INSTRUCTOR: Scott Bakal

JOHN MAVROUDIS
john@zenpop.com
www.zenpop.com
p 88 MERIT
CLIENT: The Nation

BILL MAYER
bill@thebillmayer.com
www.thebillmayer.com
p 35 MERIT
ART DIRECTOR: Wade Thompson
AD AGENCY: Son&Sons
CLIENT: AIGA
p 51 MERIT
ART DIRECTOR: Michael Hendricks
PUBLISHER: Easton Press

STUART MCREATH
smcreath@hotmail.com
www.stuartmcreath.com
p 210 MERIT

XIAO MEI
xiaochanmei@outlook.com
xiaochanmei.com
p 336 MERIT
INSTITUTION: School of Visual Arts
INSTRUCTOR: Josh Cochran

EUGENIA MELLO
hola.eu@gmail.com
www.eugenia-mello.com
p 60 MERIT
ART DIRECTOR: Katie Cantrell
CLIENT: Demo Duck
p 337 MERIT
INSTITUTION: School of Visual Arts
INSTRUCTOR: Marshall Arisman

CAMERON MILLER
cam_miller@live.ca
www.cammiller.ca
p 312 MERIT
INSTITUTION: OCAD University
INSTRUCTOR: Gary Taxali

FAUSTO MONTANARI
fausto.mnt@gmail.com
www.faustomontanari.it
p 41 MERIT
ART DIRECTOR: Fausto Montanari
ANIMATOR: Nikolay Ivanov
p 227 MERIT
ART DIRECTOR: Fausto Montanari

MIGUEL MONTANER
hello@miguelmontaner.com
www.miguelmontaner.com
p 81 MERIT
ART DIRECTOR: Martin Schulz
CLIENT: Zifferdrei

JOSEPH MURPHY
jmmurphyillustrator@yahoo.com
www.jmmurphyillustrator.com
p 295 MERIT

MANICA K. MUSIL
manica@manicamusil.com
www.manicamusil.com
p 277 MERIT

VARVARA NEDILSKA
varvaranedilska@gmail.com
www.varvaranedilska.com
p 360 DISTINGUISHED MERIT
INSTITUTION: OCAD University
INSTRUCTOR: Jon Todd

TRAM NGUYEN
designertvn@gmail.com
www.tramillustration.com
p 151 MERIT

RICARDO NUNEZ SUAREZ
rhinunez@gmail.com
www.rinunez.com
p 56 MERIT
ART DIRECTOR: Ricardo Nunez Suarez

MAYUMI OONO
hello@o-ono.jp
www.o-ono.jp
p 68 MERIT
ART DIRECTOR: Eiji Sakagawa

YI PAN
yipan0101@gmail.com
www.yipan.co
p 69 MERIT
DESIGNER: Yi Pan

ENZO PÉRÈS-LABOURDETTE
enzo@artofenzo.com
www.artofenzo.com
p 258 MERIT
ART DIRECTOR: Claudia van der Werf
PUBLISHER: Leopold
p 280 MERIT
ART DIRECTOR: Claudia van der Werf
PUBLISHER: Leopold

HELENA PEREZ GARCIA
helena@helenaperezgarcia.co.uk
www.helenaperezgarcia.co.uk
p 215 MERIT

DARIA PETRILLI
littlestone70@hotmail.com
it.pinterest.com/littlestone70/my-
illustrations-works
p 192 MERIT
p 204 MERIT
p 214 MERIT

VALERIA PETRONE
valeria@valeriapetrone.com
www.valeriapetrone.com
p 133 MERIT
ART DIRECTOR: SooJin Buzelli
CLIENT: Planadviser Magazine
p 266 DISTINGUISHED MERIT
PUBLISHER: Carthusia Edizioni
p 267 MERIT
ART DIRECTOR: Daniele Garbuglia
PUBLISHER: Eli Edizioni
p 298 DISTINGUISHED MERIT
ART DIRECTOR: Maurizio Varotti
CLIENT: Style Piccoli Magazine

ZARA PICKEN
zara@zaraillustrates.com
www.zarapicken.com
p 193 MERIT

ASIA PIETRZYK
japietrzyk@gmail.com
www.asiapietrzyk.com
p 209 MERIT

ANNA PINI
info@annapini.com
www.annapini.com
p 297 MERIT

LUIS PINTO
info@luispintodesign.com
www.luispintodesign.com
p 70 MERIT
ART DIRECTOR: Laurene Boglio
CLIENT: Little White Lies Weekly

ROBERT PIZZO
rp@robertpizzo.com
www.robertpizzo.com

p 190 MERIT
DESIGNER: Robert Pizzo

EMILIANO PONZI
info@emilianoponzi.com
www.emilianoponzi.com
p 66 BRONZE
ART DIRECTOR: Oliver Gallmeister
p 91 MERIT
ART DIRECTOR: Rina Kushnir
DESIGN DIRECTOR: Nicholas Blechman
CLIENT: The New Yorker
p 124 MERIT
ART DIRECTOR: Angelo Rinaldi
p 140 MERIT
ART DIRECTOR: Chris Curry
CLIENT: The New Yorker

ANDY POTTS
info@andy-potts.com
www.agoodson.com/illustrator/andy-
potts
p 156 MERIT
GALLERY: Sonos Studio, London

NATALIE PUDALOV
studio@nataliepudalov.com
www.nataliepudalov.com
p 86 MERIT

YUWEI QIU
yuweiqiu.art@gmail.com
www.yuweiqiu.com
p 114 MERIT
ART DIRECTOR: Julia Goodman
CLIENT: The Spectacle Literary

KIKÉ QUINTERO
enriqueq119@gmail.com
www.colorsandstories.com
p 52 MERIT
DESIGNER: Kiké Quintero

FATINHA RAMOS
hello@fatinha.com
www.fatinha.com
p 141 MERIT
CLIENT: MO* Magazine

XIN REN
nixner@outlook.com
www.cargocollective.com/xinren
p 311 GOLD
INSTITUTION: University of the Arts
London

NICOLE RIFKIN
n.rifkin.91@gmail.com
www.reformforest.com
p 98 MERIT
ART DIRECTOR: Philipp Hubert
CLIENT: The Intercept
p 233 MERIT

PABLO J. RIVERA
pjrivr@gmail.com
www.pablonotpicasso.weebly.com
p 382 DISTINGUISHED MERIT
INSTITUTION: San Jose State University
INSTRUCTOR: John Clapp

BENE ROHLMANN
mail@benerohlmann.de
www.benerohlmann.de
p 123 MERIT
ART DIRECTOR: Maud Radtke
CLIENT: Welt am Sonntag

EMILIO ROLANDI
rolandiart@gmail.com
www.emiliorolandi.com
p 220 MERIT

MANUEL ROMERO
manuel@romeroilustracion.com
www.romeroilustracion.com

p 216 MERIT
ART DIRECTOR: Manuel Romero

GIULIA ROSSI
giuliarossiart@gmail.com
www.giuliarossiart.tumblr.com
p 304 DISTINGUISHED MERIT

FEIFEI RUAN
art@feifeiruan.com
www.feifeiruan.com
p 106 DISTINGUISHED MERIT
ART DIRECTOR: Tian Ke
CLIENT: Wissen Magazine

MERAV SALOMON
merav.salomon@gmail.com
www.salomondaughters.com
p 166 MERIT
DESIGNER: Naama Tobias
PUBLISHER: Salomon & Daughters
Books

AMY SCHIMLER-SAFFORD
amy@amyschimler.com
www.amyschimler.com
p 294 MERIT

STEPHAN SCHMITZ
stephan.schmitz@gmx.ch
www.stephan-schmitz.ch
p 46 MERIT
ART DIRECTOR: Annette Beger
PUBLISHER: Kommode Verlag Zürich
p 119 MERIT
ART DIRECTOR: Serena Jung
CLIENT: Schweizer Monat

SCHORSCH FEIERFEIL
schabenschorsch@gmx.at
www.schorschfeierfeil.com
p 118 MERIT
ART DIRECTOR: Dirk Merbach
CLIENT: Anzeiger, Das Magazin für die
österreichische Buchbranche

THOM SEVALRUD
thom@thomsevalrud.com
www.thomsevalrud.com
p 80 MERIT
ART DIRECTOR: Morgan Jordan
DESIGN DIRECTOR: Kelly McMurray
DESIGN FIRM: 2Communique
CLIENT: Nobles

ANN SHENG
shenganlu@gmail.com
www.annsheng.com
p 367 MERIT
INSTITUTION: OCAD University
INSTRUCTOR: Shea Chang

QIAOYI SHI
www.qy-shi.com
p 331 MERIT
INSTITUTION: Tyler School of Art

JHAO-YU SHIH
cochan1211@gmail.com
www.littleoil.tumblr.com
p 40 BRONZE
ART DIRECTOR: Jhao-Yu Shih (Little Oil)
ANIMATORS: Bei Chen, Peter Huang,
Chun-sheng Ju

CATALINA SILVA GUZMÁN
catalinasilvaguzman@hotmail.com
www.catalinasilvaguzman.com
p 303 DISTINGUISHED MERIT
PUBLISHER: Editorial Zigzag

STEVE SIMPSON
mail@stevesimpson.com
www.stevesimpson.com
p 22 DISTINGUISHED MERIT
CLIENT: Doma 도마

LASSE SKARBÖVIK
lasse@lasseskarbovik.com
www.lasseskarbovik.com
p 162 MERIT
GALLERY: Ronneby Konsthall

MARK SMITH
marksmith71uk@gmail.com
www.marksmithillustration.com
p 53 MERIT
ART DIRECTOR: Irene Gallo
PUBLISHER: Tor.com

LILY SNOWDEN-FINE
lily@snowdenfine.com
www.lilysnowdenfine.com
p 358 MERIT
INSTITUTION: OCAD University
INSTRUCTOR: Adrian Forrow

DEENA SO OTEH
deena.so.oteh@gmail.com
www.deenasooteh.com
p 383 MERIT
INSTITUTION: School of Visual Arts
p 368 SILVER
INSTITUTION: School of Visual Arts
INSTRUCTOR: Viktor Koen

ILEANA SOON
ileana.soon@gmail.com
www.ileanasoon.com
p 160 MERIT
GALLERY: Giant Robot
p 238 SILVER

SPOOKY POOKA
spookypooka@virginmedia.com
www.spookypooka.com
p 254 MERIT

CARLO STANGA
carlo@carlostanga.com
www.carlostanga.com
p 300 MERIT
ART DIRECTOR: Roberto Di Puma
AUTHOR: Carlo Stanga
p 111 MERIT
ART DIRECTOR: Mary Butler
CLIENT: American National Trust for
Historic Preservation

STUDIO-TAKEUMA
studio-takeuma@hotmail.co.jp
www.studio-takeuma.tumblr.com
p 155 MERIT

KATI SZILAGYI
info@katiszi.com
www.katiszi.com
p 50 MERIT
p 256 MERIT

MAY TA
maypta18@gmail.com
www.maytta.com
p 365 MERIT
INSTITUTION: California State
University of Long Beach
INSTRUCTOR: Mark Michellon

ELISA TALENTINO
info@elisatalentino.it
www.elisatalentino.it
p 48 GOLD
ART DIRECTOR: Paolo Berra
DESIGNER: Elisa Talentino
PUBLISHER: La Grande Illusion
IMPRINT: Fantigrafica Cremona

BINNY TALIB
binny@binny.com.au
www.binny.com.au
p 260 MERIT
ART DIRECTOR: Binny Talib
PUBLISHER: Hachette Publishing
IMPRINT: Lothian

JACQUELINE TAM
hello@byjacquelinetam.com
www.byjacquelinetam.com
p 222 MERIT

SHAUN TAN
shauntan@it.net.au
www.shauntan.net
p 247 MERIT

WENJIA TANG
wjtangart@gmail.com
www.wenjiatang.com
p 83 MERIT
ART DIRECTOR: Ke Tian
CLIENT: Wissen Magazine
p 92 MERIT
ART DIRECTOR: Ke Tian
CLIENT: Wissen Magazine
p 357 MERIT
INSTITUTION: Maryland Institute
College of Art
INSTRUCTOR: Allan Comport
p 386 MERIT
INSTITUTION: Maryland Institute
College of Art
INSTRUCTOR: Rebecca Bradley

SÉBASTIEN THIBAULT
sebastienthibaultillustrations@gmail.com
www.sebastienthibault.com
p 115 MERIT
ART DIRECTOR: Jay Yeo
CLIENT: Monocle
p 120 MERIT
ART DIRECTOR: Robert L White
CLIENT: The Guardian
p 130 MERIT
ART DIRECTOR: Johanna Ritgen-
Sheobaran

MARC TORICES
marctorices@gmail.com
www.behance.net/marctorices
p 164 MERIT
ART DIRECTOR: Marc Torices
PUBLISHER: Nórdica Libros

CALLUM TROWBRIDGE
callum.trowbridge@live.com
www.ctillustrate.myportfolio.com
p 385 MERIT
INSTITUTION: Arts University
Bournemouth

RITA TU
qianwentu@gmail.com
www.ritatu.com
p 326 MERIT
INSTITUTION: Savannah College of Art
and Design
INSTRUCTOR: Don Rogers

GERRY TURLEY
gerry_turley@yahoo.co.uk
www.gerryturley.com
p 268 BRONZE
ART DIRECTOR: Jennifer Stephenson
PUBLISHER: Hachette Book Group
IMPRINT: Hodder Children's Books

ANDREA UCINI
uciniandrea@hotmail.it
www.andreaucini.com
www.agoodson.com/illustrator/andrea-
ucini
p 242 MERIT
DESIGNER: Andrea Ucini
p 252 MERIT
DESIGNER: Andrea Ucini
p 253 MERIT

JOÃO VAZ DE CARVALHO
contacto@jvazcarvalho.com
www.jvazcarvalho.com
MERIT

DESIGN DIRECTOR: Mariana Rio
PUBLISHER: Canto das Cores

MARIO WAGNER
mail@mario-wagner.com
www.mario-wagner.com
p 132 MERIT

MANUJA WALDIA
manujawaldia@gmail.com
www.manujawaldia.com
p 72 GOLD
ART DIRECTOR: Paul Buckley
DESIGNER: Manuja Waldia
PUBLISHER: Penguin Random House
p 234 MERIT

DORA WANG
dorawang.art@gmail.com
www.dorawang.net
p 315 DISTINGUISHED MERIT
INSTITUTION: Massachusetts College of
Art and Design
INSTRUCTOR: Scott Bakal
p 377 MERIT
INSTITUTION: Massachusetts College of
Art and Design
INSTRUCTOR: Scott Bakal

LIN WANG
lin_136@hotmail.com
www.wendylynn.com
p 276 MERIT
ART DIRECTOR: Christy Hale
PUBLISHER: Lee & Low

LUYI WANG
luyiwangart@gmail.com
www.luyiwang.weebly.com
p 332 MERIT
INSTITUTION: Maryland Institute
College of Art
INSTRUCTOR: Whitney Sherman

MARK WANG
markwangillustration@gmail.com
www.markwangillustration.com
p 321 DISTINGUISHED MERIT
INSTITUTION: Fashion Institute of
Technology
INSTRUCTOR: Brendan Leach

SHU-MAN WANG
amanwww@gmail.com
www.flickr.com/amannwang
p 270 SILVER

MICHAEL WARAKSA
michaelwaraksa@att.net
www.michaelwaraksa.com
p 90 MERIT
ART DIRECTOR: SooJin Buzelli
CLIENT: Plansponsor Magazine

ANDREW WATCH
watchandrew@gmail.com
www.andrewwatch.com
p 345 BRONZE
INSTITUTION: OCAD University
INSTRUCTOR: Chris Kuzma
p 353 MERIT
INSTITUTION: OCAD University
INSTRUCTOR: Chris Kuzma

NEIL WEBB
neil@neilwebb.net
www.neilwebb.net
p 60 MERIT
DESIGN DIRECTOR: Jim Sutherland
DESIGN FIRM: Studio Sutherlamd
CLIENT: Royal Mail

KATJA WEIKENMEIER
info@weikenmeier.de
www.weikenmeier.de
p 255 MERIT

TAYLOR WESSLING
taylor@taylorwessling.com
www.taylorwessling.com
p 103 MERIT
ART DIRECTOR: Lindsay Ballant
CLIENT: The Baffler

JOE WHANG
joe@joewhang.com
www.joewhang.com
p 228 MERIT

CARL WIENS
wiens@kos.net
www.carlwiens.com
p 231 MERIT

**NATALIA WILKOSZEWSKA,
NATKASTUDIO**
natalia@natkastudio.london
www.natkastudio.london
p 240 MERIT

ILENE WINN-LEDERER
ilene@winnlederer.com
www.magiceyegallery.com
p 213 MERIT
ART DIRECTOR: Ilene Winn-Lederer

CHEN WINNER
chenchanges@gmail.com
www.chenwinner.com
p 44 DISTINGUISHED MERIT
DESIGNER: Chen Winner
DESIGN FIRM: Studio MM
CLIENT: CNN
ANIMATOR: Chen Winner

SARA WONG
sara.ariel.wong@gmail.com
www.saraarielwong.com
p 64 MERIT
p 317 BRONZE
INSTITUTION: Washington University
in St. Louis
INSTRUCTOR: DB Dowd

CHEN WU
chenmei0658@yahoo.com.tw
www.behance.net/chenwugraphicdesign
p 351 MERIT
INSTITUTION: National Taiwan Normal
University
INSTRUCTOR: Bi Ni

TAILI WU
monstershaper@gmail.com
www.monstershaper.com
p 42 MERIT
CREATIVE DIRECTOR: Ryan Dunn
DESIGNER: Taili Wu
CLIENT: Chrlx
ANIMATOR: Taili Wu

STEPHANIE WUNDERLICH
info@wunderlich-illustration.de
www.wunderlich-illustration.de
www.agoodson.com
p 105 MERIT
ART DIRECTOR: Annett Osterwold
CLIENT: Die Zeit

KEIKO NABILA YAMAZAKI
hello@knyamazaki.com
www.knyamazaki.com
p 333 MERIT
INSTITUTION: School of Visual Arts
INSTRUCTOR: Aya Kakeda
p 324 MERIT
INSTITUTION: School of Visual Arts
INSTRUCTOR: David Soman

JAMES YANG
james@jamesyang.com
www.jamesyang.com
p 184 MERIT
DESIGN DIRECTOR: Alexandra Zsigmond

CLIENT: Our Fears
p 286 BRONZE
ART DIRECTOR: James Yang
CLIENT: lammama.com
PUBLISHER: lammama.com

SUNNY B. YAZDANI
www.sunnyyazdani.com
p 384 BRONZE
INSTITUTION: Savannah College of Art
and Design

JI HYUN YU
hellohowdyhiya@gmail.com
www.hellohowdyhiya.com
p 194 MERIT

NATALIA ZARATIEGUI
nataliazaratiegui@gmail.com
www.nataliazaratiegui.com
p 78 MERIT
PUBLISHER: Ardicia

ALICE ZENG
alicez3ng@gmail.com
www.behance.net/alice-zeng
p 307 MERIT
INSTITUTION: Capilano University
INSTRUCTOR: Pascal Milelli

CONGRONG ZHOU
congrong0712@gmail.com
www.congrongzhou.com
p 375 MERIT
INSTITUTION: School of Visual Arts
INSTRUCTOR: Bruce Waldman

FRANCESCO ZORZI
me@francescozorzi.it
www.francescozorzi.it
p 178 MERIT
CLIENT: Macma

PUBLISHER'S NOTE
*Every effort has been made to ensure that the
credits and contact information comply with the
information provided us. 3x3 is not responsible for
missing information or credits.
We apologize for any omissions or spelling errors
that may have been carried through from the
original submission of materials.*

INDEX

HONORABLE MENTIONS

Congratulations to our honorable mentions. An * denotes multiple entries in that category. Artwork that was awarded honorable mention is also displayed online at 3x3mag.com/annual14

SAMIA AHMED
www.samiaahmed.com
Student Show

GERT ALBRECHT
www.gertalbrecht.de
Professional Show: Packaging

JOE ANDERSON
www.joeandersonstudio.com
Professional Show: Unpublished

CASEY BABB
www.breakingbabb.com
Student Show

CASEY BABB
www.breakingbabb.com
Student Show

ALEXANDRA S. BADIU
alexandrabadiu.myportfolio.com
Student Show

GIACOMO BAGNARA
www.giacomobagnara.com
Professional Show: Editorial
Professional Show: Unpublished

ANAGH BANERJEE
www.anaghbanerjee.com
Student Show

ROGER LUGO BAPTISTA
rogerlugob.wixsite.com/rogerlu-gob-portfolio
Student Show

CALVIN BAUER
www.calvinbauer.com
*Student Show

ALEXANDRA BEGUEZ
www.alexandrabeguez.com
Professional Show:
Self-Promotion

DAN BEJAR
www.bejarprints.com
Professional Show: Editorial

KATE BELLE
www.katebelle.com
Professional Show:
Self-Promotion

BELLEBRUTE
www.bellebrute.com
Picture Book Show: Young Adult
Professional Show: Posters

ALISSA BERKHAN
www.behance.net/aliceberkhan
Student Show

ROBERTO HIKIMI BLEFARI
www.hikimi.it
Professional Show: Editorial

JUDGE BOCKMAN
www.judgebockman.com
Student Show

KATARZYNA BOGDAŃSKA
katarzynabogdanska.blogspot.com
Professional Show: Editorial
Professional Show: Unpublished

SISHIR BOMMAKANTI
www.sishir.com
Student Show

DAVIDE BONAZZI
www.davidebonazzi.com
Professional Show: Editorial

MARK BORGIONS
www.handmademonsters.com
*Professional Show: Gallery

JOANA ROSA BRAGANÇA
www.joanarosab.com
*Professional Show:
Self-Promotion

DIETER BRAUN
www.brauntown.com
Professional Show: Editorial
Professional Show: Gallery
Professional Show: Unpublished

PEDRO BURGOS
www.pedroburgos.tumblr.com
Professional Show: Editorial

DAVID BUSHELL
www.davidbushell.net
Professional Show: Unpublished

MIKAYLA BUTCHART
www.mikaylabutchart.com
Student Show

MICHELA BUTTIGNOL
www.michelabuttignol.com
Professional Show: Posters

JILL CALDER
www.jillcalder.com
Professional Show: Editorial

GABRIEL CANICOSA
www.gabrielcanicosa.com
Student Show

MARIA CARLUCCIO
www.mariacarluccio.com
Professional Show:
Self-Promotion

SARA GIRONI CARNEVALE
www.saragironicarnevale.com
Professional Show:
Self-Promotion

ANDRÉ CARRILHO
www.andrecarrilho.com
Professional Show: Editorial

GIULIO CASTAGNARO
www.giuliocastagnaro.com
Professional Show: Editorial

KEVIN ARNOLDO CATALAN
www.kevincatalan.com
Student Show

ASU CEREN
www.asuceren.com
Student Show

ELLIOTT CHAMBERS
www.elliottchambers.com
Student Show

ANGEL CHANG
www.angelchangart.com
Professional Show: Editorial

JANICE CHANG
www.janicechangart.com
*Student Show

EMILY CHEN
www.emichenart.com
Student Show

ZHII-RONG CHEN
www.behance.net/ZhiiRongc
Student Show

KUN-SEN CHIANG
www.behance.net/mrmori
Student Show

RYAN CHO
www.ryanchoart.com
Student Show

CELINE CHOW
www.celinechow.com
Student Show

CHRISTINA CHUNG
www.christina-chung.com
Professional Show: Editorial

JENNA NAHYUN CHUNG
jennahyunchung.myportfolio.com
Student Show

MARIYA CHUPILINA
www.mariyachupilina.tumblr.com
Professional Show:
Self-Promotion

LIVIA CIVES
www.liviacives.com
Professional Show: Covers

FABIO CONSOLI
www.fabioconsoli.com
Professional Show: Posters

CAMERON COTTRILL
www.camcottrill.com
Professional Show: Editorial

CRISTIANA COUCEIRO
www.cristianacouceiro.com
*Professional Show: Editorial

DANE COZENS
www.danecozens.com
*Student Show

MIRKO CRESTA
www.mirkocresta.com
Professional Show:
*Self-Promotion

SARA CUNHA
www.saracunha.net
Professional Show: Gallery

HANNAH CUNNINGHAM
www.oddjobart.com
Student Show

GERARD D'ALBON
www.gerarddalbon.com
Student Show

GIOVANNI DA RE
www.giovannidare.com
Picture Book Show: Published Illustration
Professional Show: Editorial

OWEN DAVEY
www.folioart.co.uk
Professional Show: Advertising
Professional Show: Editorial

ALESSANDRA DE CRISTOFARO
www.alessandradecristofaro.com
Professional Show:
Self-Promotion

ADAM DE SOUZA
www.kumerish.com
*Student Show

MAI LY DEGNAN
www.mailydegnan.com
Professional Show: Gallery
Professional Show: Greeting Cards
Professional Show: Unpublished

ALICE YU DENG
www.alicedy.com
Student Show

SALLY DENG
www.sallydeng.com
Professional Show: Gallery

CHRIS DICKASON
www.chrisdickason.co.uk
Professional Show: Editorial

ANNIE DILLS
www.anniedills.com
Student Show

SANDRA DIONISI
www.sandradionisi.com
Professional Show: Unpublished

SEAN DOCKERY
www.seandock.com
Professional Show: Gallery

LEA DOHLE
www.leadohle.de
Professional Show: Covers

JESSICA DRYDEN
www.jessicadryden.com
Student Show

CHRISTOPHER DUPON-MARTINEZ
www.christopherduponmartinez.com
Student Show

RICHARD EMBERTON
www.richardemberton.com
Professional Show:
Self-Promotion

GRACE EMMET
www.graceemmet.com
Student Show

SAM ESTRABILLO
www.sam-estrabillo.com
Student Show

FABULO
www.fabuloworld.tumblr.com
Professional Show: Editorial

LOGAN FAERBER
www.loganfaerberdesign.com
Professional Show: Gallery

MOLLY FAIRHURST
www.mollyfairhurst.com
Student Show

LISA FALKENSTERN
www.lisafalkenstern.com
Professional Show:
Self-Promotion

JADE FANG
www.jadeartz.com
Professional Show:
Self-Promotion

CHRIS FERRANTELLO
www.chrisferrantello.com
Professional Show: Gallery

SARA FRATINI
www.sarafratini.com
Professional Show: Gallery

ERIC LEIF FREEBERG
www.ericfreebergillustration.com
Picture Book Show: Published
Illustration

FANGFANG FU
www.fangfangfu.com
Student Show

MOLLY GAMBARDELLA
www.mollygambardella.com
Professional Show: Three-
Dimensional
Student Show

PAUL GARLAND
www.paul-garland.com
Professional Show: Editorial
Professional Show: Posters

FELIX GEPHART
www.felixgephart.de
Professional Show: Books

GARRETT GERBERDING
gkgerberding.portfoliobox.net
Student Show

SUZY GERHART
www.suzygerhart.com
Professional Show: Editorial

JAMES GILLEARD
www.folioart.co.uk
Professional Show:
Self-Promotion

LENKA GLOBANOVA
www.lenkaglobanova.jp
Professional Show:
Self-Promotion

IGOR GNEDO
www.igorgnedo.com
Professional Show: Posters
Professional Show:
Self-Promotion

ANNA GODEASSI
www.annagodeassi.com
Professional Show: Editorial

ESTHER GOH
www.esthergoh.co
Professional Show: Fashion

SHIRLEY GONG
www.behance.net/xunigong
Student Show

AAD GOUDAPPEL
www.aadgoudappel.com
Professional Show: Corporate
Communications
Professional Show: Editorial

PATRICK GRAY
www.grayillustration.com
Professional Show:
Self-Promotion

SHREYA GUPTA
www.shreyaillustrations.com
Student Show

SALLY SOWEOL HAN
www.sallyhanillustration.com
*Student Show

SOOJI HAN
www.sjhanart.com
Student Show

KELLEN HATANAKA
www.kellenhatanaka.com
Picture Book Show: Published
Book

ANDREW HAVILAND
www.andrewhaviland.ca
Professional Show:
Self-Promotion

HEATHER HECKEL
www.heatherheckel.com
Professional Show: Editorial

JOY HO
www.joyabigailho.com
*Student Show

KEVIN HONG
www.khongart.com
Student Show

PAUL HOPPE
www.paulhoppe.com
Professional Show: Editorial

PAUL HOSTETLER
www.phostetler.com
Professional Show:
Self-Promotion

ØIVIND HOVLAND
www.oivindhovland.com
*Professional Show: Editorial

ANGELA HSIEH
www.angelahh.com
*Student Show

SHEN CHEN HSIEH
www.shsieh.creatorlink.net
Student Show

AVALON YANGCHEN HU
www.avalonhu.com
Professional Show:
Self-Promotion

CHIU-HSUAN HUANG
www.cargocollective.com/chiuh-
suanhuang
Student Show

DAVID HUANG
www.david-huang.com
*Student Show

KURI HUANG
www.kurihuang.com
*Student Show

YU HAN HUNG
www.yuhanillustration.com
Student Show

ENRIQUE IBANEZ
www.enriqueibanez.myportfolio.
com
Student Show

IC4DESIGN
www.ic4design.com
Professional Show: Covers

JANNE IIVONEN
www.janneiivonen.net
*Professional Show: Covers
Professional Show: Packaging

**SERGIO INGRAVALLE
(MAIVISTO)**
www.maivisto.de
Professional Show: Editorial
Professional Show:
Self-Promotion

JAMIE JONES
www.whoisjamiejones.com
Professional Show: Editorial

FEDERICO JORDAN
www.fjordan.com
Professional Show: Corporate
Communications

HAAM JUHAE
www.dogravity.tumblr.com
Professional Show: Books

DANA KANG
www.kangdanakang.net
*Student Show

**ALINA KAROTKAYA (BELA
PAPERA)**
www.instagram.com/bela_papera
Student Show

BLAIR KELLY
www.blairkellystudio.com
Professional Show: Packaging

SARA KENDALL
www.sarakendall.net
Student Show

GRACE HEEJUNG KIM
www.graceheejungkim.com
Student Show

HYOEUN KIM
www.hyoeunkim.com
Student Show

JENICE KIM
www.jenicekim.com
*Student Show

SEONGEUN KIM
www.seongeunkimart.com
Student Show

SU KIM
sukim20@student.scad.edu
Student Show

CHRIS KINTNER
www.chriskintner.com
Student Show

DARIA KIRPACH
www.dariakirpach.com
Professional Show: Editorial

BAILEY KNUDSEN
www.baileyknudsen.com
Professional Show: Textiles &
Patterns

KOKO
s.koko0801@gmail.com
Student Show

JADWIGA KOWALSKA
www.jadwiga.ch
Picture Book Show: Published
Book

ANNA KWAN
www.akwanster.com
Student Show

AYOUNG KWON
www.ayoungkwon.me
Student Show

JESS LAGRECA
www.jesslagreca.com
*Student Show

GABRIELA LARIOS
www.gabrielalarios.com
Professional Show:
Self-Promotion

MARC LARIVIÈRE
www.marclariviere.com
Professional Show: Editorial

RAZ LATIF
www.razlatif.com
Professional Show: Fashion

CINDY LEE
www.cdyillustration.com
*Student Show

DONGJUN LEE
www.illudj.com
Professional Show: Editorial

EUNJOO LEE
www.polarbluebird.com
*Student Show

HA GYUNG LEE
www.hagyunglee.com
Professional Show: Unpublished

INSU LEE
www.insulee.wix.com/insu
Professional Show:
Self-Promotion

JISU LEE
www.jisulee.format.com
Student Show

NAYEON LEE
www.nayeon-lee.com
Student Show

SOHYUN LEE
www.cargocollective.com/long-
shortstory
*Professional Show: Unpublished

VIC LEE
www.viclee.co.uk
*Professional Show: Corporate
Communications
Professional Show: Unpublished

HANNA LEFCOURT
www.hannalefcourt.com
*Student Show

**CHRISTIAN LEON
GUERRERO**
www.christianleonguerrero.com
Professional Show:
*Self-Promotion

WEI-MING LEONG
www.mingleong.com
*Student Show

RICKY LEUNG
www.rickyleungart.com
*Professional Show: Unpublished

AURA LEWIS
www.auralewis.com
Student Show

CHANG (LILLIAN) LI
www.changlillian.com
Student Show

HANNAH LI
www.hannahliart.com
*Student Show

HELEN LI
www.helenofkoi.com
Student Show

HENGGUANG LI
www.instagram.com/bonrange_li
*Student Show

JING LI
www.jinglistudio.com
*Student Show

TAOYU LI
www.tuyoutoyou.com
Student Show

VANYA LIANG
www.vanyaliang.com
Student Show

DANIEL LIÉV
www.lifeisanillusion.com
Professional Show: Sequential

JIANRONG LIN
www.jianronglin.com
*Professional Show: Fashion

JUN LIN
yjunlin.tumblr.com
Student Show

YUKITO LIN
www.behance.net/kidisland
Professional Show: Books

HUANG LING HSING
www.behance.net/danmian
Picture Book Show: Unpublished
Illustration

XINMEI LIU
www.catmoverart.net
Student Show

XINMEI LIU
www.catmoverart.net
Student Show

ZHIHE (HANK) LIU
www.liuhank.com
Student Show

MARK LUCZAK
www.markluczak.com
Student Show

JIMMY MALONE
www.xoxojimmymalone.com
Professional Show: Posters

WENKAI MAO
www.wenkaimao.com
Student Show

MARCO MARELLA
www.behance.net/marcomarella
Professional Show:
Self-Promotion

ADAM MARIN
www.adamjmarin.com
Student Show

TANYA MARRIOTT
www.tanyamarriott.co.nz
Professional Show:
Three-Dimensional

VINCENT MATHY
www.instagram.com/vincentma-
thy
Professional Show: Posters

JUTTA MATVEEV
www.jutta-matveev.de
*Student Show

CAITLIN MAVILIA
www.caitlinmavilia.com
Student Show

VICTORIA MAXFIELD
www.victoriamaxfield.com
*Student Show

BILL MAYER
www.thebillmayer.com
*Professional Show: Editorial

HAYDEN MAYNARD
www.haydenmaynard.com
Professional Show: Editorial

FENNELL MCCORMACK
www.fennellm.com
Student Show

KEVIN MCGIVERN
www.kevinmcgivern.com
Professional Show: Gallery

MICHELLE MEE
www.michellemee.com
*Student Show

YINGHUI MENG
yinghuimeng.carbonmade.com
*Student Show

ROSANNA MERKLIN
www.rosarai.de
Professional Show:
Self-Promotion

VASSILIS MEXIS
www.behance.net/vame
Professional Show: Posters

ZACH MEYER
www.zachmeyerillustration.com
Professional Show: Editorial

FAUSTO MONTANARI
www.faustomontanari.it
Professional Show: Editorial

MIGUEL MONTANER
www.miguelmontaner.com
*Professional Show: Editorial
*Professional Show:
Self-Promotion

YUKI MORI
yukimoriportfolio.blogspot.com
Student Show

AYA MORTON
www.ayamorton.com
Professional Show: Posters

MANICA K. MUSIL
www.manicamusil.com
Picture Book Show: Unpublished
Book

MUHAMMAD MUSTAFA
www.behance.net/picxo
Professional Show: Covers

VARVARA NEDILSKA
www.varvaranedilska.com
Student Show

VARVARA NEDILSKA
www.varvaranedilska.com
Student Show

ROBERT NEUBECKER
www.neubecker.com
Picture Book Show: Published
Book
*Professional Show: Editorial

NIK NEVES
www.nikneves.com
Professional Show: Editorial

NICO189
www.nico189.tumblr.com
Professional Show: Editorial
Professional Show:
Self-Promotion

KATY NICOLAU
www.katynicolau.cl
Student Show

FONZY NILS
www.fonzynils.com
Professional Show: Editorial

AVALON NUOVO
www.avalonnuovo.com
*Student Show

JAMES O'BRIEN
www.obrien.art
Professional Show: Editorial

INES OLIVEIRA
www.inesoliveira.net
Picture Book Show: Published
Book

OOONG
www.behance.net/ooong
Student Show

**GABRIELLA NICOLE
PADILLA**
www.gabriellanicolepadilla.com
Student Show

MARTA PANTALEO
www.martapantaleo.com
Professional Show:
Self-Promotion

LARA PAULUSSEN
www.cargocollective.com/larapau-
lussen
Student Show

DI PEI
www.behance.net/dipei203354
Student Show

LOUIS PRONZY PEREZ
www.pronzyart.com
Student Show

HELENA PEREZ GARCIA
www.helenaperezgarcia.co.uk
Professional Show:
Self-Promotion

DARIA PETRILLI
it.pinterest.com/littlestone70/
my-illustrations-works
Professional Show:
Self-Promotion

VALERIA PETRONE
www.valeriapetrone.com
*Professional Show: Editorial

PAMELLA PINARD
www.pamellapinard.com
*Student Show

ARTHUR PLATEAU
www.arthurplateau.com
Student Show

EMILIANO PONZI
www.emilianoponzi.com
Professional Show: Covers

SKARLETT KAY PRITTIE
www.skarlettkay.com
Student Show

QINGWONG
www.olivia223.lofter.com
Student Show

JULIETTE RAJAK
www.julietterajak.com
Student Show

FÉ RISKÉ
www.refiske.tumblr.com
Professional Show: Posters

PABLO J RIVERA
pablonotpicasso.weebly.com
Student Show

DUNCAN ROBERTSON
www.duncanillustration.com
Professional Show: Advertising

GRACE ROBINSON
www.gracerobinsonillustration.
com
Professional Show: Unpublished

MATTHEW RODICH
www.matthewrodich.com
Student Show

CHRISTINE RÖSCH
www.christineroesch.de
Professional Show: Editorial

EMILY MAY ROSE
www.emilymayrose.com
Professional Show: Gallery

BAILIE ROSENLUND
www.bailierosenlund.com
Professional Show:
Self-Promotion

PIA SABEL
www.piasabelart.no
Student Show

PAOLA SALIBY
www.paolasaliby.com
Professional Show:
Self-Promotion

KELLYN SANDERS
www.kellynsanders.com
Student Show

MANELI SARMADI
www.danecozens.com
Student Show

SHUNSUKE SATAKE
www.naturalpermanent.com
Professional Show: Sequential

ALESSANDRA SCANDELLA
www.alessandrascandella.com
Professional Show: Animation

JEREMY SCHILLING
www.jeremyschilling.com
Professional Show:
Self-Promotion

AMY SCHIMLER-SAFFORD
www.amyschimler.com
Picture Book Show: Unpublished
Illustration

RICK SEALOCK
www.ricksealockart.com
Professional Show: Editorial

ASHLEY SEIL SMITH
www.seilsmith.com
Professional Show: Editorial

ANDREW SELBY
www.illustrationweb.com/
andrewselby
Professional Show: Posters

MARTA SEVILLA
www.martasevilla.es
Professional Show: Covers

JHAO-YU SHIH
www.littleoil.tumblr.com
Professional Show: Gallery

LASSE SKARBÖVIK
www.lasseskarbovik.com
Professional Show: Gallery
Professional Show:
Self-Promotion

MAREK SKUPINSKI
www.marekskupinski.com
Professional Show: Covers

KATHERINE SMITH
www.kateeshillustration.com
*Student Show

SONYA ABBY SOEKARNO
www.sonyaabby.carbonmade.com
Student Show

VALERIE SOKOLOVA
www.bit.ly/vsportfolio
Picture Book Show: Published
Book

ILEANA SOON
www.ileanasoon.com
*Professional Show: Editorial
*Professional Show: Gallery
Professional Show: Unpublished

STUDIO-TAKEUMA
studio-takeuma.tumblr.com
Professional Show: Corporate
Communications
Professional Show: Unpublished

TAKAHIRO SUGANUMA
www.silverrat.net
Professional Show: Books

SARAH SUNG
www.sarah-sung.com
Student Show

**HALA WITTWER
SWEARINGEN**
www.artbyhala.com
Professional Show: Gallery

KATI SZILAGYI
www.katiszi.com
Professional Show: Covers
Professional Show: Editorial

JACQUELINE TAM
www.byjacquelinetam.com
Professional Show: Editorial

Professional Show:
Self-Promotion

GARY TAXALI
www.garytaxali.com
Professional Show: Editorial

SÉBASTIEN THIBAULT
www.sebastienthibault.com
Professional Show: Corporate
Communications
Professional Show: Editorial

TRABOZAB
www.trabozab.com
Professional Show: Comics/
Cartoons

GRACE TSAI
www.gracetsaiart.com
*Student Show

MU LING TSAI
www.mulingillustration.com
Professional Show: Unpublished

RITA TU
www.ritatu.com
Student Show

SARA TYSON
www.saratyson.com
Professional Show: Editorial

ANDREA UCINI
www.andreaucini.jimdo.com,
www.agoodson.com/illustrator/
andrea-ucini/
Professional Show: Unpublished

TOMA VAGNER
www.tomavagner.com
*Student Show

JULIE VAN MILDERS
www.julievanmilders.com
Professional Show: Posters
Student Show

VANCAI
www.vancai.net
*Student Show

RACHEL WADA
www.rachelwada.com
Professional Show: Editorial

DORA WANG
www.dorawang.net
*Student Show

MARK WANG
www.markwangillustration.com
*Student Show

HUBERT WARTER
www.hubertwarter.de
Professional Show: Editorial

KAILEY WHITMAN
www.kaileywhitman.com
Professional Show: Unpublished

SHIELLA WITANTO
www.shiellawitanto.com
*Student Show

SARA WONG
www.saraarielwong.com
Professional Show: Unpublished

FEI XIAN
www.behance.net/hi_fibby
Student Show

KEIKO NABILA YAMAZAKI
www.knyamazaki.com
*Student Show

ELLIE JI YANG
www.ellie-yang.com
*Student Show

HUI YANG
www.hyang.myportfolio.com
Student Show

TERRY YANG
www.terryang.com
Professional Show: Gallery

SUNNY B. YAZDANI
www.sunnyyazdani.com
Student Show

ZINA YE
zinaye.zcool.com.cn
Professional Show:
Self-Promotion

CHLOE YEE MAY
www.chloeyeemay.com
Professional Show: Editorial
Professional Show: Unpublished

JO YEH
www.joyehillustration.com
Professional Show: Editorial

JULIA YELLOW
www.juliayellow.com
*Professional Show: Editorial
Professional Show: Unpublished

OR YOGEV
www.flickr.com/
photos/127968762@N04
Student Show

JI HYUN YU
www.hellohowdyhiya.com
Professional Show:
Self-Promotion

MIHYUN YU
www.illustmyu.com
Picture Book Show: Young Adult

TENG YU
www.tengyulab.com
Professional Show: Graphic
Novels

AMY YUNG
www.amyyung.com
Professional Show: Gallery

ALICE ZENG
www.behance.net/alice-zeng
Student Show

QI ZHAN
www.qizhan.ca
Student Show

RUXIN ZHANG
www.xinillus.com
Student Show

YUCHEN ZHANG
www.yuchenzhang.net
Student Show

RAN ZHENG
www.ranzhengart.com
Student Show

FRANCESCO ZORZI
www.francescozorzi.it
Professional Show: Posters

PUBLISHER'S NOTE
*Every effort has been made to ensure
that the credits and contact infor-
mation comply with the information
provided us. 3x3 is not responsible for
missing information or credits.
We apologize for any omissions or
spelling errors that may have been
carried through from the original
submission of materials.*

HONORABLE MENTIONS

SHOW CHAIR
Rod Hunt

DESIGN DIRECTOR
Charles Hively

SENIOR DESIGNER
Sarah Munt

SHOW COORDINATOR
Skye Bolluyt

COVER ILLUSTRATION
Ahn Na Lim

HONOREE
Rutu Modan

ISBN 978-1-946750-03-7

Printed in Canada by The Prolific Group

The text faces are Calluna and CallunaSans, designed by Jos Buivenga at the Exljbris Font Foundry, 2009.

The book was printed four-color process on 100lb Endurance Silk cover and 80lb Endurance Silk text.

SPECIAL THANKS
To our judges for taking time out of their busy schedules to judge more than 4,700 images. Judging was done digitally and independently over a two-week period. Judges were not given a quota nor any limits on how many pieces an entrant was allowed in the annual. Judging was done by image number, not by the name of the entrant; results were tabulated automatically once the judging process was complete. Winners were announced and promoted on our site, blog and social media.

And finally, thank you to all our entrants for entering our show. Without their engaging entries there wouldn't be a need to produce a volume dedicated to fostering interest in contemporary illustration.

If you are interested in our previous annuals, they are available in print and digital editions for purchase in our online shop at shop.3x3mag.com.

If you are interested in entering next year's show, please join our mailing list at 3x3mag.com/about/mailinglist and put shows@3x3mag.com in your address book to receive future announcements.

Follow us on Facebook, Instagram and Twitter.

www.3x3mag.com

While Artisanal Media makes every effort possible to publish full and correct credits for each work included in this annual, sometimes errors of omission or commission may occur. For this Artisanal Media is most regretful, but hereby must disclaim any liability.
As this book is printed in four-color process, illustrations reproduced here may appear to be slightly different from their original reproduction.
The 3x3 Illustration Annual is designed by HivelyDesigns 649 Morgan Avenue Suite 4A2 Brooklyn New York 11222.
The 3x3 Illustration Annual is published by Artisanal Media LLC and distributed worldwide.
Artisanal Media is the parent company of 3x3 and publishes its magazine, annuals, books and directory.